The Statue of Liberty Restoration

Proceedings of
The Statue of Liberty — Today for Tomorrow
Conference

October 20-22, 1986
New York City, New York

Proceedings edited by

Robert Baboian, E. Blaine Cliver, and E. Lawrence Bellante

Sponsored by

National Association of Corrosion Engineers
National Park Service

Cosponsored by

American Association for State and Local History
American Institute for the Conservation of Historic and Artistic Works
American Society of Civil Engineers
ASM International
Association for Preservation Technology
ASTM
National Institute for Conservation of Cultural Property
National Society of Professional Engineers
National Trust for Historic Preservation
Society for Industrial Archaeology
Statue of Liberty–Ellis Island Foundation

Published by
National Association of Corrosion Engineers

Published by
National Association of Corrosion Engineers
1440 South Creek Drive
Houston, Texas 77084

Production Artists
Sandy Cox
Denise A. Whitton

Associate Director, Publications
Suzanne M. Pearson

Typesetting
Teri J. Poldervaart

Managing Editor, Books
Laura A. Wagner

ISBN: 1-877914-12-6
Library of Congress Catalog Card Number: 90-61053

Cover by Robert L. Laverdiere, Texas Instruments Inc., 1989

■ *Foreword*

The papers in this book were presented at the National Association of Corrosion Engineers Conference "The Statue of Liberty—Today for Tomorrow," October 20-22, 1986, in New York City, New York. They tell the fascinating story of the Statue, from its symbolic history and why it was constructed to the completion of the restoration project. The presentations at the conference and the papers in this book were contributed by persons intimately involved in the restoration project and experts on the various aspects of the Statue and her history.

■ *Preface*

The restoration of the Statue of Liberty was a great national undertaking. Funds from every segment of society—individuals and foundations, corporations and grassroots groups—went into this effort. Included in these donations was the technical support provided by industry in conjunction with the NACE Public Affairs Subcommittee on Conservation of Artistic and Historic Works. Working closely with the technical staff of the National Park Service North Atlantic Historic Preservation Center, these people provided scientific and technical assistance and helped to establish the parameters around which the restoration was accomplished.

The results of this effort were presented in a public symposium on October 20 and 21, 1986, the papers from which are found in this publication. By providing information on the background of the project, the Statue's history of construction, and the technical considerations faced during the work, the immense scope of the task is recorded for posterity. For this publication, the editors and members of NACE are to be complimented for a job well done. In the accomplishment of the Statue of Liberty restoration, the American public should find something for which it can be justly proud. No pride is more deserving, for, as a people, we rose to the task of saving our national symbol, "Miss Liberty."

Lee Iacocca
Chairman Emeritus
The Statue of Liberty–Ellis Island Foundation
July 25, 1989

■ *Table of Contents*

■ *Introduction*

The Statue of Liberty is recognized today as America's foremost symbol and a world-class monument. However, the Statue was not originally created to symbolize the American nation, but rather to serve as a monument to friendship and the struggle for freedom. The status of national symbol was achieved after several decades and the patriotism resulting from two World Wars. Liberty's link to immigration is also inseparable as a symbol of welcome to a free and open America. After 100 years of exposure, the Statue began to show her age.

On May 26, 1981, a meeting was held in Washington, D.C., composed of representatives of the French engineering team and National Park Service personnel. Thus began the project to restore the Statue of Liberty. During the next five years, through the efforts of many individuals and orgainzations and with the overwhelming support of the American public, this work was brought to fruition with the opening of the newly restored Statue on July 4, 1986.

After 100 years of the ravages of time, the Statue of Liberty stood ready for a helping hand. Iron armature bars in the torch were severely corroded and those within the body suffered from galvanic corrosion yielding exfoliating forces that popped rivets through the copper skin. Preliminary investigations were conducted to develop a scope of work for the future project. Of primary concern was the Statue itself, followed by the pedestal; the project was expanded later to include renovations to the landscaping, the administration and concession buildings, the maintenance area, and the addition of a new museum space.

The primary problem to be addressed was the deterioration of the iron armature bars that provided rigidity to the copper skin. Next was the state of her structure, especially that supporting the raised right arm. The torch exhibited the greatest deterioration, and its flame became the focus of this critical area. Protection of the skin required much analysis and investigation and became an important aspect of the project. Within the Statue, the visitor experience was confined because of alterations that had been made over the years. It was decided therefore to make improvements to the visitor experience a part of the renovations, and a new glass elevator and stainless steel stairs were included. Lastly, to enhance the work that would be done, a new lighting system was planned for the exterior of the Statue.

To facilitate the work, the Statue of Liberty–Ellis Island Foundation was formed as the fund-raising and contracting organization. Working in conjunction with the National Park Service, architectural, engineering, and construction management firms were hired. So begins the story of the project to restore "Miss Liberty." It became a project of which all those who were involved, whether paid or volunteer, can be proud. More than any other project ever attempted in our country, it is this one to which the American people have given their greatest support; for it was they, the individual person and family, who contributed the dollars that made the project possible. As such, it is to the American public that this work is dedicated.

Robert Baboian
Principal Fellow
Texas Instruments Inc.

E. Lawrence Bellante
Chairman of the Board
GSGSB, Architects and Engineers

E. Blaine Cliver
Chief, Historical Preservation Center
National Park Service

■ *Section I: Origin and History of the Statue*

■ The Statue of Liberty and Lessons in the "Whole-Building" Ecology

Hugh C. Miller, FAIA
National Park Service, Washington, D.C.

The restoration activities undertaken for the preservation of the Statue of Liberty provide a laboratory for evaluating the performance of materials and systems in other structures. The knowledge gained in analyzing existing conditions and finding solutions to repair, rehabilitate, or restore the Statue may be directly applicable to building preservation, maintenance, and even redesign for new adaptive uses for all types of existing structures. The lessons learned regarding performance of materials and systems in the Statue's existing structures may also be applicable to the design of new structures.

The Statue of Liberty project is a model of the analytical approach toward preservation of a structure. The full understanding of the existing conditions, synthesized with careful evaluation of the written record and graphic material, reveals a 100-year field test of the behavior of the Statue's materials and systems. We now have the ability to compile an annotation of the successes and failures of these materials and systems in a methodology that can be applied broadly to preservation technology of buildings in their environments. This is a "whole-building" ecology.

■ 3 ■

As we look at the Statue of Liberty model, we recognize that there are five diverse ways in which we can learn about this monument's performance and apply this knowledge to other structures: We can learn about why systems perform well if we take the time to analyze why they survived; we can learn about the limitations of systems if we can accept that buildings, having survived, do function at some level; we can learn from inspecting and monitoring for change and deterioration and by determining the rates of change; we can learn from documenting previous maintenance, repair, and replacements, as well as new work, for their effectiveness and effects on other elements of the building system; and we can learn from material and building failures, failures of the original design and workmanship or failures resulting from inappropriate or lack of maintenance or abusive and consumptive use by the building owner or occupant. Understanding these factors, we can improve the existing structure to meet current standards or new expectations of uses. We can collect information about actual conditions, the seriousness of change, and the rates of decay. We can determine what is the appropriate "fix" to make the system work or meet new needs. We can schedule preventive maintenance and predict necessary actions to repair or replace deteriorating elements.

The multifaceted restoration work at the Statue of Liberty was based on a whole-building ecology in its detailed analysis of the external environmental conditions, as well as the internal forces that have acted upon this historic structure. The development of a rationale for understanding the monument's survival over time has suggested the solution to the restoration problems in sometimes novel ways. The transfer of the information developed by this project not only will help in solving technical problems for other existing structures but also may help establish a new "whole-building thinking." This is the real lesson to learn from the Statue of Liberty restoration project.

□ Introduction

There are many lessons we have learned from the repair, restoration, and rehabilitation of the Statue of Liberty. We have learned from the process of documentation and evaluation of an existing structure. We have learned about the application of a variety of technologies to solve special problems. We have gained some basic knowledge about traditional materials and today's environment. We have learned about building trades that are not obsolete and about the scheduling, logistics, and management of spe-

cialized construction that is new. While the Statue of Liberty is a one-of-a-kind structure, the lessons learned do have application to the understanding of other existing, well-built structures, to the preservation of other historic buildings, and to the management of the built environment.

The organization and administration of the work on the Statue of Liberty were unusually complex. The partnership between the U.S. government and several foundations in the United States and France resulted in dealing with layers of government officials, boards of directors, technocrats, and private individuals. As the work progressed, this layering was compounded with architectural, engineering, and materials consultants; construction managers, contractors, trades mechanics, and union officials; equipment manufacturers, materials vendors, etc. Yet, because of the efforts of some key people (who are also participating in this conference), the potential for the project turning into a Tower of Babel was redirected instead into a problem-solving energy that brought out the inner desire of all involved to be constructive forces in the work on the Statue of Liberty. Old, almost-forgotten methods for fabrication and repair of sheet copper were practiced with pride. New methods were designed, tested, and applied with an awe and realization that made them work. Equipment and systems were designed with original components manufactured just for the Statue of Liberty. Most important, the analytical approach espoused by the new profession of historical architects was tried and proved.

□ The Analytical Approach to Restoration

The analytical approach used to plan and execute the work on the Statue of Liberty is not new for the conservation of architectural landmarks, but these principles often are not applied to structural repairs, replacement of deteriorated elements, or rehabilitation of circulation systems in buildings of no less value. Here, the decision factors grew from a knowledge of design, construction, weathering, maintenance, and changes: an understanding of what the Statue is, how it got that way, and what it should be.

Although the image of the Statue seems always to have been with us, there was only one good published history of its design and construction and no comprehensive record of changes, repair, or maintenance that described apparent alterations after the trial erection in Paris or the numerous coats of paint applied to the interior in recent times. An archival search for the expected documentation revealed incomplete correspondence, reports, articles, drawings, and photographs. Some were known to be lost and others may never have existed. However, the documents that were discovered were very instructive. Some of Gustave Eiffel's structural drawings found unexpectedly in architect Richard Morris Hunt's papers were useful, as was the discovery of a painting of the Statue rising above the houses of Paris (1884) that gave the sense of the original color of the copper skin. All together, this eclectic material provided convincing evidence about the building of the Statue. The information was not frozen in a "history report" as an academic abstraction of the facts but was synthesized and analyzed with facts gathered from the existing structure as a dynamic database. Historic photographs were enhanced, overlaid, or projected to prove a thesis about changes to the original design of the arm. Metallurgical analysis of the copper supported the scanty records concerning the source of the ore. Knowing the date the interior was coated with tar became important for understanding the deterioration of the copper skin. The continuous collection of historic documentation and its evaluation with physical information, collected even during "restoration," provided not only better information about "what the Statue was," but allowed deductions to be made and theorems to be proved that often suggested the treatment or repair needed to re-establish "what the Statue should be."

Of course, the analysis did not start or stop with proving or disproving an original theorem posed by incomplete or incorrect interpreting of historic documentation. Physical measurements were made of the movement of the structure, its interior air quality was analyzed, and there were time–motion studies of the "people flow" up the pedestal. Studies were made of a myriad of other conditions, materials, and systems that existed in the Statue. Many questions were raised and evaluated and many answers were rejected. A research and development mode was established to solve problems of lighting, materials for the new armature, building the vertical transportation system, and other problems for which traditional solutions would not work. This successful problem definition and solution process was perhaps the result of the tight time frame, but it most certainly reflected the desire of all involved to get answers before designing solutions. This continuous analytical process led to the comprehensive understanding of the whole Statue: the envelope, structure, interior compartments, infrastructure, and site with its landscape and environment. The dynamic relationships of these five elements and systems are the components of the whole-building ecology, a dynamic relationship that is often not recognized in the management of an existing building or even the design and construction of a new building.

☐ Achieving a Whole-Building Ecology

For whole-building thinking, we need to know the interaction of these five elemental parts and ask a series of searching questions: (1) What's working? (2) What's limiting? (3) What's changing and how fast? (4) What went wrong? and (5) What's the "fix"? The answers to these questions are the lessons to learn from existing buildings. These questions are basic to the analytical process and the understanding of an existing building. In the case of the Statue of Liberty, we have a 100-year-old laboratory of systems' performance in a whole-building ecology.

What Works

We can learn about why systems perform well if we take time to analyze the reasons they have survived—what's working? At the Statue of Liberty, the original intent was to erect a well-built monument using modern (1880s) materials in a novel design. The system of a relatively thin copper skin supported in a dynamic manner from a wrought-iron frame is quite remarkable and is working well. The choice of wrought iron and copper was a good one, because they are not only resistant to weathering but also are flexible enough to move and to spread the stress or load throughout the system. This lesson of the fatigue factor of materials and the flexibility of materials and structural systems is an important one to learn from the Statue. (Today, we often try to make structures, particularly retrofit existing structures, too stiff, stiff to the point of failure.) Even at the critical junction of these two materials, the original designers and fabricators understood the limitations of placing iron and copper together, and there was an attempt to mitigate corrosion with a gasket of the best available materials. Unfortunately, most of the problems addressed in the current work were the result of changes and additions as well as deferred or inappropriate maintenance. In spite of the long list of problems in the project scope, it can be clearly stated that the Statue of Liberty as a system "worked" as designed.

Identifying Limiting Factors

If we accept that buildings, having survived, do function at some perhaps minimum level, we must then ask analytical questions about what are the limiting factors—what's limiting? If we can improve these factors, we may be able to make the elements of the structure perform to meet current standards or new expectations; that is, to make them perform, to "work," not necessarily to "work better." The "lady's" congenitally weak, upraised arm and the confusing and difficult stair to the crown were long recognized as limiting problems for both the stability of the monument and for visitor satisfaction.

Early in the project, using a "design approach," it was proposed to remove the arm and construct a new framing system and to insert a new elevator or easier stair in the Statue itself. Because of the impact on the historic integrity of the structure, these proposals were abandoned in favor of solutions found using the "analytical approach." By analyzing the question of "What is really limiting?" it was possible to reinforce the existing structure of the arm and to modify the existing circulation to make it work. In this manner, the maximum amount of the existing structure and the historic fabric were retained, and acceptable standards for preservation and use were met.

Learning from Change

Continuing the analytical questions, we can learn from understanding change. By inspecting and monitoring the entire structure in a comprehensive and scheduled program, one can document what is changing and how fast. With this information about actual conditions, the seriousness of decay and the rate of change can be projected to schedule necessary actions. The analysis of change and rates of change were important to understand the nature of many of the elements of the Statue and to separate its expected and real problems. Changes at the time of construction were found by comparing historic photos and drawings with photos and measured drawings of existing conditions, such as the arm or head and crown construction. There were some drawings for the later work, such as modifications to the flame or repairs to the arm. These were helpful in understanding the extent of these interventions and in evaluating the success or failure of the material or system used historically.

Perhaps most important was the ability to analyze and interpret continuous or incremental change, such as the condition of the copper skin. The understanding of the surface chemistry and the changes to the patina in the ever-changing, polluted, marine environment have taught us a great deal about the environment and about copper as a material. The measurement of the rate of change or loss of thickness of the copper was remarkable scientific detective work using historic documentation and modern nondestructive testing methods. This analysis and documentation of stability and slow loss of thickness of the copper made the decision not to strip the patina and coat the Statue with a protective film even more defensible in the face of a public letter-writing campaign to make the Statue "penny bright."

Recognizing Mistakes

In any analytical process, we can always learn from materials and systems failure. Asking the question "What went wrong?" is particularly useful when it is possible to analyze the failure mechanism of what really happened. In the cases of the two most significant failures of the Statue of Liberty—the 1916 reworked flame and the armature saddles—the problem could be traced to a basic design/material fault. The reworking of the flame from an opaque "structural skin" to an open, glazed skeleton frame, using much of the original sheet copper as "glazing bars," created grand expectations, but the new design required the flame to be something that it could not be structurally. The glazing of over 250 pieces of glass into an existing tight skin form had built-in faults of materials and methods. This was failure that could not be repaired for long-term performance.

The combination of materials of the wrought iron supporting the armature and the copper saddles fastened to the copper skin formed an electrical and electrolyte contact resulting in galvanic corrosion. (The resulting "oxide jacking" was a textbook example of the expanding corrosion products pulling the rivets of the saddles through the copper skin.) This phenomenon was understood in the 1880s, but there were no better materials available to make this physical connection or to isolate the dissimilar metals (or even for the 1930s repairs), so an "inherent vice" was built into the system.

"Fixing" the Statue

What should be the last question in the analytical process—What's the "fix"?—is too often the first question asked. At the Statue of Liberty, answering the previous questions of the analytical process in sequence led to the decision to repair the structure of the upraised arm rather than replace it. Answering these questions in sequence also led to the decision to replace the wrought-iron armature bars with a substitute material [type 316L (UNS S31603) stainless steel] and to make a new flame to replicate the same form and materials and methods of the original (but much-modified) flame. Without applying the rigor of the analytical process, the problem solving for the repair or restoration of a historic landmark or any well-built building is too complex to assume that an old method or new material will function in the whole-building system, in an ever-changing environment, and for new user demands.

Where the "fix" for the Statue was a traditional use of materials, it was reassuring to know that the trades necessary were still available. Although the problems of "fixing" the Statue were a challenge to the mechanics, who had become accustomed to assembling previously fabricated parts, they now had to bring all their skills, knowledge, and experience together to make complex elements or features from scratch or fashion a repair that would leave no trace. Pride of workmanship is alive! Where new methods or materials were called for, there were a multitude of lessons learned with many successes, and some failures.

The design and erection of the scaffold and hoist demanded structural and supporting requirements not normally applied to aluminum construction staging. The process of selecting materials from industrial applications not usually found in buildings, such as the use of inorganic zinc coating or high-performance epoxy paints, was also an instructive lesson: to learn how to look beyond the usual building material sources or uses.

The application of processes in principle, such as finding methods of reducing dust and flammability usually associated with paint removal, were lessons learned. This led to the successful removal of thick, encrusted paint coats by freezing it off with liquid nitrogen. The need to remove tar coatings from the interior led to the introduction of a vacuum/abrasive-blasting device not competitively used in commercial sandblasting but very effective in removing the explosive and health hazards of dust. The abrasive was sodium bicarbonate, a material sometimes used by museum conservators. This worked, but the vacuum/blasting tool and abrasive tended to clog in the high humidity inside the Statue. Where the sodium bicarbonate filtered through joints in the skin, it turned the exterior copper blue, a temporary discoloring that may have some effect on the patina over time.

□ Lessons Learned

Lessons were learned from bringing together scientists who had the curiosity to apply scientific principles to materials performance and invent solutions. The work of corrosion engineers and metallurgists and the contributions of time by individuals, Texas Instruments (Attleboro, Massachusetts), AT&T Bell Laboratories, and other companies are already well recorded in the literature. Less well recorded are the lessons of applying state-of-the-art systems such as the computer-aided design system (CAD) or diagnostic instrumentation to measure indoor air quality.

These engineering studies and solutions can be models for recording conditions and monitoring change in the future. That a nationally significant project can generate product inventions was yet another lesson of the Statue restoration project. H.M. Brandston & Partners, Inc. (New York, New York) took on the challenge of the lighting consultation to provide a system that could light the entire Statue with the color of warm morning light. Since no existing lamp or fixture could be modified for the purpose, the General Electric Company (Cleveland, Ohio) took up the lighting consultant's challenge and invented a high-intensity metal-halide lamp, a fixture to focus the light on the entire height of the Statue and a ballast to "kick off" this remarkable 250-watt bulb.

This conference and the resulting publications have, for the first time, brought together client groups, historians, curators, architects, engineers, lighting consultants, material scientists, exhibition designers, and other consultants, construction managers, specialty contractors, material and system manufacturers, and trades mechanics to learn about the technical accomplishments of one project: the restoration of the Statue of Liberty. These individuals and groups worked on the project because they realized that the work was special and that their knowledge and skills were worth sharing. The fact that there is something to learn from an historic structure is perhaps the most important lesson of the Statue of Liberty restoration. In its detailed analysis of the external environmental conditions as well as the internal forces that have acted upon this historic structure, the multifaceted restoration work at the Statue of Liberty was based on a whole-building ecology.

This development of a rationale for understanding the monument's survival over time has suggested the solution to the restoration problems in sometimes novel ways. The transfer of the information developed by this project not only will help in solving technical problems for other existing structures but also can establish a new whole-building thinking. This is the real lesson gained from the Statue of Liberty. Today we must have the willingness to use historic structures or other well-built buildings as laboratories. This is essential not only in learning about the performance of materials or systems over time but also in realizing that the monitoring of conditions is critical to the structure's maintenance and even to its survival. For the future, the analytical process developed for the Statue's restoration must be applied to the continued monitoring of the surface chemistry of the copper skin and the environment; the movement of the structure and the continued dynamics of the copper skin and stainless steel supports; and the quality of the indoor air, particularly humidity and moisture from condensation and leaks. The preservation of the Statue depends on maintenance with comprehensive planning in the analysis process to establish appropriate treatments for housekeeping, routine scheduled work, preventive maintenance, and repair. To paraphrase British writer, sociologist, and philanthropist John Ruskin, "Take good care of your monument and you will not have to restore it."

■ *The Government, the Commission, and the Foundation: Public/Private Cooperation in the Restoration of the Statue of Liberty and Ellis Island*

F. Ross Holland Jr.
Formerly of the Statue of Liberty–Ellis Island Foundation, New York, New York

The care of cultural resources within the National Park Service has never been an easy task. Invariably, there are many resources and little money. This was particularly evident at Ellis Island, a collection of 23 buildings composing a site that commemorated one of the most important themes of American history—immigration. Despite their importance, these historic and magnificent masonry buildings were deteriorating rapidly. The immigration station had been abandoned for over 10 years when it was turned over to the National Park Service; another decade was to pass before any effort was made even to open the place to the public, and that effort came only through the prodding of interested citizens, who requested money from Congress to clean up part of the island so that people could visit it. The first appropriation was $1 million, and the money went primarily into the Main Building to clean up the interior debris and make the building safe for visitors to walk through.

This initial appropriation and subsequent appropriations over the next six or seven years totaled about $8 million, the bulk of which went into repair and restoration of the sea wall that held the island together. The island was open during a portion of the year for visitors. There were no exhibits, and the visitor learned the island's history from the park rangers who gave guided tours. Though visitor reaction to this place elicited numerous favorable comments, the number of people who visited the site was small—indeed, tiny—when compared to those who visited the better-known nearby Statue of Liberty.

□ Requests for Proposals

There was not enough money to do any real work on the buildings, and the likelihood of getting money from Congress, particularly during the austere times of the Carter and Reagan administrations, drove those of us concerned about this historic site to think of other avenues to preserve the structures. At about that time, the National Park Service planning representative in New York brought a master plan for the site to completion. A brainstorming session was held in the National Park Service office in Washington, where it was decided to take advantage of the recently passed Historic Preservation Leasing legislation and send out a "request for proposal" to find out if the private sector was interested in some sort of rehabilitation and use of Ellis Island. The secondary historic structures were to be considered for development for any appropriate use, with the exception of an amusement or theme park. The Main Building at Ellis Island, the largest and most historically significant structure there, would be developed in the traditional Park Service way; that is, the building would be restored, exhibits placed in it, and the structure's history interpreted.

The request for proposal evoked considerable interest in the private sector, and 13 developers sent in proposals for the development of Ellis Island. An evaluation panel consisting of National Park Service representatives and specialists (including historical architects, planners, and economists) from outside the government was assembled to evaluate the various proposals. The proposals were quickly narrowed down to nine, and the panel, after considerable evaluation, reduced that number to six, and after further evaluation to three. One of the three decided to throw in his lot with another finalist, the Center for Housing Partnership, thus reducing the number to two competitors. After much deliberation over the two proposals, the team recommended the proposal for the conference center/hotel submitted by the Center for Housing Partnership.

■ 9 ■

☐ Raising Money

Meanwhile, many people were approaching the National Park Service wanting to do nice things for both Ellis Island and the Statue of Liberty. The Ellis Island Restoration Commission was one of the first. The Department of the Interior had entered into an agreement with this group during the Carter administration to raise funds for the restoration of Ellis Island. The organization had raised no money but was responsible for the first $1 million appropriated by Congress in 1976. A French group approached the National Park Service about studying and restoring the Statue of Liberty at no cost to the government. A marketing group requested the National Park Service allow the group to handle the 100th anniversary celebration of the Statue. Another group came proposing to raise money for Ellis Island; this group centered around the sculptor Philip Ratner, who oversaw the donation of the sculptures of immigrants to the Statue of Liberty. Several women proposed forming a fund-raising organization to solicit money for the preservation of Ellis Island.

It became apparent that all of these people could not be assigned to raise money for the Statue of Liberty and Ellis Island, because it would confuse the fund-raising marketplace. Consequently, it was decided to establish an umbrella group, whose duties would be to act as a "traffic cop" to control where the individual organizations went to raise money. That idea was quickly dismissed with the establishment of the Statue of Liberty–Ellis Island Centennial Commission, and most of the other organizations were absorbed into the new organization with their representatives serving as members of the Commission.

☐ The Statue of Liberty–Ellis Island Centennial Commission

The Statue of Liberty–Ellis Island Centennial Commission was announced in May 1982 at the White House by President Ronald Reagan, who introduced its new chairman, Lee A. Iacocca of the Chrysler Corporation. Iacocca was energetic; he immediately began to organize the project and embraced the other groups. The marketing group was not represented on the Commission because it had other interests; namely, selling sponsorships. The marketing group, however, had established the Statue of Liberty–Ellis Island Foundation under the laws of the State of Delaware and suggested that the foundation act as the working arm of the Commission in the fund-raising effort. Iacocca accepted the offer. At that time, it was envisioned that the private sector would raise funds for the restoration work at the Statue of Liberty and Ellis Island, then turn these funds over to the National Park Service, which would perform the actual work.

Iacocca asked a former colleague who had been the president of the Chrysler Corporation to come out of retirement and get the Foundation operating. That individual, J. Paul Bergmoser, agreed to act as head of the Foundation for one year. During that year, he hired the senior fund raisers, the controller, and others as the staff of the Foundation. Also at this time, the staff developed a fund-raising program. In view of the time shortage (this was 1983, and the 100th anniversary of the Statue was just 3-1/2 years away), it was decided that fund-raising efforts would target all directions—grassroots, foundations, civic and patriotic organizations, ethnic groups, and the business community.

The fund-raising staff determined that in approaching businesses, they would seek money from the corporations' advertising funds rather than the charitable funds businesses usually allocate for such purposes. The reason for that approach was simple: Corporations place far more money in advertising budgets than in charitable funds budgets. To encourage corporations to give from their advertising budgets, the fund raisers formalized a sponsorship program the marketing group had been following, and over the next several years, approximately 19 corporations became Founding and Official Sponsors and Official Suppliers of the restoration effort. Founding and Official Sponsors gave about $66 million to the project, donated for the most part over a 3- to 5-year period. To attract sponsors and other large contributors, the Foundation developed a schedule of benefits. The million-dollar donor received a number of benefits ranging from a named gift opportunity at Ellis Island to the right to produce limited-edition commemorative items. The $25,000 donor received a limited-edition commemorative item and personalized certificate of appreciation. This donor could also place one advertisement in a trade journal, while the larger donor could place an advertisement in a magazine with a much wider circulation.

Meanwhile, the French–American Committee, which had initially wanted to conduct the restoration of the Statue of Liberty, entered into an agreement with the National Park Service to do the studies for the restoration of the Statue and to develop drawings and contract documents for the work. This work was to be done at no cost to the government. At the request of the Foundation, the National Park Service decided the Foundation would undertake the restoration work. Thus was created an uneasy alli-

■ 10 ■

ance between the Foundation and the French–American Committee; this alliance endured until it was destroyed by internal dissension.

Though in the end the Foundation was hugely successful, its programs did not come about easily. A great deal of work went into organizing the Foundation, and in its early months, the Foundation survived on a loan from the Coca-Cola Corporation. Nearly a year passed before funds began to be donated in amounts adequate to permit the Foundation to perform its duties with a degree of comfort and still be able to set money aside to carry on the restoration work. The Foundation paid for all of the expenses of the National Park Service personnel involved in the restoration process, and in those early months, the Park Service's request for funds created some difficulty for the Foundation. Though corporate sponsors were on board at that time, there was not a great deal of money in the bank, because only relatively small initial payments by these businesses were available. The Foundation faced many problems in those early months, but the employees working there had such an enormous amount of enthusiasm and pride in being involved in this noble effort that they were able to withstand the difficulties of getting an organization going. Most of the people arrived early, worked late, and spent parts of their weekends at the office.

The traditional fund-raising program began with a relatively small staff of three or four. The fund raisers' early efforts focused on ethnic, civic, and patriotic organizations and on foundations. Success was mixed, but the Foundation was soon to be flying. The marketing group had approached American Express about becoming a sponsor, but the corporation proposed instead to celebrate the 25th anniversary of its credit card with dinners at night at the Statue of Liberty for their key customers. In return, American Express agreed to conduct a campaign in which part of the sales of traveler's checks, credit card use, and new credit card sales would go to the Foundation. Though American Express had made similar efforts on the local and state levels in the past, this was the first time it had undertaken a national project.

☐ Gathering Momentum

A satellite television press conference kicked off the program. The press conference emanated from Paris, where the chairman of American Express was visiting at the time, and from New York, in the company's boardroom. Barbara Walters acted as mistress of ceremonies, and the broadcast went to 16 American Express offices around the country, where local reporters gathered to ask questions. Though there had been mention of the 25th anniversary of the credit card, the journalists' interest focused on the work at the Statue of Liberty and Ellis Island; consequently, virtually all of the questions centered on the fund-raising and restoration efforts. The press conference was successful, and American Express immediately issued a number of television and radio commercials as well as newspaper advertisements that discussed the restoration and informed people how they could participate through the use of the American Express credit card and other services. These advertisements were dignified and made people aware of the Foundation. This three-month program was a symbiotic relationship, and I feel it was done in good taste. At the last dinner held by American Express on Liberty Island, an official of the company presented the Foundation with a traveler's check in the amount of $1 million, the largest traveler's check ever issued. Ultimately, the American Express effort produced $1.75 million. As I look back on it, it was at this moment the Foundation got the momentum it needed, a momentum that carried the project through to the end.

☐ Roles of the Commission and the Foundation

In those early days, problems arose in trying to get a clear separation between the Commission and the Foundation. No one understood the necessity for this separation at first, including the government, for it was the government representatives who, in an effort to bring responsibility where responsibility belonged, had requested Iacocca serve not only as chairman of the Commission, but also as chairman of the board of the Foundation. At about this time, the problems in dealing with the marketing group came to a head, and because of activities generally regarded as conflicts of interest, the government representatives persuaded the board of directors of the Foundation to sever the Foundation's relations with the marketing group.

Sometime earlier, the Department of the Interior had taken a deeper interest in the restoration activities and assigned one of its lawyers to act as liaison with the Board, the staff of the Foundation, and the Commission. This increased interest by the Department did not eliminate the National Park Service's liaison role, for the National Park Service labored on one level and the Department worked on another. The Department of the Interior representative and the National Park Service representative both

worked diligently, at times under difficult circumstances, to make the public/private relationship work.

Throughout the project, the National Park Service had approval over all advertising and products issued under the Foundation's licensing program, and every part of the restoration of the Statue, Liberty Island, and Ellis Island for which the Foundation did the contracting work had the approval of the National Park Service.

The project has been a cooperative work effort. The National Park Service was responsible for assigning some of the contracts and the Foundation for others. The architectural and engineering work on the Statue of Liberty was done by Swanke Hayden Connell (New York, New York), an architectural firm under contract to the Foundation since the breakup of the French–American Committee. The firm of John Burgee with Philip Johnson (New York, New York) under contract to the Foundation did the design work for the remainder of Liberty Island. All construction was managed by the Foundation with Lehrer/McGovern Construction Managers (New York, New York) as the construction manager. At Ellis Island, the design work for Unit I was done by the firm of Beyer Blinder Belle, which was under contract to the National Park Service. The interpretive planning and development work for both Liberty and Ellis Islands was done by the Statue of Liberty–Ellis Island Collaborative under contract to the National Park Service. All the Park Service contracts were paid with funds donated by the Foundation. The firm of GSGSB Architects and Engineers (New York, New York) worked directly for the Foundation as managing architects and engineers. The people associated with the Foundation and those associated with the National Park Service shared a close working relationship, and because there were a number of people involved in the design and construction work at Ellis Island, the Statue of Liberty, and Liberty Island, there was generally a great deal of discussion among the various participants, each of whom represented a different perspective on the work. Sometimes, the discussions got quite heated and tempers flared, feelings were injured. There were times when I thought it a minor miracle that decisions were reached. But, even with this dark side of the process, there was a considerable degree of pride in working on the project by all the participants; perhaps it was that element that kept the project on track.

An important part of the planning and design process is the advisory committees. The History Committee of the Commission, for example, was concerned primarily with the interpretive developments at Liberty and Ellis Islands and to some degree with the restoration work. The committee members had a perspective that was sometimes in conflict with the history consultants hired by the contractors. On the whole, the National Park Service and its contractors were able to deal with the issues to the satisfaction of the History Committee. The Preservation, Architectural and Engineering Committee of the Commission, during its existence, was in considerable conflict with one of the architectural and engineering firms over design work at both of the islands. This conflict contributed significantly to the slowness in getting a decision on the development of the south side of Ellis Island. The Restoration Coordinating Committee of the Foundation worked directly in the construction process, primarily reviewing contracts and giving advice.

□ **Can Public/Private Cooperation Work?**

At the upper levels of leadership, there was considerable controversy and clashing, some of which appeared in the spring of 1984 in the media. Political considerations seemed to underly this conflict. The controversy did not help the project, certainly, and the crossfire of words caused some development issues to become confused in the public's mind. Nevertheless, while the titans battled, the workers continued to labor.

It has been interesting to view the rather laughable attempts by some of the news media to deal with the Foundation and its operations. The vast majority of the media has been helpful and fair to the Foundation. But a few of the fringe magazines and low-rated television programs seem to have achieved a small amount of momentary recognition from their distorted assaults upon the Foundation. I know of only two articles that have been written with a critical eye toward the Foundation that can be considered reasonably accurate, and these articles were done by Martin Gottlieb of the *New York Times*.

All of these things, I suppose, are to be expected with the fund-raising campaign so highly profiled and successful, and, to some degree, they have a bearing on the question of whether or not public/private cooperation can work.

It is too early and too little assessment has been done to state with certainty that public/private cooperation can work. Most assuredly, there have been many successes. One can state unequivocally that the first objective has been achieved; that is, the Statue is restored and in better condition than ever. Moreover, the Fourth of July celebration was spectacularly successful, by most standards. Per-

haps more importantly, seldom before, if ever, have so many citizens had a voluntary and direct role in a public project.

The third phase is the restoration of the principal historic buildings on Ellis Island. I am confident that whatever happens at Ellis Island, it will be done well, and certainly the island's resources will be in far better condition and more adequately interpreted than before. For the first time, there will be a historical park to interpret the immigration story, a most important theme in the history of our country. It will be a memorial to all the immigrants who have come to the United States.

The American public has responded magnificently to the project, and I do not feel there was undue commercialization of any of the activities. Also, the project seems to have played a role in giving Americans a renewed faith in their ideals, in their nation, and in themselves. Certainly, in the last few years, it has not been the only factor, but it has been an important one, in the revitalization of American pride. All segments of our society—school children, civic and patriotic organizations, individuals, corporations, and unions—have contributed to the success of the project. The children's interest and work for this project gave special meaning to it, and when one thinks less than kindly about corporate participation, please remember that the greatest amount of money came from the grassroots effort. Commercial contributors, moreover, have not tried to influence what has been done for the resources or what is said in the interpretive programs at either of the sites.

Can public/private cooperation work in such endeavors? If pressed for an answer now, I would have to give a tentative yes.

■ *Liberty: To Build and Maintain Her for a Century**

Carole L. Perrault
National Park Service, Boston, Massachusetts

Recognized today both as America's foremost symbol and a world-class monument, the statue of *Liberty Enlightening the World* welcomed her second century on October 28, 1986, newly renovated. Lavish support was generated over the preceding six years with the common goal of perpetuating Liberty's life. The commitment by both the private and public sectors afforded a unique opportunity to scrutinize every detail of her physical being and her historical past. This provided new insight into her construction, the ingenuity of 19th-century technology, and the myriad of people who built and maintained her for a century—their persevering commitment to, and pride in, the enterprise and the ideal. The current renovation represents only the most recent phase in a long history of physical change. To comprehend more fully its historic significance, this paper not only probes the intricacies and complexities of the Statue's construction, but also chronicles the subsequent 100 years of repairs, alterations, and improvements, highlighting exterior illumination, the copper Statue and its iron structure, the island, and the visitor's experience. May we learn from her past so that, following this moment of centennial glory, she does not fall victim to the eclipses of administrative, financial, and physical support that so characterized her first century.

■ 15 ■

□ Introduction

One hundred years ago, in anticipation of her long-awaited inauguration, a temporary veil was stretched across the classic countenance of this metallurgical wonder, momentarily shrouding a spectacular construction history that spanned one decade and two continents. Resembling a small handkerchief, the canvas mask was in reality more than 50 feet (15.24 meters) wide by 17 feet (5.18 meters) high—a fact that no doubt tantalized even the most skeptical of the curious, who were traveling in ever-increasing numbers to the tiny island in the harbor.

That same Statue, despite her unwavering stance, was by 1983 suffering from a century of physical change caused by man, time, and the environment. Concealed within her monumental cavities, these changes went largely unnoticed by the public, which continued to visit the Statue in endless numbers, seeking to rise to her glorious heights.

This is her story: the physical history of the Statue of Liberty, a history that belongs to those who built and maintained her for a century. It belongs to the sculptors, master craftsmen, carpenters, and metal workers in a Paris workshop, where she blossomed forth from sheets of rolled copper, attaining a structure and a final form. It belongs to the engineers, contractors, stonecutters, masons, laborers, riveters, and iron workers who gave her a foundation, an anchorage system, and a pedestal—all, so that she might withstand the vulnerability of her new position. Finally, it belongs to those who kept a watchful eye on her for some 100 years: the U.S. Light-House Board, 1886 to 1902; the War Department, 1902 to 1933; and the National Park Service, 1933 to the present.

* This paper was originally presented as an illustrated slide lecture. Although the text of the lecture was modified slightly for publication here, most illustrations and footnotes are not included. The content of this paper is based on the research performed by the author for the National Park Service's Statue of Liberty historic structure report.

□ Chronicling a Decade of Construction

The Statue in France (1876 to 1884)

The year is 1876. The place is the workshop of Monduit & Co., fabricators of decorative metalwork, on the outskirts of Paris. The scene is the right forearm, hand, and torch of the sculptor Auguste Bartholdi's statue of *Liberty Enlightening the World*, ultimately destined for New York Harbor. On display here, receiving finishing touches before being transported to the International Exhibition in Philadelphia, Pennsylvania, the arm and torch are devoid of head or body. They consist of hammered copper 2.5 millimeters thick. (The hammered-copper technique is also referred to as beaten copper or repoussé work.)

The steps required to achieve this monumental form, although only a fragment of the whole, were numerous and complex, and riddled by tedious experiments in search of the best combination of material and technique. Several accounts exist of the selection and fabrication process. One of the most thorough was prepared by J.B. Gauthier in 1885. Metal craftsmen Gaget and Gauthier joined the Monduit enterprise as partners in 1874; by 1878, they would own the workshops. Thus, they were on the scene of the Liberty project from the beginning. Gaget was described as "the engineer who in the material execution of the work has brought to bear indefatigable zeal and intelligence."

We learn from the historical accounts that three overriding requirements convinced the sculptor and his collaborators to choose the technique of beaten copper. The process would (a) answer artistic needs, allowing excellent detail because it is all done by hand; (b) provide the dual advantages of solidity and lightness, joined with qualities of endurance and longevity; and (c) permit a large subdivision of the pieces, making transportation easy. This was particularly important in a monument destined for another continent. The selection of the copper thickness necessitated finding a gauge thick enough to stand up to the rigors of open sea and exposed winds but thin enough to allow hammering techniques, riveting, and brazing.

Novel problems arose throughout the planning stages. Material concerns and difficulties were compounded by the fact that the work was to be paid for by public subscription, falling on the shoulders of the citizens of France. Fortunately, a "patriotic" French manufacturer donated a reported 25 tons of his copper, valued at 64,000 francs. The right forearm, its hand clutching the torch, and the head were the first features to be completed in their mammoth proportions, to serve as fund-raising enticements.

The fabrication of the work was not without calamity. Bartholdi initially undertook the enlargement of the plaster models in his own atelier, or workshop. To perfect the final outline in monumental dimensions, the process required a series of enlargements based upon geometrical principles. Ultimately, the plaster model would be divided into full-sized, workable sections. In March, the plaster-hand section was shattered in transit to the Monduit workshop for its translation into copper. The irrepressible sculptor recommended work immediately. With only two months of the Centennial Exhibition in Philadelphia remaining, the forearm-and-torch assembly made its debut in America. "Better late than never" became the motto that best characterized the Liberty project from beginning to end.

In February 1877, the completed fragment of the Statue was reassembled in New York's Madison Square, coinciding with the announcement by the New York-based American Committee of a national campaign to raise $250,000. This was the amount thought necessary to construct a pedestal for the statue that was slowly but surely becoming a reality.

Back in France, work continued on the colossal head. The newspapers were already reporting the "curiosities of measurement" that abounded in the atelier, referring to the full-grown workmen as pygmies and Lilliputians as they worked around the scaffolding, performing their tasks. On May 1, 1878, the opening day of the International Exposition in Paris, the French citizens were given their first view of Liberty as the classically endowed head appeared.

In these early days of the fabrication, architect-engineer Eugène Viollet-le-Duc was a significant force, primarily addressing the structural needs but influential in many intangible ways. He met the immediate requirements of support for the exhibited head; a section of this structure, in the form of an umbrella-like frame, remains intact today as his tangible legacy. Viollet-le-Duc's untimely death in 1879 brought into the project not only a new engineer but new ideas for the Statue's support system. The originally proposed scheme of sand-filled interior coffers was replaced by an unprecedented design attributed to engineer Gustave Eiffel, who would give "the guarantee of all his science to the iron work *(sic)* of the colossus."

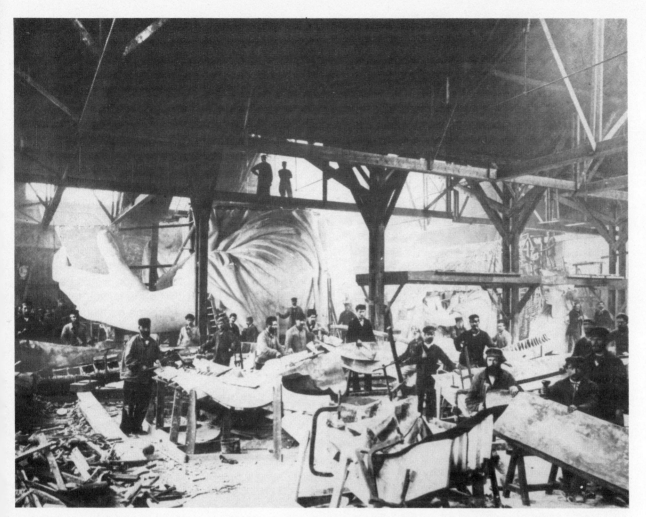

FIGURE 1. *The fabrication of the Statue of Liberty in France. No date. The workshop of Gaget, Gauthier et Cie., on the Rue de Chazelles in Paris, where the sculptor Frederic-Auguste Bartholdi's creation blossomed forth—first in plaster, then from sheets of rolled copper tediously worked (photo: Musée Bartholdi, Colmar).*

Essential to the project was the construction of a shed about 100 feet (9.29 meters) square, built solely for the accommodation of the one inhabitant and her attendants. On these premises over the next four years, a marriage between art, technology, and industry was consummated—a spectacle witnessed by a reported 300,000 people.

The fabrication and assembly proceeded quickly with a numerous and skillful force (Figure 1). The huge shed allowed four sections of the effigy to be worked upon at once. Plaster sections were modeled by skilled plasterers under the supervision of professional sculptors. Following the perfection of plaster models, wooden molds were brought into play to make the final outline of the Statue—a process involving very complicated joining techniques. The copper sheets were rammed and hammered into these molds; both sides were hammered to produce the finished product.

For rigidity, the copper was attached to a wrought-iron framework, forged to follow the contours of the hammered copper after the work of shaping was complete. (This latticework frame, completely assembled, resembles a woman's hooped dress form.) The copper was secured to the wrought-iron "armature bars" by riveted staples, or saddles, as they are referred to today. The potential problems of expansion and galvanic action inherent in this system were recognized by the fabricators. They sought to minimize the effects of galvanic action between iron and copper in a sea environment by proposing that a barrier of red lead and cloth-covered copper plates be introduced between the two metals. The Americans were to develop their own barrier system during reassembly in New York.

By November 1881, the structural system had been redesigned by its new engineer. Little is known of the personal involvement and commitment to this project by either Eiffel or his office. Two sets of handwritten specifications and a series of drawings with extensive calculations survive, many dated 1882—after the structure was already soaring above rooftops.

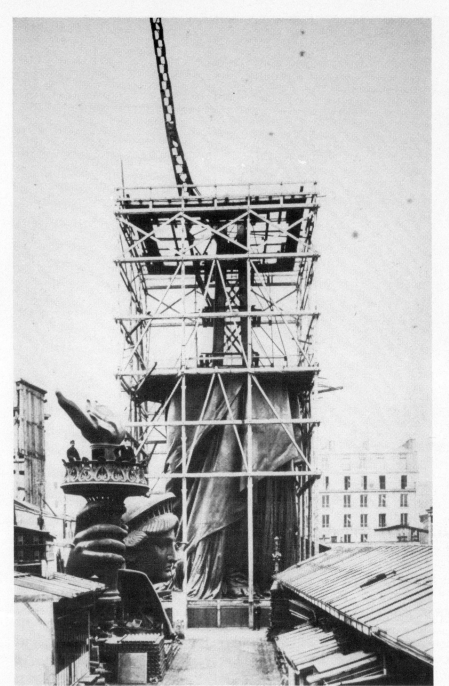

The support system, or "skeleton," consisted of a pylon (made up of four angle-iron corner posts), serving as the primary structure; a secondary system of truss work and flat bars upon which the copper envelope would hang; and a daring, cantilevered arm structure that mystified many people at the time and continued to do so for the century that followed. Bartholdi praised the fact that all of the elements of construction would be visible on the inside, thus facilitating the continued preservation of the monument. Originally, the skeleton made of puddled iron was to have been made in New York; however, as work proceeded, it was decided to have it made in Paris. By October 24, 1881, the skeleton was ready to receive its "skin." As the majestic head stood guard in the foundry yard—the right forearm and torch were absent—U.S. Minister to France Levi P. Morton drove the first rivet into the goddess' left foot.

Photographs offer the best clues as to the intricacies of the installation. Beveled seams and surface rivets were used to join the copper plates in such a way that the many parts would appear as one from a distance. As fast as they were hammered to the proper shape, the copper

18

FIGURE 2. *The mounting court of Gaget, Gauthier et Cie., Paris (circa 1882-1883). Assembly of the wrought-iron "skeleton" and copper "skin" continued in the mounting court of the workshop of Gaget, Gauthier et Cie., while the noble head and hand-and-torch assembly stood undisturbed on the ground (photo: Musée Bartholdi, Colmar).*

plates with the armature were attached to the structure. For temporary assembly in France, the sections were simply screwed together. The photographs divulge the fact that the saddles were secured by only four screws, not six rivets, as in the final United States installation.

The fact that the torch with its forearm was still in Madison Square became a subject of much concern as the Statue grew swiftly before Parisians' eyes. After persistent efforts by Bartholdi, the essential section made its way back to the Paris workshop by August 10, 1882. The sculptor had directed that only the copper, not the ironwork, be sent back.

A photograph taken sometime later shows the Statue with its arm structure in place and the copper skin assembled only to waist level (Figure 2). The head and torch sections sit undisturbed on the ground of the mounting court. A published volume of photographs, dated November 1883, chronicles the construction of the Statue to that date; one image depicts the copper head installed but with the arm

structure missing. This combination of photographs implies that the workers encountered problems with the dual alignment of the head and arm, necessitating the removal and reworking of the arm structure to accommodate the head's off-center placement.

The problem was resolved, allowing for Bartholdi's "eldest daughter," as he affectionately referred to his creation, to be finished essentially by January 1884. Exceptions were the interior staircase and the small accessory work. She was to intrigue thousands before her dismantling began in earnest a year later; the numbering and classification of pieces commenced sooner. (Vestiges of that numbering system were uncovered during the current renovation as a century of paint coatings was removed.) By May 21, 1885, the 300 pieces of France's noble gift were packed in more than 200 crates, ready, at last, for a journey.

The Pedestal in America (1881 to 1886)

As the first rivet was driven in 1881 on distant shores, the American Committee was in pursuit of an architect for the pedestal design. Choosing to avoid the delays and difficulties of a wide competition, "one of our own eminent architects" was selected in December: Richard Morris Hunt. As architect-in-chief, he was to receive $5,000 for the commission.

The site had been officially designated years before (1877) based on the recommendation of General William T. Sherman to Congress. It was Bedloe's Island in New York Harbor, already occupied by Fort Wood, an early 19th-century masonry fortification under the jurisdiction of the War Department. The sculptor Bartholdi was captivated by the site on his initial visit to America in 1871; it became his first choice for the proposed international monument.

The concept called for having the pedestal rise from the fort's 11-point star shape. The pedestal and the fort were to coexist in an intimate architectural relationship. The acceptance of a final design was to be a two-and-a-half year process, involving two models and numerous renderings.

In January 1883, while Hunt's office continued to address the aesthetic issues of a pedestal design, an engineer-in-chief was sought. A lagging fund-raising effort for the pedestal and the complexities of the task made the search a difficult one. General Charles Pomperoy Stone, who was seeking to recover from a blemished military past, was introduced to the American Committee by General Sherman as a man who "attaches little importance to the matter of pay. What he now needs most is the recognition of such men as compose your Committee." On April 6, the West Point graduate undertook the duties of engineer-in-chief at a salary not to exceed $500 per month. His first assistant for drawings, computations, and inspection work was Colonel Samuel Lockett; he was succeeded by G.F. Simpson. General Stone's responsibilities encompassed the design and construction of the foundation mass; the design of the interior of the pedestal, as well as all of the working drawings for the pedestal's construction; the design of the anchorage system; and the ultimate reassembly of the Statue on Bedloe's Island. Ground was broken within the parapet walls of Fort Wood on April 18, 1883; three years and four days later, the capstone was laid.

General Stone's design for the foundation mass included a truncated stepped pyramid. Two tunnels 7 feet (2.13 meters) high by 10 feet (3.048 meters) wide pierced the mass at ground level, with an open shaft where they intersected. Concrete was selected, instead of "good stone masonry," as the material for the foundation; cost was the overriding concern in the selection process. Excavation, which commenced in June, proved complex and costly, as unexpected substructures related to Fort Wood were encountered. As excavation progressed, architect Hunt introduced to the public a model of his pedestal design, which had been accepted by the American Committee "subject to such changes as they may see fit to make." It was referred to as the Pharos' design because of its similarity to the ancient lighthouse of Alexandria.

The contract for laying the foundation was awarded on August 14, 1883, to Francis Hopkinson Smith, with associates Alexander McGaw and John Drake, at a price of $3.94 per cubic yard (1 cubic yard = 0.7646 cubic meter). The contractor supplied all materials except the concrete. Smith was a civil engineer whose specialty was government work. His selection was partially based on his offer to leave the hoisting plants and structures erected for moving his materials for the future use of the committee. This equipment included a 600-foot- (183-meter-) long heavy timber trestle built over the parapet wall from the wharf to the parade ground of the fort. Alfred Pancoast Boller, an expert in bridge engineering, was employed as a consulting engineer for the project.

Labor on the foundation began October 9 (Figure 3). Workers had quarters on the island. Actual work had to be suspended during the frost season; however, by spring 1884, the concrete mass (and its boarded sides) was swiftly growing. A large force was employed, mostly for mixing concrete. By May 17, the foundation was finished at a cost of $93,830.94.

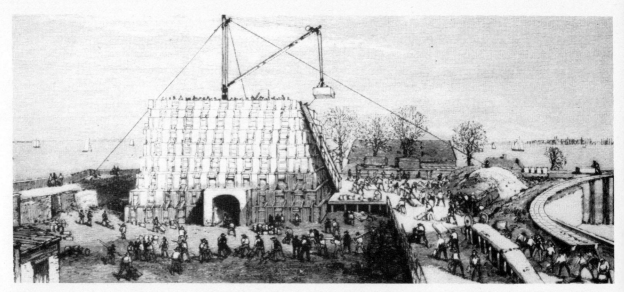

FIGURE 3. *Progress on the construction of the pedestal's concrete foundation (from* Frank Leslie's Illustrated Newspaper, *May 10, 1884). Ground was broken on Bedloe's Island for the construction of the pedestal's concrete foundation on April 18, 1883. Despite unexpected obstacles, an "army of workers" quartered on the island successfully completed the work by May 17, 1884, at a total cost of $93,830.94 (photo: National Park Service, Statue of Liberty National Monument).*

With the removal of the wooden forms and the final grouting of the exterior surface, the cornerstone for the pedestal was ready to be set with full Masonic ceremony on August 5, 1884. "The clouds hung low over Bedloe's Island and a drenching rain fell" as the 6-ton cornerstone was dropped into its place in the northeast corner.

On May 16, 1884, one day before the foundation was completed, the American Committee entered into a contract with David H. King Jr. for construction of the pedestal at a sum of $132,500, including dressing stone. The stone was supplied by the Beattie Quarry of Leete's Island, Connecticut. King, a well-known builder in New York City, magnanimously offered to return any unspent funds to the committee.

Shortly thereafter, architect Hunt was asked by the American Committee to prepare a modified design, primarily to reduce costs. The design of the lower portion was to be retained, since stone was already quarried and dressed for those courses. The new final design was approved August 7, 1884. Ironically, it ultimately cost more than the original because of added stone dressing and care required in the construction. Believing the new design to be far superior, however, the American Committee chose to proceed with its construction despite the expense. Contractor King rescinded his original estimate; he sought and secured $152,000.

The interior plan, described by its designer, engineer Stone, was "extreme simplicity, intended above all else to secure stability, strength and durability to the structure." A vertical shaft 27 feet (2.5083 meters) square was to pass from base to summit. A cost-saving measure was introduced: only the facing, 3 feet thick, would be granite; the backing, or interior surface, was to be the best-quality béton, a type of concrete.

In November, the work came to a halt on the seventh course for two reasons. Winter had set in, and—perhaps more critically—the American Committee's fund-raising efforts had reached a standstill. The press had a field day with the Statue's plight. The committee turned to Congress in the hope that the lawmakers would come to its rescue. The bill failed, but in March 1885, Joseph Pulitzer, publisher of the New York newspaper the *World*, came to the aid of the encumbered pedestal committee. Through the power of his press, the aggressive journalist was able to solicit contributions from the formerly reticent public. The project was salvaged within months. The complicated series of delays and spiraling construction costs left their mark, however. Work resumed in May; by June, the 11th tier of stones was being laid. A lack of crushed stone for the béton forced a temporary suspension of work at the 14th course. This coincided with the arrival on June 17 of France's noble gift, aboard the *Isere*. (The Statue would be officially welcomed in full naval parade on June 19.)

A contract was let to W.E. Chapman of 70 South Street for $700 for the unloading and placement of the Statue on Bedloe's Island. With the *Isere* anchored off the shoals on the south side of the island, two heavy lighters with derricks tied up alongside the vessel on June 22. Every precaution was taken

against accidents; General Stone even had the contents insured. The cargo came in three varieties: bundles of iron rods; pieces of the stanchions, or internal support columns; and huge crates. The structural fragments were primed in red lead. When loaded, the lighters moved to the wharf, and the pieces were lifted by a crane to the tramway running along the trestle. They were deposited in a cart and moved to the edge of the fort. A shed was eventually constructed to house most of the metallic fragments. Within five days, the Statue was entirely on American soil.

As the *Isere* was being unloaded, General Stone announced that the Keystone Bridge Company of Pittsburgh (owned by Andrew Carnegie) had begun rolling the steel girders for the anchorage system. The method of fastening the colossus to her pedestal was a subject analyzed on both sides of the ocean, but the ultimate design would be that of General Stone and his assistant, Colonel Lockett. The design consisted of two systems of heavy girders. These were embedded in the masonry of the pedestal's interior, one at the top, the other 60 feet (18.29 meters) below. Four sets of tie bars united the two systems. The girders extended across the well at right angles to each other, connected at the top to Eiffel's structure. Since all parts of the system were to be visible after construction, repairs and adjustments would be possible. The Keystone Bridge Company agreed to supply the complete steel anchorage finished, placed, and painted for 4.8 cents per pound. Delays in the delivery and placement of the girders amounted to four weeks, however. Charles Schneider, the well-known engineer of the New Niagara Bridge, was responsible for the inspection duty.

General Stone came under criticism by the New York press and former contractors only days after the Statue arrived. A controversy ensued over Stone's competency regarding the following issues: his ability to develop a system to adequately protect the Statue from galvanic action; his ability to secure the arm structure; and his supervision of the concrete foundation, for which he was forced to submit a cost estimate to the newspapers. Exasperated, he wanted to call a meeting of the American Committee, stating: "I am weary of being made the newspaper scapegoat for the Committee and the pedestal."

The construction of the pedestal continued during the autumn of 1885, in spite of the journalistic lambasting. The labor of sorting the contents of the crates and the preliminary preparation of the anatomical fragments was begun. Bartholdi arrived to consult with General Stone on the final installation and to survey the works. He visited the site on November 6, accompanied by Stone and Richard Butler, the American Committee's secretary.

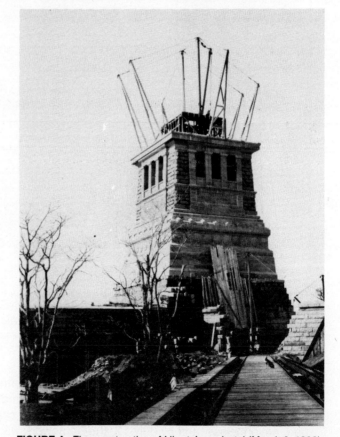

By March 6, 1886, the derricks had been moved into final position (Figure 4). The 40th of the entire 46 courses had just been completed. The end was in sight. On March 21, the last set of iron girders was lowered into place. The vast enterprise was finished on April 22 as the capstone was swung into place, embedded in mortar into which handfuls of silver coins were thrown. Engineer-in-Chief Stone was proudest of the fact that "no life of a human being was sacrificed" in the construction. The largest granite block weighed 11 tons.

Assembling the Statue on Bedloe's Island (May through October 1886)

General Stone issued a national plea on March 6, 1886, for $15,000 to set the goddess on her pedestal. The fund-raising coffers were empty. A contract was negotiated on May 5, 1886, between the American Committee and King, the contractor of the pedestal, for the erecting and secure placing of the Statue of Liberty. Included in the work was the installation of a protective barrier against galvanic action: All surfaces of contact between the iron and copper would be shellacked and strips of asbestos interposed. This was the American solution. With the

FIGURE 4. *The construction of Liberty's pedestal (March 6, 1886). The derricks used in constructing the pedestal had been moved into final position by March 6, 1886. The cornerstone for the pedestal was laid August 5, 1884, and on April 22, 1886, its capstone was swung into place (photo reprinted with permission from the American Institute of Architects Foundation, The Octagon Museum, Washington, D.C., Prints and Drawings Collection).*

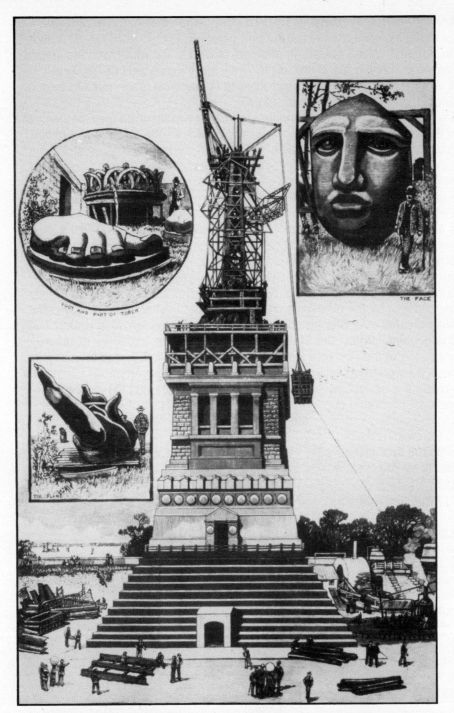

FIGURE 5. *The mounting of the Statue of Liberty on Bedloe's Island, New York Harbor (from Frank Leslie's Illustrated Newspaper, August 21, 1886). The assembly of the Statue on Bedloe's Island took six months, from May to October 1886. The copper sections were hoisted aloft in a long wooden box; riveters hung from rigging secured to the wrought-iron structure (photo: National Park Service, Statue of Liberty National Monument).*

interposed. This was the capable superintendence of Bartholdi's representative, Mr. Bouquet, the assemblage began in May as the primary structural unit—the pylon—was set into place.

Thoughts now turned to the inauguration. General Stone submitted an estimate of $106,100 in hopes of securing a congressional appropriation to cover the costs of the inauguration and the completion of the pedestal's interior details and entrances. Included was an estimate for an electric lighting plant. A parsimonious Congress whittled the estimate to almost half—only $56,500 was secured. The members of the American Committee had no choice but to temporarily drop all work items except the lighting. How could Liberty begin her task of enlightening the world if she herself were not lighted? Bartholdi had addressed the artistic issues, but the technical realities connected with lighting the monument were left for the Americans to tackle. At the recommendation of Major-General J.M. Schofield, President Grover Cleveland's appointed representative for the inaugural preparations, a Light-House Board engineer was secured. He was Lieutenant John Millis, noted for the exterior illumination of the lighthouse at Hell Gate in New York.

In June, as Lieutenant Millis pondered the issues of lighting, engineer Stone persevered in his role, although with stretched patience. He privately expressed his dissatisfaction with the contractor, stating: "Mr. King has undertaken something in setting up the statue that he knows nothing about . . . the cheap and nasty course is pursued." Work continued, nevertheless, and by July 12, the framework was complete, the hoisting machine was moved into place, and the riveting was ready to begin. The mounting of the copper sections was undertaken for the most part with hoisting equipment and rigging rather than scaffolding. The installation of the copper skin took three months of intensive work.

The process began at the Statue's base and would progress in horizontal stages, with the pieces being hoisted aloft in a long wooden box (Figure 5). Because of erroneous and missing numbers, the

greatest difficulty experienced by foreman Charles Long was the selection and fitting of different elements. The work also was delayed because at times it was necessary to lift several pieces to find the right one; it was a monumental jigsaw puzzle. As the work progressed and fewer pieces were left, the process became easier. A large force of riveters hung in a swing of ropes on the outside of the Statue while others were at work inside. A narrow, wooden stairway was constructed to reach the interior heights. The scene was enlivened by falling bolts and rivets.

On the last day of September, an official date was finally set for the unveiling, as the already familiar face was hoisted into position. It was necessary to erect a scaffold and derrick to allow workers to move around her chin. With only 20 days remaining, work was principally confined to the top of the right hand, the shoulders, the face, and the crown. An opening was left temporarily in the top of the head, for the convenience of workmen riveting the diadem and securing its rays. With the exception of the torch, every part of the Statue was off the ground by this time (Figure 6). The beaten copper letters for the tablet had only arrived from France on August 17; the reason for the delay is unknown.

Preparations were made to raise the flame. The tips of the flame had been altered slightly from the time of its assembly in Paris to its reassembly on Bedloe's Island. The hoisting was a slow and difficult process, but by noon on October 13, it had arrived at its new place of prominence. A modification was made almost immediately: Two rows of staggered circular holes were cut in the flame. The explanation for this action was that after the flame was securely placed, Lieutenant Millis presented his plan for illumination, which called for placing the arc lights inside as a protective measure. The press was appalled at the practical but insensitive action, describing it as a mutilation of Bartholdi's Statue.

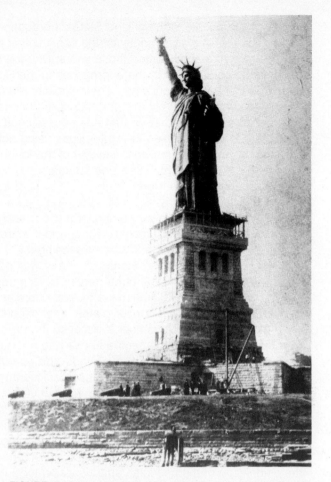

FIGURE 6. *Liberty nearly ready for her inauguration (October 1886). With the inauguration only weeks away, the riveters continued their task of securing the copper plates. The work focused on the torch, the tablet, the head, and the shoulders. The flame was not hoisted into position until October 13. Note the man standing on the tablet (photo: National Park Service, Statue of Liberty National Monument).*

■ 23 ■

With only a fortnight left until the momentous occasion, the engine and boiler house were set in proper order. The president of the American Electric Manufacturing Company (New York, New York) donated, as a patriotic gesture, the electric lighting apparatus and engine house when Congress failed to provide the funding. (The terms of the contract required maintenance of the light without expense to the government for one week after the date of the inauguration.) The boiler was supplied by Edward P. Hampson & Co. (New York, New York). The iron workers from the Heckler Iron Works (Brooklyn, New York) were at work installing their staircase in the pedestal. The last piece of copper—the goddess' sandal pad, which was left open as a point of access and for light—was set in place. The three-and-a-half-year-old construction site was cleared of debris under the supervision of landscape architect Frederick Law Olmsted, while a platform was constructed for the inaugural ceremonies. The scaffolding at the Statue's feet was removed, as was her canvas mask for a brief encounter with her "interpreter": Bartholdi had arrived. The canvas would be replaced by a veil designed to resemble the French flag.

The Inauguration (October 28, 1886)

As night turned to day on October 28, 1886, the moment of glory for the monument of art, engineering wonder, and architectural form had arrived. Even the ominous sky and wet streets did not dampen the spirits of a million eager persons who had come to witness the long-awaited event. Captivated with optimism by the occasion of her unveiling, the Liberty seekers spoke hardly a word of the tumultuous years that marked the making, acceptance, and final assembly on Bedloe's Island of this, France's no-

ble gift to the people of the United States. Forgotten in the splendor were the financial struggles, the artistic and administrative conflicts, the construction difficulties and delays, the moments of despair and disappointment that so tainted those years. Unheralded went the fact that a tremendous amount of work remained to complete both the approaches to the Statue and its pedestal, and that funding was not imminent for such necessary work. The onlookers did not speak of the fact that Liberty lacked an officially appointed guardian. Surely this portended an uncertain future for the Statue of Liberty.

The inclement weather on that day necessitated postponing the presentation of the lights for four days. Millis's complete plan called for illuminating not only the torch, but also the entire Statue by "electric projections" installed in several of the fort's 11 points. (This was an avant-garde notion, as floodlighting's heyday was still some 30 years into the future.) Following a dazzling pyrotechnic display, the Statue's lights shone forth. In an ironic twist of fate, however, the pedestal stood out grand and imposing against the ebony sky, while the regal figure of the Statue was shrouded in darkness. Millis's attempt at floodlighting failed primarily for two reasons: the limited reflective qualities of the copper skin (it was the shade of a dull brown penny) and the projecting mass of the pedestal, which prevented light from lamps mounted on the fort from reaching the Statue.

The guardianship of the Statue of Liberty was passed from the American Committee to the United States on October 28, 1886, but a neglectful Congress failed to pass the necessary legislation to provide her with an officially authorized federal guardian. While riveters continued the endless process of permanently securing the copper plates, a tangle developed over custodianship. The Statue's lights were extinguished on November 7 because the term of the contract with the American Electric Lighting Company for operating the engine house had run out. President Cleveland finally took action, and on November 16, he placed the Statue under the guardianship of the U.S. Light-House Board. On November 22, the Statue cast off her red-tape shackles and her beacon shone again, into the next century.

Much work remained to complete the monument of art. However, Bartholdi—after his return to France—wrote the American Committee to express his pleasure with the success of the work, both in its details and as a *tout ensemble*: "I have not the slightest fault to find and I have no doubt that with care and looking after, the monument will last as long as those built by the Egyptians." He further expounded upon several aspects of the project that had yet to be fully realized: the questions of lighting, the completion of the pedestal, and his vision for a national park. These became the challenges of a century.

□ 100 Years of Repairs, Alterations, and Improvements

Firmly secured to her pedestal, *Liberty Enlightening the World* was ready to take on those challenges. During her first 100 years, she rose in ranks from an insignificant beacon in 1886 to the status of a national monument by 1924, and finally to a recognized world-class structure in 1986. Her physical history reflects the particular mission and sensibilities of the various federal agencies that were her administrators. Thus, the years spent under the U.S. Light-House Board were characterized by alterations and repairs to improve the beacon and floodlight the monument of art. The War Department years focused on the island primarily as a military post and only secondarily as the site of a national monument. The National Park Service stewardship has concentrated on the interpretation of the symbolic qualities of the Statue.

The colossus was often in jeopardy during her first century as she struggled to survive a multitude of problems. These included a complex, and at times discordant, administrative framework; custodians often ignorant and insensitive to her intrinsic value and physical being; and a neglectful Congress that made the good intentions of the administrators even more impossible to fulfill. Concurrently, a medley of physical forces—some more subtle than others—played silently on her structural and aesthetic integrity. Threatening her very existence were construction systems inherently prone to failure; modifications dating to the original construction process; a century of repairs and alterations, in which one problem was corrected but inevitably created another; and the lethal combination of time, the environment, and the omnipresent visitor. All left their own special imprint on the 19th-century mass of metal and masonry.

Lighting Improvements

While the Third District Inspector of the Light-House Board was establishing the Statue as an official light station, the district engineers were investigating the special problems of improving and increasing the Statue's lighting, not only as an aid to mariners, but as an *objet d'art* as well. The first step was to install a permanent lighting plant. (The hastily installed inaugural plant was imperfect and intended only

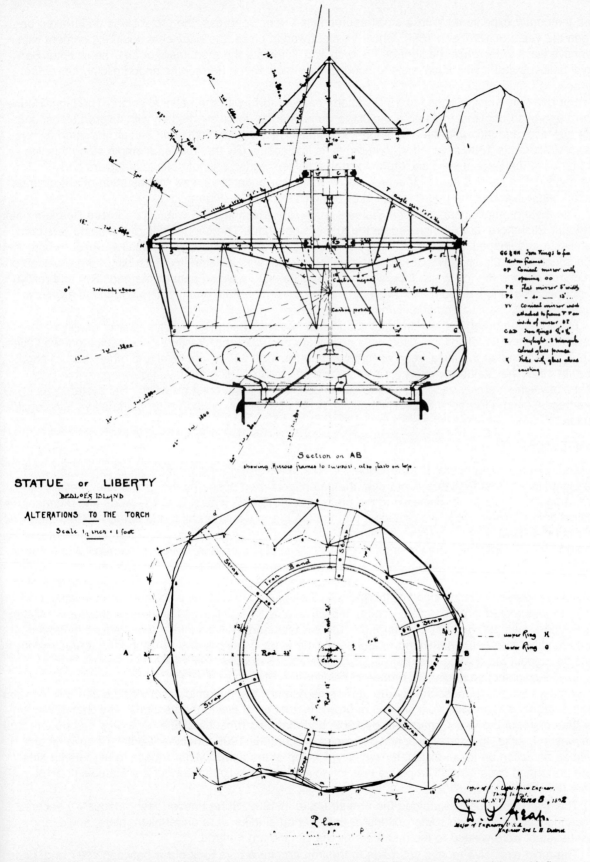

FIGURE 7. *Alterations to the torch—Major D.P. Heap's 1892 plan (June 8, 1892). The metamorphosis of the torch's flame began in 1886 and continued throughout the Statue's first century. The second major step in this process occurred in 1892. At that time, the top row of holes introduced in 1886 was transformed into a glazed belt of plate-glass panes, while the flame as a whole was crowned with a multicolored lantern (photo: U.S. Coast Guard).*

as a temporary expedient.) With a small appropriation from Congress, the project was undertaken between the years of 1887 and 1890. Once the plant was in place, the engineers could experiment with inventive ways to increase the light of the torch and illuminate the monument of art. The sculptor Bartholdi believed that it was impossible to floodlight the monument; he recommended gilding her entire surface.

For one brief shining period in 1892, Liberty dazzled forth with the national colors. The Light-House Board approved and implemented a project to illuminate the goddess' diadem with colored bulbs, spotlight her face, and increase the magnitude of light in the flame. As mentioned earlier, the torch flame was first altered in 1886 in an effort to improve its luminosity. (By the 1980s, attempts along this line had reduced the original solid sculptural form to a glass-studded relic of countless repairs and alterations.) The second step in this process, which occurred in 1892, saw the insertion of a horizontal glazed belt in place of the upper row of circular holes from 1886 (Figure 7).

The most dramatic change in the Statue's flame took place in 1916 with John Gutzon Borglum (later of Mount Rushmore fame) employed as the artistic consultant. The copper skin of the flame was completely cut and shaped, the structure was reworked, and cathedral glass was installed. Also, to bring the monument out of the shadows, a new floodlighting system was initiated, in which lamps were placed on structures beyond the fort walls. Liberty's own luminous history would parallel the evolution and refinement of floodlighting—as both a technology and an art—in the 20th century. Improvements always included the latest, most advanced illumination equipment.

Because of the harsh environmental conditions, poor maintenance, and the inferior quality of the apparatus, a new floodlighting system was necessary by 1932, and Westinghouse equipment was used. The system included the installation of lights that surrounded her at foot level and others on her shoulders. In 1945, the Statue received yet another system, incorporating the latest development in bulb technology—the mercury vapor bulb. A foremost concern was the color rendition. The system was updated again in time for the U.S. Bicentennial in 1976, with energy conservation being taken into consideration.

Protecting the Statue

During the waning hours of 1886, undercurrents of misgiving were already being expressed within the Light-House Board establishment over the potential burden posed by the gargantuan metallic structure. A lighthouse engineer declared to the press that the Statue was structurally weak and defenseless against time's erosive tooth. He predicted that the torch arm would break in the not-too-distant future and that the sheet copper—which was already showing signs of corrosion—would be a constant expense to the government. The press turned to the construction engineer-in-chief, General Stone, for an explanation. Stone counterbalanced those fears with a reassuring response. He cited the monumental Italian sheet copper statue depicting St. Charles Borromeo, which was 190 years old and still standing without any discernible diminution of thickness in the copper skin. Stone's solution for maintaining the structure was rooted in pragmatism, recommending the cyclic painting of the internal structure and skin. Rising more than 300 feet (91.4 meters) into the air, featuring limitless joints, and plagued by inadequate funding, the Statue continued to arouse maintenance concerns and present difficult repair problems throughout the coming century.

In 1890, lighthouse engineers proposed painting the Statue white; Bartholdi suggested a varnish coating as a protective measure. By the turn of the century, the dynamic action of time and environment had turned her copper skin from shades of brown to shades of black and verdigris. The Statue was under the control of the War Department by 1902, and that department's astute engineers had no fear that she was in trouble. In a detailed conditions report prepared in 1905, engineer Sedley Chaplin recommended no action be taken except for regilding the top of the flame. Minor repairs to her interior skin were performed *circa* 1920. The patina was left to evolve naturally throughout the Statue's first 100 years (Figure 8).

The War Department reinforced the arm structure in 1932. (It had never been adequately secured according to Eiffel's design.) After extensive engineering studies were undertaken, plate, angle, and channel steel were welded to the members by the electric-arc method.

The most extensive repairs yet made to the iron armature bars took place between 1937 and 1938, because the asbestos barrier was slowly failing (Figure 9). Numerous corroded armature bars were removed, and new ones were fabricated right on site, as part of a Works Progress Administration (WPA) project. The new bars were installed with self-tapping screws. The brass rays of the diadem were removed and given a new support structure. Finally, in the early 1970s, some ornaments of the torch's balcony were replaced.

Painting of the interior of the Statue and pedestal was performed for two primary reasons. First, paint was used as a protective measure: With the Statue's miles of seams exposed to the penetration of the elements, coatings with sealant properties were applied, including a coal-tar paint in 1911 and an aluminum-flake paint in 1932. The second reason for painting was to conceal graffiti, which started to appear shortly after construction. By 1947, lipstick became the most popular medium for the graffiti artist; thus, a specially formulated enamel paint was developed by the Inertol Company, Inc. (Newark, New Jersey) to make graffiti removal possible without repainting. The paint manufacturer's advertising of this product guaranteed the Statue was now "kiss-proof."

Transformation of an Island

Bartholdi had a grand vision for the entire island—that it was "destined to be made into a pleasure ground for the soul of the American people, a place of pilgrimage for the citizens of the whole nation, a National Museum of the glories and memories of the United States." The underdeveloped conditions on Bedloe's Island in 1886 visually offered great possibilities for the fulfillment of Bartholdi's dream for an "ideal National Park." The immediate future provided a different scenario. The island evolved from mostly open land in the 1890s to a maze of military structures and roads by 1933. The War Department's motto may well have been, "Form follows function." The island underwent a visual transformation of incredible magnitude under its jurisdiction (Figure 8).

This was the situation when the National Park Service entered the picture in 1933. The National Park Service in that year was only given control of the 2-1/2 acres occupied by the national monument. However, it immediately set to the task of obtaining jurisdiction over the entire island. By 1937, the

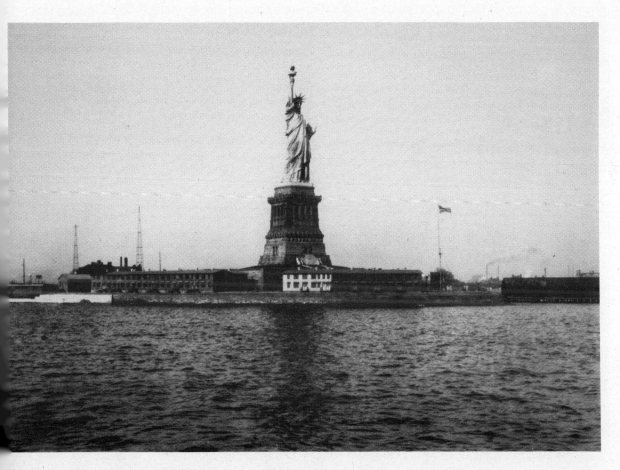

FIGURE 8. Liberty Enlightening the World, *view from New York Harbor (February 7, 1919). The dynamic action of time and environment had turned the Statue of Liberty's copper skin from shades of brown to shades of black and verdigris by the turn of the century. War Department engineers recommended no action be taken to counteract this natural evolution. Although sensitive to the state of her patina, the War Department was not as sympathetic to her site. The island evolved from mostly open land in the 1890s to a maze of military structures and roads by 1933. This photograph shows the condition of the Statue and her surroundings on February 7, 1919. Note the terreplein and stone stairway introduced in 1907 (photo: National Archives).*

island was the Park Service's, and over the course of the next 30 years, the island would become Liberty's.

A master plan was developed, including a formal, axial landscape plan with a mall. The Statue was to tower over a tree-covered island. The concept was to have the visitor travel via ferry past the front of the Statue from east to west, landing at a west pier. (Visitors at that time landed at the east pier, without traveling around the Statue.) Concessions and administration structures were to be located at the island's northwest end. The visitor on land was to approach the Statue from the rear and enter at the fort's base.

Construction work to achieve this plan began in earnest in the early 1940s, but it came to an abrupt halt because of World War II. By that time, the concessions and administration buildings were in place and the mall was emerging. The project resumed after the war; employee housing was completed in the early 1950s. By 1956, the master plan was realized: Bedloe's Island was officially renamed Liberty Island and the announcement was made that an American Museum of Immigration would be constructed at the pedestal's base. The museum was completed in the mid-1960s.

Visitor Improvements

From the outset, the Light-House Board realized that regulations for visitor admission to the attraction were essential if any semblance of order was to be maintained. In 1887, the Light-House Board published "Rules for the Admission of Visitors." The "rules" noted that not more than 10 persons would be allowed in the Statue at any one time. The management of the ever-increasing numbers of visitors continued to challenge administrators of the monument throughout her first 100 years.

In spite of persistent efforts by the remaining American Committee members in the late 19th century, Congress did not come forth with the $50,000 needed to complete the pedestal as designed. The original design called for the creation of a terreplein punctuated by four grand staircases leading up to each of the monumental doors. The Statue's approaches to the pedestal stood incomplete for two de-

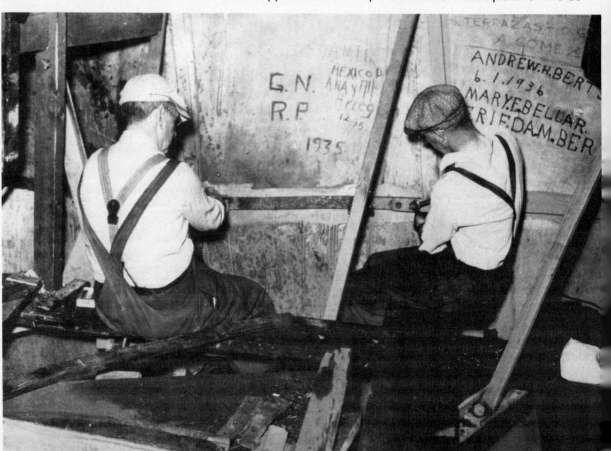

FIGURE 9. *Repairs to the copper skin's interior armature (June 8, 1938). Two WPA iron workers are shown replacing corroded armature bars inside the Statue. New bars were forged on the island and installed with self-tapping screws between 1937 and 1938. Note the graffiti, a recurring problem since the Statue first opened to visitors in 1886 (photo: National Park Service, Statue of Liberty National Monument).*

cades following her inauguration, "as a mortification to the people and a discredit to the nation." Not only an eyesore, the conditions were hazardous to the safety of the visitors, who were required to traverse a dilapidated wharf and boardwalk to reach the parade ground of the fort and then climb a temporary wooden stairway to the entrance of the pedestal. In 1907, the War Department improved the approaches by filling in the area within the walls of the fort and installing a stone stair, although not as originally designed (Figure 8). Other visitor services were improved, including the building of a waiting station.

Once inside the monument, the concept was to allow the visitor to experience the colossal structure and all its internal workings (Figure 10). During the Light-House Board years, visitors climbed a decorative cast-iron staircase that encircled the pedestal's walls. (No elevator was present at that time.) The visitors passed through the impressive steel anchorage system, finally reaching the base of the Statue. Here, they had a view of the Statue's skeleton, which would have been more awe-inspiring if the light had been better. The temporary construction stairway leading to the crown remained until 1888, when double-helical stairs replaced it. Access to the torch (via a 53-rung ladder secured to the arm's structure) was always restricted and eventually prohibited.

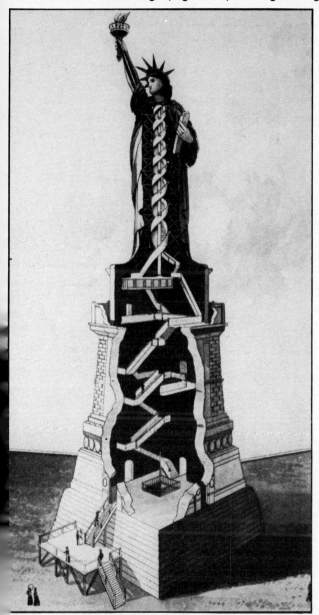

The first elevator, manufactured by the Otis Elevator Company (New York, New York), was introduced in 1907 by the War Department. The National Park Service replaced the cast-iron pedestal stairs in 1938, because of structural failure, with reinforced concrete stairs that scissored their way up one side of the pedestal. This interior work included the construction of concrete floors and a concrete elevator shaft. The introduction of these features in concrete dramatically altered the visitors' view of the Statue's impressive anchorage system—which now could be seen only in parts. Although the double helical stairs in the Statue itself survived, they were enclosed in 1947 in a cage of metal screening installed to address the graffiti problem and safety concerns. This cage substantially diminished the visitors' experience of the impressive expanse of the Statue's interior space. After a century of "improvements," the visitor was no longer able to clearly witness the genius of General Stone, Gustave Eiffel, and Auguste Bartholdi.

By 1980, confusion reigned; it was time to rethink Liberty's various paths.

■ 29 ■

FIGURE 10. *A vertical section through the Statue of Liberty (1896). As depicted in this sectional diagram of the pedestal and Statue, the original concept was to allow the visitor to experience the massive size of the colossal structure and all its internal workings. Over the years, repairs and improvements dramatically altered the visitors' interior views of the monument, as the passageway became engulfed in a sea of concrete and wire cages (photo: National Park Service, Statue of Liberty National Monument).*

Readers interested in learning more about the Statue's construction history and first 100 years are directed to two published sources on the subject, as follows:
The New York Public Library, et al. *Liberty: The French-American Statue in Art and History*. New York, NY: Harper & Row Publishers, Inc., 1986.
Trachtenberg, Marvin. *The Statue of Liberty*, revised edition. New York, NY: Penguin Press, 1986.

■ *Bartholdi and His Genius* [1]

Edward L. Kallop Jr.
National Park Service, Boston, Massachusetts

An important by-product of the centennial anniversary of the Statue of Liberty is a re-examination of all aspects of the Statue. Not the least of these are fresh appraisals of the colossal figure as physical phenomena: how idea was translated into physical conception, the steady course of the conception that, in the end, transcended the idealistic intention of its supporters and even the highly sophisticated purpose of the Statue's creator, Auguste Bartholdi.

The principal genius of Bartholdi was the ability to transform an essentially routine concept, one that conformed to academically inspired artistic tastes of the late 19th century, into a result so bold that it can only be described as breathtaking. Liberty is the best-known example, but there are other works that readily illustrate the point, beginning with an earlier project for a lighthouse planned for the entrance to the Suez Canal, a project that failed but that in physical form bears features later incorporated into the design of the Statue of Liberrty.

For Bartholdi, the realization of the Statue was a goal pursued with a driving passion as well as remarkable practical acumen. So successful was this probably otherwise obscure French sculptor that the Statue of Liberty is a household image not only in the United States but around the world, with smaller-scale replicas erected during the past 100 years from Paris to Bangkok. Whatever their individual purpose, all are witness to the mystique of Liberty and the genius of her creator.

■ 31 ■

Throughout the spring and early summer of 1986 and culminating in the centennial celebrations held during the week of July 4, the Statue of Liberty was the focus of national and, to a degree, international attention unmatched by war, plague, or royal weddings. Critic Paul Goldberger noted on July 17 in the *New York Times* ". . . the wild and extravagant praise for the Statue of Liberty . . . the ubiquitousness of (its) image . . . with pictures of the Statue from every angle, taken at every time of day and night, on television, in newspapers and magazines." He commented that "the miracle of it all is how well the Statue of Liberty survived all this . . . with every bit of its dignity intact." Goldberger concluded that the genius of the Statue is a culmination of many factors: its symbolism, its monumental size, and, above all, its placement. "The Statue of Liberty was not," said Goldberger, "placed where it stands by accident. It is not in the middle of Nebraska, or even in the middle of Brooklyn. It is out in the harbor, on an island, where it faces out to the sea, and it performs a gesture of welcoming. By so doing, it enters into an essential relationship with the city, and this is the real key to its brilliance as a symbol." Goldberger is not the first to notice that the Statue's location was a brilliant choice, a choice made by its creator, Auguste Bartholdi, as he entered New York Harbor for the first time in 1871.

Aside from the media-fed attention to the restoration, many re-examinations of the Statue of Liberty resulted during this period: studies of all aspects of the Statue's history, symbolism, physical condition, and influence in ways that heretofore went largely unexamined, and studies in the form of publications, exhibitions, and symposia (such as the conference that produced this publication). All offered fresh appraisals of the Statue, with most providing genuine contributions to scholarship as well as a welcome relief from the plethora of books on the subject written for "the general public," which usually repeat outworn anecdotes and often contain inaccurate information.

[1]This subject is treated in more detail by the author in *Images of Liberty: Models and Reductions of the Statue of Liberty, 1867-1917* (Christie, Manson & Woods International) published as the catalogue to a special centennial exhibition held in New York, New York, January 25 through February 15, 1986.

The earliest of the re-examinations was by Marvin Trachtenberg, an art and architectural historian who, in 1976, at the time of the nation's Bicentennial, wrote a work titled simply *The Statue of Liberty* (Penguin Press, revised 1986). Trachtenberg's contribution was to treat the Statue for the first time as a physical phenomenon rather than an almost exclusive product of symbolic ideas. In a wide-ranging study, Trachtenberg offered original points of view at every turn and, like Paul Goldberger, concluded that the true genius of the Statue lies in its location. The credit must unmistakably go to the great monument's creator, Auguste Bartholdi.

Bartholdi had an unfailing sense of grandeur, of the possibilities of heroic proportion for sculptured works that saw its fullest realization in the Statue of Liberty. As a young man, Bartholdi traveled in Egypt, where he was struck apparently to the point of obsession by the gigantic sculptured monuments that were the glory of ancient Egypt. He photographed them, drew them, and returned home never to forget them. The sculptor's Egyptian experience resulted in a project he undertook a decade later, in 1867, for a lighthouse at the entrance of the Suez Canal. The project failed, largely owing to the inability or unwillingness of Egypt's ruler, the Khedive Ismail, to pursue the idea. As a lighthouse, the planned monument was not only a reference to the ancient Pharohs of Alexandria but an uplifting symbol that bore the name *Egypt Carrying the Light to Asia*. The connotation of the title bore later fruit in the Statue of Liberty's official name, *Liberty Enlightening the World*, and in even closer connection, the physical form of the figure was to be translated into the Statue of Liberty as a successor to the failed project.

Heroic proportion and gigantic scale were in every case related to location; Bartholdi was continually concerned with siting. This is implied in the Egyptian project and is evident in Bartholdi's other works created about the same time, the best known of which is the *Lion of Belfort*. Nestled in sandstone cliffs and carved from the rock itself, the recumbent lion symbolizes the heroic defense of the city of Belfort against the Prussians during the Franco–Prussian War of 1870. Huge, outsized, but in perfect scale with its site, the lion in concept may be seen as a conventional figure for the symbol it connotes. Indeed, Bartholdi used conventional means as it suited him, since he relied for professional success in the marketplace on commissions for public monuments of one kind or another. His sculptural vocabulary reflected the academically inspired tastes of the late 19th century.

But beneath this overlay, the sense of heroic scale was the point of departure, producing his most memorable works, and was on occasion matched by an equally unconventional sense of the bizarre. The latter is best seen in a funerary monument in a cemetery at Colmar, Bartholdi's native city in eastern France, which suffered badly during the Franco–Prussian War. The monument is a memorial to the local heroes of the war, the native dead, and its design shows a half-raised tomb slab with a bare arm either reaching from or withdrawing into the grave. In concept, it is both bizarre and breathtaking in its unconventional ambiguity.

The Statue of Liberty must, in justice, be viewed as a conventional sculptural concept. Its design can be traced from the Egyptian project in a series of design studies called *maquettes*, located in the Bartholdi Museum at Colmar. They begin with the earliest figure, a 19-inch (482.6-millimeter) model in clay for the Suez lighthouse, and continue in subsequent studies for the project, models dated 1869, and through a series of models, hand sculpted and cast, the dates of which begin in 1870 and end in 1875. In these can be seen the steady course of the physical development of Liberty as we know her today. There were subtle changes in design; the most notable is a shift in position for the left arm, which, in the final design, holds the familiar tablet inscribed with the date of the Declaration of Independence. Initially, the left arm was lowered with the forearm slightly thrust from the body, clutching in its hand the broken shackle symbolic of freedom. Purportedly, the change came when Edouard de Laboulaye, the eminent historian and father of the idea for a monument to freedom as a gift to the American people, noted to Bartholdi that the design symbolized not liberty, but liberation, which was a temporary condition rather than a permanent ideal.

By 1875, the final design, one termed by Bartholdi *modèle d'étude*, was ready, and work began on construction of the Statue in full scale in the Paris workshops of metal craftsmen Gaget and Gauthier. Four feet (1.22 meters) high, the model (Figure 1) served as both a design reference and a physical point of departure for escalation of subsequent models to eventual full size. Another purpose, unconnected with the construction of the Statue itself, was served by the *modèle d'étude*: fund raising. Costs for construction of the figure in Paris and of the pedestal in this country were largely the responsibility of the Union Franco–Américaine, first headed by Edouard de Laboulaye, then, following Laboulaye's death in 1883, headed by the builder of the Suez Canal, Ferdinand de Lesseps. The Paris-based organization was divided in two parts: the French Committee (Comité Français) and the American Committee of the Statue of Liberty. For the former, Bartholdi produced an edition of terra cotta models, casts made from the 4-foot *modèle d'étude*, that were sold by the French Committee. Each was inscribed

FIGURE 1. *The Statue of Liberty's design can be traced from an earlier project and by 1875 was fully developed. This 4-foot (1.22-meter) cast in the collection of the Statue of Liberty National Monument represents the final design, termed by the Statue's sculptor, Auguste Bartholdi, a* modèle d'étude *(photo: National Park Service).*

"*Modèle du Comité,*" and, after casting, each was inscribed with the cold-stamped seal of the Union Franco–Américaine. Each was also unique in bearing an individually inscribed number. They were cast in Bartholdi's own studio, probably in 1878 or 1879 when the Union Franco–Américaine embarked on its most vigorous fund-raising effort. Each cost 1000 francs in France, $350 in the United States. This was a great deal of money at the time, and not all casts were sold; Bartholdi was forced to give them away as late as 1890 to museums throughout France.

Although in 1904 the *New York Times* reported Bartholdi's death with the subhead "Died Poor," he was in fact not poor. Hardly the starving artist in a garret, he lived in the comfortable style of the French upper middle class. Nonetheless, money was an ever-present concern for him, and he continually complained, primarily to Richard Butler, secretary of the American Committee who was both friend and benefactor to Bartholdi, about how much the Statue cost him. As a consequence, he was continually looking for opportunities to raise money. Aside from the subscription sales of the Union Franco–Américaine, funds were realized by a purely commercial arrangement Bartholdi had with a Parisian firm named Avoiron et Cie.

Avoiron was a founder not associated with casting of sculpture in general, or with any other works Bartholdi had cast, which were usually executed by foundries with names as recognizable today as in Bartholdi's day for their cast sculpture. Avoiron specialized in ornament and in electrical fittings. Nevertheless, Avoiron entered into a contract with Bartholdi, who supplied a model from which Avoiron cast reproductions in three sizes: 2, 3, and 4 feet (0.61, 0.10, and 1.22 meters) high. On sales by Avoiron, Bartholdi was paid a royalty of 10%. What the models sold for is unknown, but it can be deduced that they sold in considerable quantity, for each cast was numbered, and "285" is inscribed on a four-foot cast that is among the few that have been identified and documented.

In correspondence, Bartholdi went to great lengths to ensure Avoiron's rights were protected, rights that after long negotiation were sold in 1886 to an American firm that was already producing the American Committee Model. (The rights, after their purchase, seem never to have been exercised.)

The firm had the unlikely name Newton Bottle Stopper and Britannia Company and was probably commissioned in early 1885 to manufacture a statuette known as the American Committee Model. Principally in two sizes, 6 and 12 inches (152.4 and 304.8 millimeters), but with a limited few that were 3 feet high, the American Committee Model was produced in vast quantities and was marketed primarily through subscription directly from the Committee's headquarters in New York. A sculptor named Max Baudelot was sent by Bartholdi from France for the express purpose of designing a model that served for casts of the 12-inch size that sold for $5 (Figure 2). Who designed the smaller of the two versions is unknown, but it sold for $1 and was by far the more popular, because it was also marketed without profit by department stores across the country. Macy's in New York City alone bought 10,000 of the

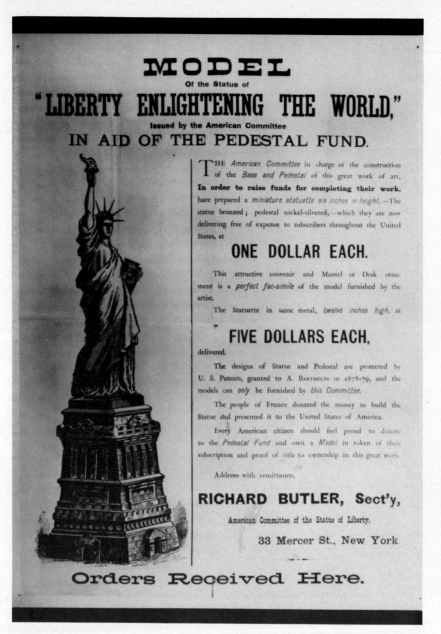

FIGURE 2. *Beginning in 1885, the American Committee of the Statue of Liberty sold miniature Statuettes of Liberty to raise funds for the construction of the Statue's pedestal (photo: National Park Service).*

6-inch statuettes directly from the American Committee, with other stores purchasing lesser but still considerable quantities, and the total produced may well have exceeded 100,000. In both French and American efforts to raise funds, Bartholdi was the incessant collaborator, using whatever personal connections he could to further the cause. He was in constant touch with those in this country who were involved in any way not only with fund raising but with the myriad of problems related to making ready the island location for his future Statue.

In France, Americans living in Paris at the time were spurred to make a return gift to the city of Paris of a reduction of Liberty just as the Statue itself was about to be delivered to the United States. In 1884, these Americans commissioned a 36-foot (10.97-meter) reduction to be cast and installed on a bridge spanning the river Seine at the western end of the city. Bartholdi supplied a *modèle d'étude* to the foundry, the distinguished house of Thiébaut Frères, and a plaster version was erected a year later in the Place des États-Unis, with the final bronze installed in 1889 on the Pont de Grenelle. Its present position on the Ile des Cygnes next to the bridge is the result of a rebuilding of the Pont de Grenelle in 1968.

From Bartholdi's *modèle d'étude* Thiébaut Frères cast a number of small-scale, table-sized models in bronze that were probably the finest artistically of any of the historical casts, and that were usually commissioned directly by Bartholdi as gifts or for presentation to those who helped him during the period of construction of the Statue. The same foundry also cast versions in bronze for outdoor installation in a 9-foot (2.74-meter) size. Most of these were destroyed during World War II, melted down for their metal content, which found its way into German armaments. The sole identified survivor is the cast that today stands in Paris's Jardin du Luxembourg (Figure 3).

More fortunate is a group of models in the same size but cast in iron, which was less desirable than bronze and was therefore saved from destruction during the war. They were first cast around the turn of the century by two firms, Antoine Durenne and the foundry of the Societé du Val d'Osne. The two were linked in some as yet undetermined way; casts bear the foundry inscriptions of one or the other yet are identical in every respect and were apparently cast from the same molds. These, too, were produced from a *modèle d'étude* supplied by Bartholdi and continued to be reproduced as late as 1956, when a

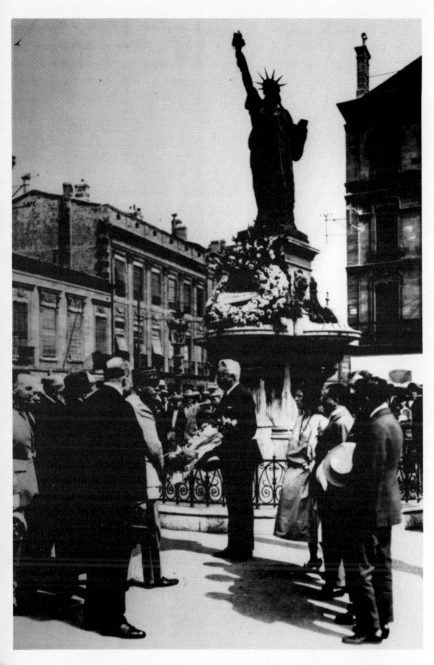

cast was made by Durenne's successor for installation at a then American military base in France.

While the 9-foot casts in iron were all made after Liberty was finished and successfully erected in New York Harbor, Bartholdi never lost sight of the value of publicity, and each reduced copy of his masterpiece was another link in the long publicity chain that for him was an uninterrupted effort from the day of Liberty's conception. Iron copies of the Statue may be seen today in various locations throughout France; the earliest that can be dated (1903) is located in Poitiers (Figure 4). Surprisingly, a companion to the group is found in Buenos Aires and represents an early extension of Liberty's physical presence that has since been matched by copies of the figure, often somewhat distant in design from the original, that have been produced and installed in locations around the world, including the United States. Examples include the statue standing on the roof of the Liberty Storage Company on New York's West 64th Street; 36-foot casts in Buffalo, New York (Figure 5), and Birmingham, Alabama; a similarly sized figure in stone atop a building once occupied by the Lib-

FIGURE 3. *Replicas of the Statue are a witness to Liberty's popularity over the past 100 years. This bronze cast in Bordeaux is one of a number that were erected throughout France in the late 19th century and melted down for German armaments during World War II (photo: New York Daily News).*

erty Shoe Company in Leicester, England; and even an adaptation of Liberty first installed in 1918 as part of a mausoleum in Canton, China. Smaller versions in various sizes are even more numerous and include some 200 statues erected in the early 1950s by the Boy Scouts of America in partial celebration of the organization's 40th anniversary. In front of the Liberty Hotel in Bangkok stands perhaps the most unusual adaptation: the familiar Statue of Liberty, but with Oriental features—a universal figure put to local purpose.

With most of these copies Bartholdi would probably have been pleased, if not with each as a piece of sculpture faithful to his original conception, at least with the result as a reflection prompted by the great passion of his life. Whatever their individual purpose or merit, all are witness to the mystique of Liberty and the genius of her creator.

FIGURE 4. *Still existing in France, with a companion in Buenos Aires, is a replica of Liberty cast in iron around the turn of the century. This example in Poitiers was installed in 1903 (photo: National Park Service).*

FIGURE 5. *In this country, copies of Liberty are in many sizes and varying forms of adaptation. One of a pair, this figure was erected in 1925 on the Liberty National Bank building in Buffalo, New York (photo: National Park Service).*

■ *Materials Choices for the Statue of Liberty*

Martha Goodway
Smithsonian Institution, Washington, D.C.

Colossal statues have been constructed of various materials, including stone, bronze, gilded cast copper, and, beginning in the 19th century, electroformed copper. Auguste Bartholdi, however, chose to realize his concept of *Liberty Enlightening the World* in sheet copper, the earliest material known to have been used for metal statuary. Yet, the Statue of Liberty is so much a part of our consciousness that one can hardly imagine it other than it now stands: a wrought-iron structure supporting a repoussé copper exterior.

The choices of materials that have been used in colossal statuary are diverse. The oldest of the world's colossal statues and the initial inspiration for Bartholdi's design, as pointed out by Edward Kallop and Carol Perrault elsewhere in this book, were those of Egypt. The Colossi of Memnon still stands there, as do the nearly monolithic Sphinx and other statues sculpted from the living rock, now familiar to all the world since the building of the High Dam and the rescue efforts at Abu Simbel.

Colossal statuary is not limited to stone. The Chinese cast large statues of iron, and the Japanese cast several colossal Buddhas in alloys of copper. These statues of cast metal, whether of iron or of bronze, are self-supporting and are, in fact, hollow. The Kamakura Buddha is one example. It was cast in sections, one upon another, each section not much smaller than the pieces of copper sheet used in the Statue of Liberty.[1]

The 19th century ushered in the Age of Steel. The Bessemer converter and the open-hearth furnace made steel economically available in huge quantities. Nevertheless, for the structure to support the sheet copper, Gustave Eiffel specified puddled iron, a form of wrought iron. Wrought iron had been in use since the 2nd millennium B.C., and puddled iron was a development of the 18th century. Thus, in its materials, the Statue stands as an example of a highly conservative technology that persisted in competition with the new alloys being developed in the 19th century.

□ The Choice of Material for the Exterior

By the 1870s, metallurgy had progressed to the point that Bartholdi had a number of alternatives to the more traditional materials available to him. Also, his choice of copper as the material of the visible form of the Statue did not dictate the use of copper sheet. Among the great advances in metallurgy—in a century full of such advances—were Elkington's invention in 1865 of electrolytic copper refining and his earlier development of the electroforming of large copper objects. The statue atop the Albert Memorial in London, erected in 1863 and more than 10 feet (3.048 meters) high, was electroformed. Electroformed statues at the Paris Opera were twice that height, and whole domes in Russia were prefabricated from electroformed copper sections. These processes became practical methods because of Woolrich's invention of the first commercial electric generator, patented in 1842. Plating out a thick layer of copper on a conductive form was no longer limited by the amount of electrical power produced by chemical cells. His original generator can still be seen in the Museum of Science and Industry in Birmingham, England.[2]

Despite the success of statues electroformed in copper, Bartholdi chose to realize his conception of the Statue in beaten copper sheet. The earliest recognized examples of manmade objects of metal are of native copper shaped into small objects by hammering. Occasionally, when the metal has become totally mineralized, these are difficult to distinguish from stone, as may have happened, for example, to a pendant excavated by Solecki from Shanidar and dated to 9000 B.C. The prehistoric Copper Culture of North America is another example of the extensive use of native copper beaten into various shapes.

The Bartholdi workshop's use of sheet copper was distinguished from these early prototypes by the use of smelted rather than native metal for the 30 tons of copper required. The copper sheet of the Statue is described as "tough-pitch" copper, which is a fairly pure copper containing small amounts of other elements that the ore also contained, along with fine particles of copper oxide, a result of the method of refining.

By the 3rd millennium B.C., statues in sheets of smelted copper were being produced in Mesopotamia. A pair of stags on a panel from Al Ubaid, now in the British Museum, and dated to about 2600 B.C. are an example of this method. A similar sculpture of a bull in sheet copper over bitumen is in the University Museum in Philadelphia. Thus, Bartholdi's workshop, in its methods and materials, had ancient antecedents.[3]

One choice not yet open to Bartholdi was aluminum. Aluminum had been available in small amounts since Oersted had developed his reduction process for this metal in 1825, but it was costly. When the tip of the Washington Monument was capped with aluminum in 1883, it was still a precious metal. The Hall-Heroult process for the cheap refining of aluminum dates only from 1886, the year the Statue was dedicated.

□ The Support System

It would seem that the story for the material of the support system would be very different, for by 1886 the Age of Steel had already begun. In 1851 in Kentucky, Kelly developed "pneumatic steel." To make pneumatic steel, air was blown through molten cast iron from the blast furnace. The air burned out some of the carbon in the cast iron, converting it to mild steel. This was done in a special vessel called a converter. (Kelly's converter is shown in Figure 1.) The cast iron, as it came from the blast furnace, contained from 3 to 5% carbon, mild steel less than a percent. In England in 1855, Bessemer made the same observation as Kelly, that the reaction of carbon with oxygen that occurred when air blew across molten cast iron was exothermic. No additional fuel was required to make the reaction proceed. Bessemer also developed a converter, and it was by his name that the process became known. By 1865, Bessemer steel rail for railroads was being rolled in Chicago. As this stronger steel rail was substituted for iron, the standard car load, which had been 20,000 pounds (9072 kilograms), was increased, until at the time the Statue was being erected in New York, the Pennsylvania railroad adopted a 60,000-pound

FIGURE 1. *Pneumatic converter believed to have been used experimentally by William Kelly at the Cambria works in Johnstown, Pennsylvania, and now exhibited in the Museum of American History of the Smithsonian Institution (photo credit: G.T. Sharrer).*

(27,216-kilogram) standard. Not only was the car load increased, but also the ratio of the car's load to its weight was nearly tripled.[4]

In 1856, an alternative method of producing steel was developed: the Siemens-Martin process of open-hearth steel making. The open-hearth furnace could produce enormous tonnages of steel, and by 1883, single ingots each weighing more than 120 tons were being produced in France from the open hearth.[5] The open-hearth furnace was capable of smelting ore, recycling scrap, and refining to steel in the same operation. Thus, if Eiffel had wished to use steel, open-hearth or Bessemer, in the support for the Statue, the amounts needed were not a constraint.

The blast furnace, which produced the cast iron converted to steel in the Bessemer converter, had existed in the West in one form or another since at least the 14th century. Before the converter, iron from the blast furnace was cast into the form of pigs that were then refined on the finery hearth at great expense in fuel, labor, and loss of iron.[6] The product of the finery hearth was wrought iron, usually supplied to the blacksmith in the form of bars and therefore referred to as "bar iron."

Traditionally, sheet copper statues were supported over a solid core, and this was the original plan for the Statue. Eiffel's solution to the problem of support, as we know, was to use a curtain-wall structure, abandoning the original plan with its 5000-year tradition. His design solution was admirably suited to the prefabricated construction required to erect the Statue first in France, dismantle it, ship it to the United States, and re-erect it in New York, all in a brief period of time. The example of the Crystal Palace (1851) had shown the feasibility of prefabricated construction in wrought iron. Using it to support a curtain-wall statue was Eiffel's innovation. His choice of material for the support system was puddled iron.

Puddled iron was a development of the 18th, not the 19th, century. There were three major developments in metallurgy in the 18th century that were important to the structure of the Statue. The first was at Coalbrookdale in England. There, in 1709, Abraham Darby found that coal could be used as fuel in the blast furnace to smelt the iron ore as long as it was coked first. Coke replaced charcoal from wood and so ameliorated the deforestation crisis in 18th-century England.

The fuel crisis was not so acute elsewhere. Charcoal-smelted iron continued to be produced in great quantities in the United States, for example, where charcoal iron production was not to peak until after the Statue was erected, sometime during the 1890s.[7] Whether fuel was in short supply or not, coke had other advantages. It was mechanically stronger than charcoal and could support a heavier burden, so blast furnaces that once were built no higher than 26 feet (7.9 meters) nearly doubled in height, with consequent increases in production and economies of scale.

The cast-iron beam in Darby's furnace at Coalbrookdale is thought by some to be the earliest,[8] and it may well be the earliest in cast iron, but the Romans had occasionally used welded iron beams in the construction of their baths.[9] Darby's furnace produced the castings for the nearby Ironbridge, which is still standing. Cast iron as a structural material had its faults; besides its tendency to be brittle, it also tended to cast with internal and hence invisible voids, a problem that wrought iron did not have.

Another development of the 18th century was the distillation of zinc by Champion at Wormley, England, in 1740, and until very recently, he was credited with the invention. A few years ago, however, zinc smelting retorts and furnaces were excavated at Zawar, near Udaipur in India.[10] They are not yet securely dated but are clearly earlier than Champion's and the source of his inspiration. With zinc available in the form of metal, iron could be galvanized for protection against rusting.

The most crucial development of the 18th century related to structural iron was the process of puddling. Cort achieved this process at Fontley Forge near Southampton, England, in 1783.[11] Several existing ideas were combined and developed in this method to produce good wrought iron from cast iron in the quantities that were being demanded by the Royal Navy, whose shipyards at Portsmouth were not far away. The puddling furnace soon replaced the smaller and less economic finery hearth for the mass production of wrought iron. The second part of Cort's process was the rolling of the iron between grooved rolls to bars of usefully shaped sections. Puddled iron, then, was a form of wrought iron.

Wrought iron was a material that had been produced since at least the 2nd millennium B.C.[12] Smelted iron had been discovered as a by-product of the smelting of copper. Early wrought iron was smelted in small furnaces directly from the ore, as small lumps of solid iron containing considerable amounts of slag. To be useful, the material had to be forged hot. The Greeks showed blacksmiths at work at the forge in vase paintings (Figure 2). The iron being smithed came from the smelting furnace as a solid lump about the size of a saucer. It had a rough surface and was not a solid lump of metal but contained numerous voids filled with slag. The slag content was an essential feature of wrought iron.

Iron smelted directly in the form of small blooms was still being made in many parts of the world up to the 20th century. It could be produced in the blacksmith's forge as well as the smelting furnace. A

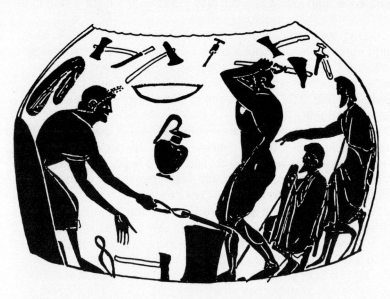

FIGURE 2. *Blacksmith at work, with an assistant and two spectators, a scene from a 6th-century B.C. amphora from Athens, now in the Museum of Fine Arts, Boston, Massachusetts (H.L. Pierce Fund).*

■ 40 ■

FIGURE 3. *Illustration of "wrought iron bars fractured to show the fibrous, hickory-like structure that is characteristic of the material."[14]*

FIGURE 4. *Illustration of "steel bars fractured to illustrate the crystalline or granular structure of the metal as contrasted with the fiberous (sic) structure of wrought iron."[14]*

great advantage of the material was that, although strong, it could be formed easily when hot. Wrought iron could also be welded to itself. Objects larger than the size of an iron bloom, such as the Roman beams, were made by welding smaller pieces together into a larger mass. The slag they contained acted as the smithing flux, dissolving surface oxides to produce a clean weld with a strong metal-to-metal bond.

Wrought iron had a long history. It was a commercial product until World War II; the last entry in the *Metals Handbook* on wrought iron appeared in 1948.[13] Traditionally, wrought iron was tested for quality by breaking it and examining the fracture. In a book on wrought iron published as late as 1939, the fracture of wrought iron (Figure 3) is compared with that of Bessemer steel (Figure 4).[14] Here we have a persuasive reason for Eiffel's specification of wrought iron rather than steel for the supporting structure of the Statue. Wrought iron, though not as strong, was less likely to fail catastrophically. This is the reason that, though Bessemer steel was quickly adopted for railroad rails, wrought iron, with very few exceptions (such as James Ead's use of chrome steel for the St. Louis Bridge in 1874), continued to be used for bridges. The photomicrograph of a sample of wrought iron that had been in service for 50 years (Figure 5) displays sets of parallel lines called slip bands. These slip bands indicate that the iron had been struck with great impact while in service, producing small movements in the metal. They are also seen in meteorites as a result of striking the earth, in armor plate struck by shells, or in anchor chain as a result of what is called "snatch." The slag stringers, which are an essential feature of wrought iron, interrupt the path of the slip bands and hence terminate the movement of the metal. The result is a tough, impact-resistant material. It took quite some time for modern steel to be developed so as to compete with wrought iron in this property.

Steel from the Bessemer converter or the open hearth was all but slag free. Its strength depended very much upon an optimum chemical composition in which strengthening elements were present and harmful ones absent. Chief among the strengthening elements in steel is carbon, but the intentional ad-

FIGURE 5. *"Photomicrograph of wrought iron which was in service for fifty years subjected to shock and vibration as well as corrosion. The parallel black lines represent the paths of slip planes, which were intercepted by the slag fibres."*[14]

dition of other elements such as manganese, chromium, nickel, vanadium, and similar elements produced a class of materials known as "alloy steels" whose development was in its infancy at the time Eiffel made his specification.[15] At that time, attention was focused on the problems engendered in steel by harmful elements, principally phosphorus.

Cort's puddling process for making wrought iron was well accepted, in part because it removed phosphorus from the iron. The presence of this element caused steel to be brittle, and such steel from the Bessemer converter was full of blowholes and undesirable for structural purposes. Production of steel on a large scale was delayed until the 1870s, and where used was highly dependent upon ores that were known not to contain phosphorus. Most ores do, however, and to deal with this problem two cousins in England collaborated on what became known as the Thomas-Gilchrist process of basic steel making. The first official blow of a basic Bessemer converter took place on April 4, 1879,[16] and the first after-blow, or continued blowing of air through the molten steel after it had been converted from cast iron, as had been suggested by Stead, took place on May 3, 1879.[17] The basic process was applied to open-hearth steel making in 1884. Thus, the improved, more reliable basic steel was not available for structural purposes when Eiffel decided upon the material for the Statue of Liberty. Instead, Eiffel, himself a bridge builder, chose wrought iron, whose properties in service were already well known to bridge builders.

Conclusion

The structural design of the Statue was innovative, but the materials chosen to realize this design were not. The 19th-century developments in steel making that ushered in the Age of Steel had not yet provided the significant improvements in the properties of steel that would eventually allow it to replace wrought iron for structural purposes. Both wrought iron and sheet copper were in use well before 1500 B.C. In its materials, the Statue stands as an example of a highly conservative technology that persisted in competition with the new alloys being developed in the 19th century.

References

1. M. Sekino, "Restoration of the Great Buddha statue at Kamakura," *Studies in Conservation*, 10(1965): pp. 30-46; K. Toishi, "Radiography of the Great Buddha at Kamakura," *Studies in Conservation*, 10(1963): pp. 47-52; T. Maruyasu, T. Oshima, "Photogrammetry in the precision measurements of the Great Buddha at Kamakura," *Studies in Conservation*, 10(1965): pp. 53-63.

2. Cyril Stanley Smith, A Search for Structure, Selected Essays on Science, Art, and History (Cambridge, MA: MIT Press, 1981), pp. 213-216.
3. R.F. Tylecote, A History of Metallurgy (London, England: The Metals Society, 1976), pp. 6-7.
4. Reported in the Scientific American, October 1885.
5. Reported in the Scientific American, June 1883.
6. An illustrated description of the procedure followed at Saugus, Massachusetts, in the 17th century is given in M.S. Clarke, Pioneer Iron Works (Philadelphia, PA: Chilton Book Company, 1968).
7. R.H. Schallenberg, D.A. Ault, "Raw materials supply and technological change in the American charcoal iron industry," Technology and Culture, 18(1977): pp. 436-466.
8. C.E. Peterson, "Inventing the I-beam: Richard Turner, Cooper & Hewitt and others," in The Technology of Historic American Buildings: Studies of the Materials, Craft Processes, and the Mechanization of Building Construction, ed. H.W. Jandl (Washington, DC: U.S. Government Printing Office, 1983), pp. 63-96.
9. An example is shown in R.F. Tylecote, The Prehistory of Metallurgy in the British Isles (London, England: The Institute of Metals, 1986), p. 166, Figure 110. Although corroded, it weighs about 250 kilograms.
10. P.T. Craddock, I.C. Freestone, L.K. Gurjar, K.T.M. Hegde, V.H. Sonawane, "Early zinc production in India," Mining Magazine Jan. (1985): pp. 45-52; I.C. Freestone, P.T. Craddock, K.T.M. Hegde, M.J. Hughes, H.V. Paliwal, "Zinc production at Zawar, Rajastan," in Furnaces and Smelting Technology in Antiquity, British Museum Occasional Paper No. 48, ed. P.T. Craddock, M.J. Hughes (London, England: British Museum, 1985), pp. 229-244.
11. R.A. Mott, ed. P. Singer, Henry Cort: the Great Finer (London, England: The Metals Society, 1983).
12. J. Waldbaum, "The first archaeological appearance of iron and the transition to the iron age," in The Coming of the Age of Iron, ed. T.A. Wertime, J.D. Muhly (New Haven, CT: Yale University Press, 1980), pp. 69-98; and From Bronze to Iron, The Transition from the Bronze Age to the Iron Age in the Eastern Mediterranean, Studies in Mediterranean Archaeology, Vol. 54 (Goteborg: Paul Astroms, 1978).
13. A.W.F. Green, "Wrought Iron," in Metals Handbook, ed. T. Lyman (Cleveland, OH: American Society for Metals, 1948), pp. 503-505.
14. J. Aston, E.B. Story, Wrought Iron, Its Manufacture, Characteristics and Applications, 2nd ed. (Pittsburgh, PA: A.M. Byers Co., 1939); illustrations on pp. 45, 46, and 62.
15. P.S. Bardell, "The Origins of Alloy Steels," History of Technology, Ninth Annual Volume, ed. Norman Smith (London, England: Mansell, 1984), pp. 1-29.
16. S.G. Denner, "The pursuit of crochets," Historical Metallurgy 13(1979): pp. 1-6.
17. K.C. Barraclough, "The setting of the stage for Sidney Gilchrist Thomas, the British steel trade 1840-1880," Historical Metallurgy 13(1979): pp. 7-10.

■ *Section II: Design of the Restoration Project*

■ *Restoring Miss Liberty: The Decision-Making Process*

E. Blaine Cliver
North Atlantic Historic Preservation Center, National Park Service, Boston, Massachusetts

The project to restore the Statue of Liberty involved many decisions. Of importance to the future preservation and appreciation of the Statue were the decisions in four main areas: the structure, the armature, the skin, and the torch flame. Keeping in mind that the primary objective of the project was the long-term preservation of the Statue for future generations, each decision was weighed against feasible alternatives, and a solution was reached. As with any decision that may affect something of public prominence, the solution will not always be seen by everyone in the same light. So it may be with those decisions affecting the Statue of Liberty. We only can show how we arrived at the decisions we made; the future will be the judge of the validity of those decisions.

Behind the garment folds and stern countenance of the Statue are the interrelated parts that make up this gigantic sculpture. The decision-making process that affected these parts was crucial to the progress of the project and directly related to the future preservation of these elements. Discussed herein are four areas for which decisions that will have a long-term effect on the Statue and that may be seen as controversial were made. First, and in some ways the most unusual of these areas, is the structural support system, comprising a central pylon surrounded by light secondary-support members. Second, and attached to this structure, is the wrought-iron armature that forms a convoluted grid of bars, similar to a woman's dress form, to which the copper skin is fastened. The copper and the iron had formed a galvanic couple that was continually deforming the Statue's skin and was leading to the eventual failure of the armature. Third, and most delicate of all parts, is the copper patina. Growth of the patina took place over a period of years; after its initial formation, the patina has continued to react and change with surrounding conditions. Fourth is the flame, which has become a symbol within a symbol. To change this part of the Statue required much thought and consideration; however, it could not remain as it was and a decision was needed.

□ Structural System

Within the copper body is the skeletal support system designed by Gustave Eiffel. This structure is composed of a rigid central core upon which a skin-supporting armature made up of iron bars, 18 by 50 mm, is attached. The central core—surrounded by a secondary, light angle-iron frame—has as its elements four iron girders composing a pylon. Eiffel's design used flat iron bars in compression to attach the armature and skin to the central structure; its rigid frame supporting a light skin represents an early example of curtain-wall construction. Acting as large, flat springs, these bars allow the copper skin and its accompanying armature to give under wind loads and thermal stress, dampening their effect.

Although Eiffel's design was found to be sound, a modification of the shoulder supporting the raised arm caused some engineering concern. The arm structure acts as a leaning or cantilevered column, resting—offset—on the central pylon. The arm structure is supported by the light framing of the secondary members. Eiffel's design retained a continuity of arm structure, secondary framing, and central pylon. When the Statue was first erected in Paris, the box truss for the arm was moved outward approximately 18 inches (257 mm). Additional members had to be added to the secondary framing, which resulted in a loss of continuity between the arm and secondary frame. This induced unanticipated stresses and bending into the secondary framing, which was designed to take only tensile or compressive stress. Whether or not Gustave Eiffel knew of or approved such changes, we do not know. However, the nature of these changes was not consistent with good engineering design, and it seems un-

■ 45 ■

likely that the design changes can be attributed to Eiffel, who would have been aware of the consequences of such an alteration.

An evaluation of this shoulder connection was made by the U.S. Army in the 1930s during a period when the Statue was under the Army's jurisdiction. This evaluation resulted in some additional members being added. During the current project the structure was re-evaluated, and it was determined that additional structural work was needed. Two alternatives were proposed as solutions: (1) removal of certain members and rebuilding the shoulder to achieve continuity and (2) addition of the required few members to obtain the same factor of safety as would be acquired in the first proposal. Although the first solution was the "cleaner" of the two, there was merit in the second. Because the original modification had taken place during the Statue's initial erection in Paris and told a story relevant to that process, the National Park Service preferred to repair and preserve the physical evidence of this modification, if possible, instead of removing and replacing it with new elements and thus losing the physical evidence of this portion of history. These minor modifications were completed and the physical story preserved.

☐ Armature Replacement

The galvanic reaction between iron and copper was mitigated originally by an ingenious insulation of the copper from the iron framework, the insulating material used being asbestos cloth (felt) soaked in shellac.[1] Over the years, through saturation with water from interior condensation and leakage, this material broke down. Because of its ability to absorb moisture, an electrolyte of soluble salts was formed. With this electrolyte in place, galvanic action began its deleterious effect on the iron. The iron, being the less noble metal, became sacrificial and lost its electrons. As this process continued, the iron oxidized and exfoliated longitudinally along piling, or fiber, boundaries. (Piling is a part of the iron-making process, in which lower-quality bars are layered with higher-quality material, all being heated and hammered together to form a material that is composed of forged layers.) During preliminary investigations for the project, this iron armature was found in some places to have lost more than half its thickness.

In preserving the Statue, stopping the galvanic action became one of the major aspects of the project. As with the original shellac-saturated asbestos, the isolation of dissimilar metals depends on the longevity of the isolating material. Not wanting to rely completely on a material whose long-term life under the conditions at the Statue was uncertain, investigation began into the use of a replacement material for the armature that would form a minimal galvanic couple with the copper and, at the same time, exhibit the elastic properties of the old armature and the flat bars. Following normal preservation policy, the replacement material was to be as close as possible to the original in physical characteristics and appearance.

Considering such parameters, mild steel, copper alloys, and stainless steel became possible replacement material. Tests were conducted, in consultation with metallurgists, to determine the reaction in a variety of electrolytes between copper and these various materials. As a result of these tests, further outside weathering tests were conducted near salt water with couples made of copper and each of five metals: type 316 (UNS S31600) stainless steel, Ferralium[†], a copper-nickel alloy, aluminum bronze, and a mild steel.[2] As expected, the mild steel showed accelerated deterioration when in contact with the copper, as had the iron armature in the Statue. The other metals showed virtually no reaction with the copper.

The action was unknown—or, more accurately, indeterminate—under wind stress and other vibration of the approximately 1800 interconnected armature bars to which the copper is attached. Therefore, it was felt that maintaining the same characteristic or elasticity was of extreme importance. Corrosion resistance in the material as well as its compatibility with copper were also of importance. However, greater strength was unnecessary. Similarity in elasticity could be achieved in two ways: using a material of the same or similar modulus, or varying the section of a material having a different modulus so that it would react in a similar mechanical way.

A parameter that affected the means of achieving a similar elasticity was the existing method used to attach the copper to the armature bar—a copper saddle about 6 inches (152.4 millimeters) long encircling the bar and riveted through the skin with 3 rivets on either side of the bar—had made a large number of holes in the skin. To avoid adding new holes, we intended the replacement saddles to be fastened in the same way, using the same rivet holes. The space between the rows of rivet holes set a limit to the width of any replacement bars. Essentially, the new bars would have to be the same width as the old ones.

[†]Trade name.

Because of this limitation, achieving a mechanical behavior similar to that of the original wrought iron, bars made of the copper alloys would have required an increase in cross-section depth (the dimension away from the skin). This increase in depth would have caused bars made of the copper alloys to weigh one-third more than the existing armature. This was considered undesirable because of possible effects from the additional weight on the structure, so copper alloys were rejected. The stainless steels were very close in modulus to the iron, so bars of that material would require no change in dimension. Under conditions similar to the Statue's interior, the stainless steel was found to have almost no reaction with the copper.[2,3] In the final solution, a stainless steel (type 316L [UNS S31603]) was selected to replace the iron of the armature based on its corrosion, mechanical, metallurgical, and fabrication properties, as well as on the preservation principal of replacing one material with a similar material. As an added precaution, a layer of Teflon[†] has been placed between the copper and the stainless steel as an electrolytic barrier. The Teflon is not intended to act as an electric insulating material, since there seems no way to prevent some contact in at least one of the hundreds of points where these different materials touch.

□ The Skin and Its Patina

Considering its years of exposure, the copper forming the main body of "the lady" is in excellent condition. Through the many holes associated with riveted seams and riveted attachment to the iron armature, the opportunity for moisture penetration has been great. Coal-tar waterproofing applied to the interior in 1911 sealed many of these points of water entry.[4] Holes punched through the copper from the interior at water-collecting points (i.e., folds in the gown, etc.) to allow moisture to run to the outside also allowed the coal-tar coating and later paintings to do so. The result has been runs and spatters of these coatings on the exterior of the skin. However, these drips, as disfiguring as they may be, are not detrimental to the preservation of the copper and affect only the appearance.

The effect of the iron armature exfoliation has been more deleterious. This galvanic disintegration of the iron was greatest at the points of attachment to the copper. Here, at the saddle fasteners, was an excellent place for the capillary collection of an electrolyte—a necessary fluid in any galvanic couple. As the iron expanded from corrosion, the force pulled a number of the rivets fastening the saddles through the copper skin. However, before the rupture occurred, pressure against the skin caused an outward bulge to be formed between the anchoring rows of rivets and an inward depression to form around the rivets themselves. Only a small percentage of the saddles had their rivets rupture the skin. A large number, though, have seen enough iron deterioration to cause considerable surface disfiguration. This disfiguration was primarily cosmetic and the copper was not reformed. To have reshaped the bulged areas would have caused damage to the exterior patina, and the original surface configuration could never have been achieved because the copper in these areas had been stretched and its surface area could not be reduced. Also, since the paint-removal process proved to be damaging to the patina, it was decided not to remove the paint and coal-tar streaks from the exterior copper surface. In time, these will disappear through weathering, and in the meantime, they are not easily seen from the ground.

Of first and foremost concern was the corrosion behavior of the copper during the first 100 years. Fortunately, a large amount of data exists on the atmospheric corrosion behavior of copper in environments near or similar to the Statue of Liberty. What these independent studies show and what we[(1)] measured is that over long exposure periods, the copper corrosion rate is 0.04 to 0.06 mils (0.0010 to 0.0015 mm)/year. These measurements of thickness loss throughout the Statue indicate no unusual degradation process has occurred. These data were obtained by ultrasonically measuring the differential thickness between areas protected by coal-tar streaks since 1911 and areas immediately adjacent to each streak.

It should be mentioned that in some areas abnormally severe corrosion of the copper occurred on the Statue. These are areas where aqueous liquid collected on the interior due to the lack of drainage. Patching of the copper was required in these locations. Skilled artisans made molds of the area to be replicated and fashioned a new piece to match.

Copper and its alloys have been used for centuries in architectural and cultural works. The stability of this metal in atmospheric environments is due to the formation of a patina on its surface. This patina serves as a protective layer, thus reducing the corrosion rate of the metal as it is formed. In industrial and marine environments, the corrosion rate for copper in the first year is up to four times greater than that in the 10th year. Between the 10th and 20th year of exposure, there is no significant change in the

[†]Trade name.
[(1)]Work done jointly with R. Baboian of Texas Instruments, Inc., Attleboro, Massachusetts.

corrosion rate of copper in these environments. During the initial years of exposure, the patina is being formed and the corrosion rate is therefore higher. However, development of the protective patina reaches a stage at which its continued formation does not affect the copper corrosion rate. Because of this characteristic, the Statue would have undergone an accelerated loss of its copper had we chosen to clean it down to "bright copper" and thus reduced its life by at least a generation. For this reason, we chose not to remove the patina nor clean the exterior, since this would affect the Statue's length of life, and we felt that it was of prime importance for the Statue to exist as long as possible.

The dynamic copper/patina system is a result of the interaction of the metal with the environment. Its thickness, composition, and appearance are therefore highly dependent on the metal composition, physical characteristics, and the nature of the environment. Although methods exist to protect copper patinas from the weathering effects of acid deposition, none of these is permanent, and periodic maintenance is therefore required. This is not possible on the Statue of Liberty because of the inaccessibility of most of the surface in the absence of the scaffolding.

We can do little at present to prevent further loss of the patina. No coating or other treatment of the exterior patina was done during the restoration because of the short life span of the products considered and the large size and inaccessibility of the Statue. However, since access to the exterior surface will be very limited once the project scaffolding is down, a program of monitoring skin thickness from accessible station points on the interior is planned. In this manner, we will be able to measure rates of copper loss over the life of the Statue, which, at present rates, should be at least 1000 years.[2]

□ The Flame

Over the past century, the Statue of Liberty has had its exterior lighted by many systems, each using the latest in lighting technology. The lighting systems that have had the greatest effect on the fabric have been those associated with the torch flame. As originally constructed, the flame was fabricated of copper in the same repoussé technique as the rest of the Statue. Displayed with the torch at the centennial exhibition in Philadelphia in 1876, the flame exhibited a solid copper surface. After several years, the torch, flame, and hand were returned to Paris. Photographs show the same flame as displayed in Philadelphia resting at the base of a half-completed Statue in Paris during this phase of construction. A photograph taken still later, when the Statue's parts were delivered to Bedloe's Island in New York Harbor, shows the flame resting at the delivery pier, its form somewhat modified from the earlier photographs.

The modifications involved the relocation of one of the salient tongues of the flame and the inclusion of what appeared to be a circular opening in the top of the flame where the tongue had been. Because of later modifications to the flame, the relocated tongue no longer exists. An obvious question arose as to whether or not the modification was a permanent one. Close inspection of photographs taken of the Statue after her completion in Paris and after her dedication on Bedloe's Island showed that the change was permanent. Inspection of the original copper of the flame (the upper half still retains much original metal) revealed evidence of this early modification; the area of copper that had surrounded the relocated tongue was seen to have been altered, as well.

The reasons for this modification are unknown. We do know that the flame remained unchanged at the base of the Statue for almost two years until the Statue was nearly complete in Paris; the relocation of the tongue would appear to have been a last-minute decision. Whatever lay behind this change, the flame's appearance was to continue to evolve. Shortly before the re-erection of the Statue in New York Harbor, two rows of holes were cut through the copper of the flame's lower half. Nine 2000-candle-power electric arc lamps were placed within, so that "Liberty" could serve as a harbor beacon for New York City. As this scheme proved aesthetically and technically unsatisfactory, further alterations were made in 1892. These consisted of removing a wide copper band from the flame's lower half, adding a lantern to the top, and, in the process, removing the previously modified flame tongue.

The hoped-for results were never quite achieved, and in 1916, under the direction of John Gutzon Borglum—the famed sculptor of Mount Rushmore—the flame was fenestrated with 250 small glassed openings, achieving its appearance at the start of the recent restoration. Within were placed several state-of-the-art, incandescent light fixtures that radiated a glow—through the panels of glass—over the surface of the flame. However, the number of joints between glass and copper remained difficult to seal, and the flame continued to leak and presented a major maintenance problem. During this century, the

■ 48 ■

[2]This calculation is based on the assumption that the skin could suffer a loss of two-thirds of its thickness before failure would occur.

greatest source of moisture penetration into the Statue was through the flame.

Because of the various alterations and deterioration, the original flame had become unstable. To repair it would have meant a total rebuilding and, in essence, a loss of the existing material. The decision, based on preserving the material, was to replace the flame and to preserve this original-though-altered relic in the museum lobby at the base of the pedestal. Accompanying the flame in the museum is the upper portion of the torch, which also has suffered greatly at the hand of time.

Naturally, the question arose as to what form the replacement flame should take. The mere reproduction of the old flame with new materials would have meant recreating a known maintenance problem. Furthermore, the original, altered flame would continue to exist on site. Consideration was given to making the new flame transparent out of either cast glass or plastic. Investigation indicated each approach to be unsatisfactory, owing to both a maintenance problem (how do you repair or replace a solid casting at that height?) and fabrication considerations. Casting glass of those proportions would have been extremely difficult within the deadline we faced. It also would add greatly to the weight resting on the arm structure. The life span of the lighter plastics, in terms of centuries, is unknown, and their use therefore became questionable.

The simplest, most watertight, and historically most appropriate solution was to return the flame to its appearance as Auguste Bartholdi created it and as it was first placed on the completed Statue in Paris. This, of course, was the copper flame without fenestrations but with the modification to the flame tongue. Research indicated that the flame had been gilded prior to 1905.[5] Therefore, a new lighting system was designed based upon a new gilded copper flame. Naturally, the new lighting scheme is an exterior one. Gleaming in the sunlight during the day, the new flame also glows at night, reflecting light emanating both from the torch balcony and from focused spotlighting on the ground.

The preceding discussion of the principal decisions affecting the Statue of Liberty is presented to help with an understanding of "why" things were done as they were. It is not expected that there will be a unanimous support for, or against, what was accomplished. Only time will be the judge of the decisions, and their validity will be measured in the experience of future generations of visitors who will continue to visit this symbol.

□ **References** ■ **49** ■

1. Scientific American, Nov. 20(1886): p. 32.
2. R. Baboian, "Atmospheric Corrosion Tests on Candidate Armature Materials" on the Statue of Liberty, Texas Instruments, Inc., Report to the National Park Service (Attleboro, MA: Texas Instruments, Inc.).
3. N. Sridhar, letter to E. Blaine Cliver, Jan. 5, 1984 (submitting Cabot Corporation report of December 12, 1983).
4. Quartermaster General Report, U.S. Army, Washington, DC (Aug. 5, 1911).
5. Civil Engineer, letter to Chief Quartermaster, Governor's Island (July 13, 1905).

Designs To Move People Through the Statue

Philippe Grandjean
Architect, Paris, France

During 1982, the National Park Service made major decisions concerning the restoration of the Statue of Liberty and at the same time requested proposals for improvements to the internal circuit of visit.

Prior to the restoration, tours were uncomfortable, even unsafe, and did not provide what was expected from such a monumental symbol. In addition, the increasing number of visitors (more than 2.5 million each year) resulted in tremendous congestion problems. To address these different issues, a complete redesign of the visitation circuit was created. The purpose of the redesign can be summarized as follows:

(a) To reconsider the internal volume, from the bottom of the pedestal to the top of the Statue itself, taking it as a single space, a huge and somewhat hieratic vertical room, a sort of "Sanctuary of Liberty" for people coming from all around the world;

(b) To match, as closely as possible, Bartholdi's original vision by demolishing recent and confusing additions (such as the concrete stairs) and enhancing the major elements of the structure and the envelope (the helical staircase, despite its discomfort, has been retained as a unique testimony to the original design);

(c) To ensure safety by a rapid access system to any point of the circuit.

The thorough archival study conducted by historian Carole Perrault did not determine whether or not the Statue of Liberty was originally intended to be visited. Nevertheless, we know that a particularly well-adorned cast-iron staircase, a portion of which has been preserved and is still visible at the balcony level, was installed a few months after October 1886; even if it gave access only to the top of the pedestal, it clearly evidences that the public was admitted very early, and further, that the fascination the Statue exerts actually appeared during its first days.

Since that time and throughout the current century, numerous additions and/or alterations to the inside of the monument were made to accommodate the increasing number of visitors: During the late 1880s, the helical staircase was assembled, giving public access to the crown and the torch platform; in the 1930s, a new elevator and concrete staircase were installed inside the pedestal. The monument's main access itself has been changed several times; the present configuration, including the paved promenades surrounding the bottom of the pedestal, dates from the construction of the American Museum of Immigration. At that time (1965), a new visitor circuit was designed, including a new elevator.

Despite all these improvements, visiting the monument during the summer in 1981 was difficult, even unsafe, because of congestion problems (the peak summer frequency had increased 70% from the peak 10 years earlier), which severely lessened the interest and enjoyment of the experience (Figures 1 and

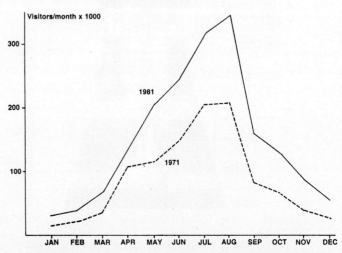

FIGURE 1. *Increase of frequentation between 1971 and 1981.*

FIGURE 2. *Congestion problems at the balcony level.*

2). The necessity of the restoration itself gave the opportunity to reconsider the overall visitor circulation system inside the monument.

The first attempts to improve the Statue concerned the interior, where the main causes of congestion were located. A complete survey had to be made to support the investigations, because no available documents were found (thanks to the survey, we discovered that the secondary frame had not been built in accordance with the original drawings by Gustave Eiffel). The options studied included a new stair system, winging through the frame of the Statue, or a glass-enclosed "inclinator," these proposals requiring only some minor changes in the original structure.

In fact, a visitor flow analysis proved that the limiting capacity factor was the length of time visitors spent on the crown platform to recover from the exhausting climb in the helical stair and to obtain the best outside view. Also, we determined that only 25% of visitors made this climb to the crown and that the experience of *ascending* to the crown was recalled, rather than the view.

Because we could not enlarge the head or the passage through the neck, we decided to preserve and rehabilitate the circular iron stairs. In so doing, we could not increase the rate of visitation to the crown, which would have solved the congestion problems inside the pedestal. We had to give a new interest to the interior of this pedestal, to keep a number of visitors from feeling frustrated by not being able to ascend to the crown (Figure 3).

□ **The Visit to the Monument**

Let us follow a visitor entering the fort by the main entrance on the west side. The stepped wall, just behind the old illuminated torch relocated to the center point of the lobby, reveals the original concrete foundation, which constitutes the lower pedestal, previously hidden by the museum additions (Figure 4). A somewhat hieratic opening gives access, through a monumental wing of stairs, to the rediscovered, original vaulted galleries that were the main entrance to the monument in the 1890s. Inside

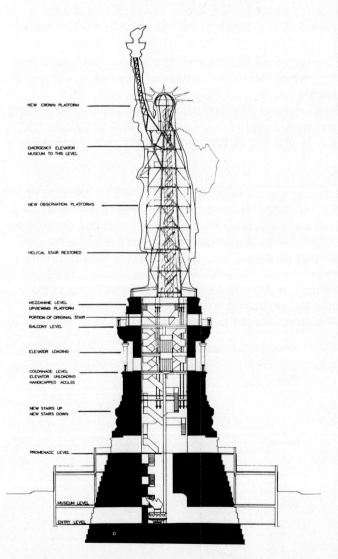

NEW CROWN PLATFORM

EMERGENCY ELEVATOR
MUSEUM TO THIS LEVEL

NEW OBSERVATION PLATFORMS

HELICAL STAIR RESTORED

MEZZANINE LEVEL
UPVIEWING PLATFORM
PORTION OF ORIGINAL STAIR
BALCONY LEVEL

ELEVATOR LOADING

COLONNADE LEVEL
ELEVATOR UNLOADING
HANDICAPPED ACCESS

NEW STAIRS UP
NEW STAIRS DOWN

PROMENADE LEVEL

MUSEUM LEVEL

ENTRY LEVEL

FIGURE 3. *Design options for the new circuit of visits.*

the core of the pedestal, a pure and hard simplicity in lighting and materials reigns: The visitor is seized by this "sanctuary-like" space and put into the right frame of mind for the visit. A glance through the east and south galleries reveals the new museum. There, the visitor has a choice of taking the elevator up to the colonnade level or using the new stainless steel stairs.

Let us take the stairs: A narrow shaft suddenly opens at the promenade level, on the out-of-scale internal volume of the pedestal, 89 feet (27.4 meters) high by 27 feet (8.2 meters) feet wide. Plunged in a mild darkness, only the highlighted anchoring structure appears. The impression is overwhelming. The aerial metallic stairs rise up or down, reminding us somehow of the spectacular drawings of the architect and artist Giambattista Piranesi.

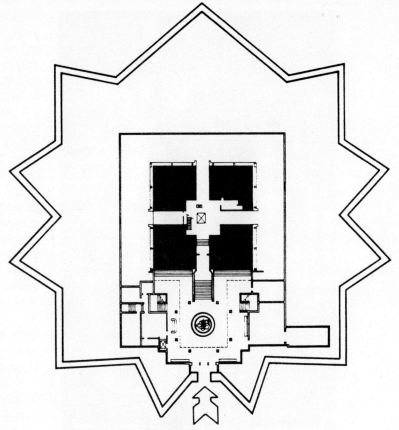

FIGURE 4. *Entry level.*

■ **53** ■

□ The New Stairway in the Pedestal

Since the 1930s, this absolutely unique space had been obliterated by heavy concrete stairs and floor slabs, as well as an enclosed elevator and various unaesthetic items such as conduits and heaters (Figure 5).

The idea to remove all of this, to rediscover the original anchoring shaft in its original integrity and then to design an aerial, metallic stair system, respectful of the walls, the tie-rods, and the dunnage beams, came to us some time before the archives research indicated that an elegant, adorned, cast-iron stairway had been installed in 1886 and 1887, at the Statue's beginning. This seemed a magistral confirmation of the validity of our design concepts.

According to these concepts,

FIGURE 5. *Additions and alterations inside the pedestal.*

the anchoring structure is used as a guideline all along the ascension in the pedestal and as a meaningful transition to the Statue itself. The dunnage and the tie-rods are highlighted by specially designed fixtures, in contrast to the relative darkness of the shaft. Low-intensity step lights guide the ascension (Figures 6 and 7).

The rhythm of the stair flights is based upon the harmonic proportions of the internal space (Figure 8). We discovered that the pedestal had been designed according to the Golden Ratio.[1] Our study revealed that the vertical axis of the Statue is offset from the symmetry axis of the pedestal by the exact value of this ratio, and that the same is true for the lateral side. (This offset was probably intended to give a more intense "movement" to the body and to avoid too tight a relationship between the Statue and its socle.)

[1] The perfectly balanced proportion used by the ancient Greeks for their temples.

FIGURE 6. *Highlighting of the tie-rods.*

FIGURE 7. *The new stairway into the anchoring structure.*

Back to our ascending visit: At the colonnade level, a platform allows the visitor to rest while giving an outside view through the colonnade. The edges of this platform are 1 foot (0.0348 meter) distant from the concrete wall, to preserve the continuity of the internal space.

After a few more steps, we enter the balcony level of the pedestal. The new design, clear and simple, eliminates the previous and numerous conflicts. The visitor circuit includes the external balcony, where the view is splendid, and, after a few steps, the mezzanine level (Figure 9). From this platform, located in the Statue itself, the view above is quite impressive. The overall internal volume, spectacular in its dimensions, its folds, the rhythm of the armature system, and the aerial secondary frame, can all be appreciated from the mezzanine, leaving a great impression even if the visitor does not continue the climb to the crown.

Each platform in the continuing climb, including the mezzanine, gives the possibility of joining the "down stream" for the exhausted visitor, or in case of congestion above.

□ The Ascension to the Crown

Preserving the helical stair for climbing into the Statue necessitated particular attention to its restoration: Sharpened handrails, slipping steps, and the iron balustrade had to be replaced (Figure 10). A new handrail on the right was added downstairs. The two old rest platforms, in poor condition, were removed and replaced by four new ones designed to give more rest and observation opportunities (Figure 11). Each is accessible by a two-person-occupancy emergency elevator, which can access every location in the circuit from the entry level to just below the shoulder platform (Figure 12).

Everything possible has been done to improve the experience and the comfort of the visitor, including removal of the wire-mesh cages, highlighting of the structure and the envelope from invisible fixtures running along the pylon corners, and supplying fresh air from ventilation ducts discreetly located behind the pylon (Figure 13).

The crown platform has been totally redesigned to avoid conflicts between moving and stationary visitors (Figure 14). Because of the inversion of up and down flights, the skyline of Manhattan is now seen first, giving a strong impression to the ascending visitor arriving in the bright light of the crown. The windows have also been redesigned. In summertime, the crown space is ventilated through the central shaft of the stair.

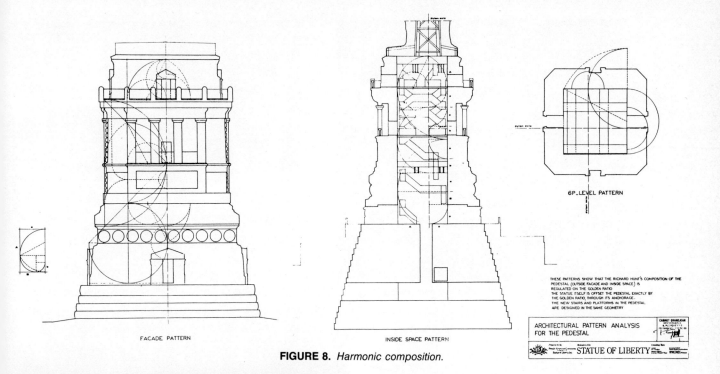

FACADE PATTERN

INSIDE SPACE PATTERN

6P LEVEL PATTERN

THESE PATTERNS SHOW THAT THE RICHARD HUNT'S COMPOSITION OF THE PEDESTAL (OUTSIDE FACADE AND INSIDE SPACE) IS REGULATED ON THE GOLDEN RATIO.
THE STATUE ITSELF IS OFFSET THE PEDESTAL EXACTLY BY THE GOLDEN RATIO, THROUGH ITS ANCHORAGE.
THE NEW STAIRS AND PLATFORMS IN THE PEDESTAL ARE DESIGNED IN THE SAME GEOMETRY.

ARCHITECTURAL PATTERN ANALYSIS FOR THE PEDESTAL

STATUE OF LIBERTY

FIGURE 8. *Harmonic composition.*

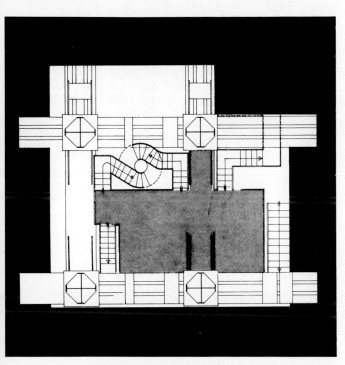

FIGURE 9. *Mezzanine level.*

□ The Elevators

Coming back to this circuit of the visitor: Clearly, a single-stair system was not sufficient to accommodate the expected frequency of visitation. A high-capacity elevator was required, but it had to be in accordance with our design concepts, based on a spatial continuity and transparency, which became a challenge. After considering the available options, the following design was selected: glass-enclosed (for a maximum view); double cabin (to avoid congestion when getting in or out); hydraulic technology (to avoid noise and pulleys); exposed shaft (rather than enclosed; glass panels are located where necessary on the railings); and accessibility to the handicapped. The lighting fixtures, inserted all around the cabin, provide gentle illumination during the elevator course.

Visitors taking the elevator at the base get out at the colonnade level. From there, they can climb a few steps to the balcony level and, if they do not choose to climb to the crown, take the elevator down at an intermediate level, then discharge at an upper museum level.

Persons with a handicap have easy access to the colonnade and can experience the ascension to the crown by watching TV monitors in the lobby. As mentioned above, the security system includes, in addition to a sophisticated TV-surveillance network, a two-person occupancy emergency elevator giving immediate access to any point on the circuit.

❑ Our Visit Comes to an End . . .

We dare believe that these new designs will help people to keep strong and meaningful impressions of the Statue, ones by which the Statue of Liberty may even more "enlighten the world."

■ 55 ■

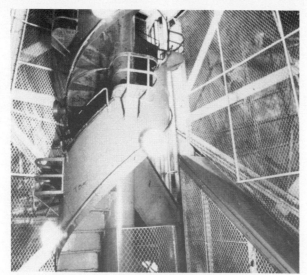

FIGURE 10. *The helical stairway imprisoned.*

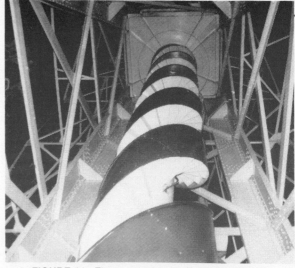

FIGURE 11. *The new stairway after restoration.*

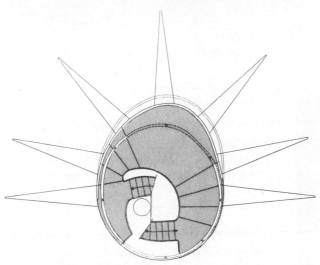

FIGURE 12. *The plan of the crown's platform.*

FIGURE 13. *Inside the Statue: an unforgettable experience.*

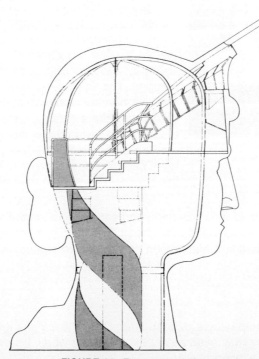

FIGURE 14. *The crown platform section.*

■ *An Engineering View of the Statue of Liberty*

Edward Cohen and Pasquale DiNapoli
Ammann and Whitney, New York, New York

The original structural system—its material design, analysis interim, and current modifications and renovations—is described as affected by changes in state-of-the-art engineering in the past 100 years. Also described are some aspects of the new electrical, heating, ventilation, and cooling systems.

❑ Original Structural System

Earlier monumental works in copper repoussé (the technique of hammering a design in relief) supported on an iron framework relied on filling the inside with a mass of masonry for its structural stability. An example of this design is the colossal statue of St. Charles Borromeo constructed near Aroma, Italy, in 1697.

For the Statue of Liberty, Alexandre Gustave Eiffel designed a unique system consisting of a rigid central pylon and secondary frame supporting the copper skin and iron armature through an assembly of sliding and articulated elements that permitted the Statue to "breathe" under thermal and wind loadings. The resulting structure permitted visitor access to the interior.

The structure was analyzed by Eiffel using a force polygon, which was state of the art at the time. His results compared favorably with the results obtained using modern computer-age technology. The foundations for the structure were designed by Charles P. Stone, chief engineer for its construction.

❑ Problem Identification

The first phase of the restoration program required a comprehensive survey and investigative program to identify the problems. This necessitated detailed field and laboratory studies, including measurements of wind effects; measurements of stresses, displacements, and frequencies and accelerations of the structural elements; metallurgical studies to determine the properties and condition of the existing materials, including fatigue properties; and comprehensive structural analyses, both static and dynamic, requiring extensive use of computers. This included a unique fatigue analysis of the structure to determine the life of the Statue consumed in the past 100 years and to predict the remaining life of the structure.

Because the original design documents prepared by Eiffel were lost in a fire in Paris, the field studies included detailed measurements of the structure to redocument the original construction.

❑ Scaffolding

To gain complete access to the entire structure, interior and exterior scaffolding was designed and erected by Universal Builders Supply, Inc. (Mount Vernon, NY). Because the Statue is unique and irreplaceable, the scaffold was designed for 100-year wind-recurrence velocity. The resulting scaffold was an innovative and extraordinary structure and became the tallest free-standing scaffold ever constructed.

❑ Armature

Although Eiffel was aware of the problem of galvanic corrosion between dissimilar metals and an attempt was made to insulate the copper skin from the iron armature, the solution was unsuccessful, and the armature was severely deteriorated, requiring a complete replacement.

Extensive studies were performed under the direction of the National Park Service to determine the structural suitability of the various options and to select the most suitable materials to replace the arma-

■ 57 ■

ture. Copper seemed a natural substitute to resolve the corrosion problem; however, in duplicating the structural properties of the armature in copper, the weight of the armature increased appreciably. A ferrous material was required to obtain the proper structural characteristics without a weight increase. Type 316 (UNS S31600) stainless steel was selected for the armature replacement.

Special fabrication procedures were developed, including a procedure for passivating and annealing, to retain the corrosion-resistant properties of the material. To ensure protection from galvanic corrosion, Teflon[†] tape was used to electrically insulate the copper skin from the armature.

□ Structural Repairs

The extensive structural studies disclosed that the major problems with the structure of the Statue were the shoulder, the head arches, and the looseness in the anchorage. The shoulder and head arch problems have existed since the Statue was constructed, a result of the misalignment of the head and shoulders from the originally designed positions, which created flexibility and over stresses in these areas. Several attempts to repair these areas had been made in the past but were unsuccessful. The solutions developed and implemented under the renovation program will ensure a life expectancy at least equal to that of the main pylon.

The architectural configurations for the new stainless steel stairways in the pedestal presented interesting and challenging structural problems that required innovative design solutions. To resolve the looseness in the anchorage, a special apparatus was developed to facilitate the retensioning operation. Unique structural systems were designed to incorporate intermediate rest platforms at vertical intervals inside the Statue and a new crown platform for improved circulation.

The manner in which the mass concrete in the pedestal structure was placed, using lifts of 6 inches to 12 inches in thickness, resulted in numerous "cold joints." These cold joints tended to delaminate when areas of the pedestal were excavated in the past. The present program called for the restoration of these areas to their original configuration and texture. A system was designed to stabilize and reinforce the delaminated areas to ensure their structural integrity.

□ Museum Modifications

■ 58 ■

The renovation program included a new museum of "The Story of the Statue of Liberty" to be incorporated into the structure surrounding the pedestal; that structure was built in the 1960s to house the Museum of Immigration and ancillary spaces. Among other changes, the new museum program called for the removal of critical columns to expose the original concrete of the pedestal and to enlarge the open spaces within the entrance lobby.

Because of the schedule constraints to reopen the Statue to visitors by July 4, 1986, the column removals had to be accomplished without the aid of scaffolding or temporary supports to avoid any impediment to the ongoing construction. To achieve these goals, unique and innovative structural systems were developed to transfer the loads from the existing structure, without harmful deflections, before the column removals were performed. Other structural problems were encountered, especially difficulties resulting from poorly documented structural changes that occurred during the original construction of the museum areas.

□ Mechanical and Electrical Systems

A unique HVAC[†] system directing tempered air to the spiral staircase and the crown platform of the Statue provide significantly improved comfort to the visitors without the necessity of air conditioning the entire Statue, a difficult if not impossible task considering the ability of the copper skin to transmit heat.

Modernized lighting, security, and fire-protection systems add significantly to the safety of the visitors. Special lighting effects, both interior and exterior, were also developed to highlight the historical characteristics and structural features of the Statue and its pedestal.

[†]Trade name.

■ *Seeing Liberty in a New Light*

Howard Brandston, FIES, FIALD
H.M. Brandston & Partners, Inc., New York, New York

This paper describes the problems faced in creating natural and appropriate lighting for the centennial restoration of the Statue of Liberty. Specifications are described for the two new types of metal halide lamps and reflector units produced by General Electric (prepared by H.M. Brandston & Partners, Inc.), and used to light the Statue's green patina exterior. The placement of these units and those used to illuminate the newly gilded torch are illustrated, and the projected life of the lighting units and their energy usage is discussed. The lighting composition of the interior is reviewed from the visitor's point of view.

□ Initial Challenges

Each year, our firm undertakes between 75 and 100 major lighting projects and specifies millions of dollars worth of lighting equipment. Usually, however, only a small part of our lighting designs require custom-made equipment, perhaps five percent. Once our firm began the task of relighting the interior and exterior of the Statue of Liberty, we immediately faced a number of problems that could only be solved by designing new light sources and equipment.

Usually, if the object or place to be lighted exists, it is used as a full-sized mockup to test lighting ideas. We visited the monument in November 1983, before it was shrouded in the scaffolding that would stay in place for the two years of the enormous restoration project. Every section of folds in the robe and every part of the pedestal and fort at its base were photographed from the island, from bridges, from buildings, and from highways near the harbor. We made precise angle and location measurements from every spot on the island that could serve as a location for lighting equipment. We tested different lamps and fixtures alone and in combination on various parts of the Statue. And we tested a sophisticated computer simulation of the Statue that allowed us to vary colors and see on the computer's screen how the Statue would look with lights focused on its different points and from different angles. Thus, we had an extraordinary opportunity to compare what the computer showed us and what our on-the-spot investigation of actual lighting effects produced.

■ 59 ■

□ History of the Statue's Lighting

The official name of this great monument is *Liberty Enlightening the World*. Through out much of its history, however, the hopes of those charged with lighting this great lady were limited by the existing technology. At the time of the Statue's original dedication in 1886, light was supposed to stream from her crown. The construction engineer suggested bright lights at the pedestal, too. Holes were cut in the copper sheeting of the torch and lamps were installed inside, but nothing worked well. The light from the pedestal caused a shadow that obscured the Statue's shoulders and head; the base lights failed to illuminate the monument. When Auguste Bartholdi visited his work in September 1893, he expressed great disappointment with the lighting and suggested that the solution might be to gild the entire Statue. The vision was not fulfilled. Today, technology can match the task to the dream: We were able to make the Statue look good when lighted.

□ Washing the Monument in Light

What did that simple goal—make it look good—mean? To us, it meant that the lighting must reveal this work of art, give it form, maintain its dignity, and compose its setting in the harbor. From the outset, the plan was to restore the Statue's majestic presence in the great New York Harbor. When the Statue of Liberty was erected 100 years ago, the harbor shoreline was dark. Few lights reflected in the water around the island on which Liberty stands. Even though the monument's lighting never satisfied sculptor Bartholdi's conception of what it should be, the tall figure was undoubtedly the brightest and most prominent object in the dark waters of the harbor. In recent years, however, the brightly lit skyscrapers on

the lower Manhattan shoreline have diminished the Statue's presence.

The solution to this problem was not to create a lighting *tour de force*, to flood Liberty in a blaze of light and have her loom suddenly out of the water's darkness. This historical monument, so important to America as a nation of immigrants, was not destined to be lit like a Hollywood spectacle. Instead, the Statue had to be a powerful welcoming presence—a light in the window at home. Therefore, the design was intended to wash the monument in light that would gradually grow brighter from the lowest level, at the base, to the highest level, at the crown and torch. This lighting design would anchor the Statue in the harbor and also draw the eye upward, enhancing the monument's height. In keeping with the dignity of the monument, the nighttime illumination was designed to recreate the natural quality of daylight.

This posed a major problem. We quickly discovered that no existing lamps could create the realistic effect we wanted to achieve on the intricate folds of the green patina surface. What was available made the figure look either too dramatic or too muddy. So we began working with scientists and engineers at General Electric to create precisely the lamps we needed.

□ Duplicating Daylight

To duplicate what happens in natural daylight requires a lamp with a warm color to illuminate the highlights of the sculpture and a second, cooler-colored lamp to fill in the folds and shadows. The lighting fixture also had to be capable of very precise focusing so that light could be exactly spotted either on the outer edge of a fold or in its depths. Furthermore, all these lamps, reflectors, and ballasts had to be designed to meet the National Park Service requirements for trouble-free, low-cost maintenance, and had to survive on an island swept by urban and industrial pollution as well as a corrosive salt atmosphere. This General Electric technological donation was the critical ingredient in the success of our design.

The lamps selected to do the job were metal halide arc lamps, chemically and structurally complex lamps invented by Gilbert Reiling, Ph.D., in 1962 and first used in a public space at the 1964-65 New York World's Fair. One of the great advantages of metal halide lamps is that they can be made to produce a wide range of colors. In an ordinary incandescent bulb, light comes from a glowing solid filament. In a metal halide lamp, gas plays the role of a filament. Compounds of metals (zinc, sodium, thallium, indium, scandium, and others) with a halogen are charged by electrodes, which excite the atoms as the temperature in the arc approaches 9000°F (4982°C). [As a point of comparison, steel melts at 4900°F (2704°C).] The halide molecules evaporate and decompose, emitting light. Then they recombine, are charged, and continue the process again, within a small quartz discharge tube that is sealed in an outer glass bulb. Mixing different halides and changing the shape of the arc tube alters the color of light emitted from the lamp.

Metal halide lamps are a good performance, low-maintenance product. They require very high-purity ingredients, precision in drawing the quartz arc tube, high-quality electrodes, and good distribution of the metal halide throughout the lamp when in use. The design of the outer jacket is also a very important factor in maintaining performance. General Electric's experts anticipate that the lamps used in this installation will last two to three years and recommend that they be replaced then as a group. The color is expected to remain stable during the useful life of the lamp.

A lamp's color is measured in degrees Kelvin (K): the higher the Kelvin, the cooler the light; the lower the Kelvin, the warmer the light. The cool lamps designed for Liberty are 5200°K, and the warm lamps are near 3800°K. (As a point of comparison, the warmer light of a standard incandescent bulb is approximately 2850°K.) Liberty's specially designed lamps are rated at 250 watts, with an initial light output of 20,000 lumens.

As a very important part of this lighting design, the reflector of the floodlight unit was given high optical efficiency by a double-polished, high-purity aluminum reflector that can be focused to project a high-intensity, narrow beam of light of over one million candlepower. To keep the reflector surface from getting dull and losing its efficiency, it was given a thin glass coating, and the air entering the light unit was charcoal filtered. During operation of conventionally designed lighting units, moving air eventually deposits dirt on the optical surface. In Liberty's units, the filter traps the dirt before it reaches the inside surface.

The intense, narrow beam was specified so that each part of the Statue could be specifically lighted. We also did not want light to spill beyond the surface of the Statue. The focus is so accurate that light can be directed to any specific small area of the monument's surface, e.g., a hand or a front surface of the book.

The new lighting system is very efficient. Only 40 lamps of 250 watts each are used to light the entire body of the Statue. The units are installed in five ground-level pits at the island's edge for proper angle and direction of focus. The yearly power bill for the entire installation was expected to be about $6000 a year, compared with about $20,500 a year for the system it replaced.

☐ Gilding the Torch and Lighting the Crown

Bartholdi's proposal to gild the statue was finally adopted for the torch during the centennial restoration project. Illuminating the torch has been a problem from the start. Until 1916, the torch barely glowed. The 1916 reconstruction produced the torch most of us remember: yellowish cathedral glass inserts in the copper, held together by a puddled iron frame and lit from within. The old, weakened torch structure has finally been removed and rests in the museum at the base of the monument.

Gold foil was draped over parts of the old torch before it was removed, so that various ways of lighting it could be explored. Once again, the solution required two types of lamps. Sixteen 250-watt Tungsten Halogen PAR[†] lamps were tucked under the railings of the torch base. On the ground, 42 120-watt, 6-volt, very narrow spot lamps (the same lamps used to monitor the clarity of air on airport runways) throw narrow beams of light upward to the torch.

Originally, an old industrial fixture hung from the crown of Liberty, lighting the space within where visitors peered out of the crown windows. During the restoration project, a copy of the original lighting fixture, which was visible in old photographs, was made out of brass and reinstalled. To intensify the light at the top of the Statue, four 1000-watt PAR 64 medium flood lamps were fastened inside the back of the head and directed so that the light streams directly out through the windows.

The solution for the exterior lighting of the Statue of Liberty was one of the most daring we have ever undertaken. In retrospect, the requirements of new lamps of such low wattage and fixtures of such high intensity, located in huge immovable pits, has made us aware of the special feats achievable when the inspiration comes from a source as powerful as the Statue of Liberty.

☐ Lighting the Interior and the Pedestal

The great engineer Gustave Eiffel designed Liberty's structural skeleton, and it served as a model for many of America's earliest skyscraper engineers. Lighting the interior to detail the intricacy and beauty of its internal structure was a major goal of this restoration project. The work was accomplished using long-life, incandescent and fluorescent lamps, luminaires, and ballasts that were currently available and did not have to be custom designed. However, some of the fixtures and mounting devices had to be specially built.

The entire monument, both sculpture and structure, rests on a pedestal designed by the American architect Richard Morris Hunt. This pedestal is the entry portal to the interior and to the goal of the many visitors: to ascend to the crown and enjoy the view of the sea and Manhattan Island.

Visitors to the restored Statue of Liberty have a newly designed circulation system in which to take their journey to the top. There are new stairs and an elevator to take them to the double-helix staircase that leads to the crown and the view of New York Harbor. Upon entering the Statue, the pedestal is dimly lit and the trip up through the space is a celebration of the structural work of Eiffel with each level of ascent getting brighter until daylight is seen through the crown windows. Each structural feature, including the beams, joinery, and bolts is highlighted to bring clarity to the support and flexibility of movement that has kept this monument erect and firm, bending with the winds and storms for a century. All the folds and intricacies of the sculpture are revealed.

Our goal was to reward those expending the energy to make this ascent with a solid understanding of the effort and genius that went into creating this gift from France—this symbol of freedom to the world. And it has taken the most modern of 20th-century lighting technology to finally realize the dream Bartholdi had more than 100 years ago: a massive monument to "liberty enlightening the world."

■ 61 ■

H.M. Brandston & Partners, Inc. lighting design team for the Statue of Liberty:
Howard Brandston, Principal
Gene Stival, Associate-in-Charge
Chou Lien, Associate—Production
Thomas Thompson
Markus Earley
Alexander Radunsky
Daniel Lotten
S. Kelly Shannon

Special thanks to the General Electric Company staff:
Ralph Ketchum
Peter Von Herrmann
Dr. Gilbert Reiling
Mary Beth Gotti
Ron Paugh

[†]Trade name.

16 — Q250 PAR 38 FLOOD UPLIGHTS ON BALCONY

42 — 120 PAR 64 LOW VOLTAGE ACCENT LIGHTS FROM
LIGHTING PITS AIMED AT TORCH

12 — Q150 PAR 38 FLOODS LIGHTING INTERIOR OF ARM

1 — 150 WATT A21 IN REPLICATED INDUSTRIAL FIXTURE

4 — Q1000 PAR 64 MFP LAMPS IN BACK OF HEAD
LIGHTING UNDERSIDE OF DIADEM, INTERIOR OF
HEAD AND WINDOWS

8 — Q150 PAR 38 FLOODS LIGHTING INTERIOR OF BOOK
AND STRUCTURE

150 — TWO LAMP FLUORESCENT CHANNELS MOUNTED TO
THE OUTSIDE OF MAIN SUPPORT PYLON LIGHTING
INTERIOR OF SKIN AND STRUCTURE

■ 62 ■

LOW VOLTAGE ACCENT FIXTURE IN STAINLESS
STEEL HOUSINGS LIGHTING TOP AND UNDERSIDES
OF DUNNAGE BEAMS, TIE RODS AND ANCHORAGE
THROUGHOUT PEDESTAL

3 — 175 WATT METAL HALIDE WALLWASHERS PER
COLONNADE

DOUBLE DECK HYDRAULIC ELEVATOR—INTERIOR
LIGHTS DIM DOWN WHEN ELEVATOR MOVES;
EXTERIOR LIGHTS DIM UP AS ELEVATOR
ASCENDS OR DESCENDS.

40 — 250 WATT METAL HALIDE FIXTURES WITH 2
DIFFERENT LAMP TEMPERATURES IN FIVE PIT
LOCATIONS—SEE SITE PLAN

LOW VOLTAGE STRINGER LIGHTS—ILLUMINATING
ALL PEDESTAL STAIRS

2 — Q1000 PAR 64 PER SIDE
LIGHTING PEDESTAL

2 — Q250 NARROW BEAM FIXTURES TO
HIGHLIGHT SHIELDS AND BALCONY

1 — Q250 WIDE BEAM
FIXTURE PER SIDE
OF FORT

Ⓐ SECTION LOOKING WEST
SCALE ⁵⁄₃₂" = 1'-0"

Restoration of the
STATUE OF LIBERTY

French-American Consulting Team

France
Architect
G. Ph. Grandjean
Engineers-Advisers
J. Levron, J. Moutard, P. Thesin

U.S.A.
Architect
Swanke Hayden Connell Architects
Associate Architect
The Office of Thierry W. Despont

Special Consultant:
Structural Analysis
CETIM
Engineers
Ammann and Whitney

■ *The Statue of Liberty Exhibit*

Gary G. Roth
National Park Service, Harpers Ferry, West Virginia

F or the first time, the Statue of Liberty has a major permanent exhibition devoted to its history and symbolism. This paper will outline the scope of the exhibit and discuss the process by which it was designed. The point of view is that of one who was intricately involved in the process as a member of the interpretive planning team that conceived the idea and as the National Park Service project manager responsible for the development and implementation of interpretive media at the Statue of Liberty.

□ **From Concept to Design**

The idea for a major permanent exhibit on the history and symbolism of the Statue of Liberty first emerged in an interpretive prospectus issued by the National Park Service Interpretive Design Center at Harpers Ferry, West Virginia. The document called for an exhibit on the history of the Statue, from its inception in France to its realization in the United States, and the symbolism of the Statue as an evolving national and international symbol. The document also suggested a number of specific ways in which the themes might be presented. Among those eventually incorporated in the exhibit were the following:

(a) Video programs about the repoussé (hammered copper) process and the Statue as a symbol;
(b) Replicas of sections of the Statue made in the same way as the original Statue;
(c) A scale model of the entire Statue; and
(d) The exhibition of portions of the Statue removed during the restoration.

To design and produce the exhibit and those on neighboring Ellis Island and at Castle Clinton (the New York embarkation point for both sites), the National Park Service turned to the private sector. This approach was chosen for a variety of reasons, including the sheer magnitude of the task, the already heavy workload of the National Park Service's own design and production facility at Harpers Ferry, and the fact that the funds for the project were donated as a result of a high-profile, private-sector fund-raising effort. Following an exhaustive evaluation of 16 proposals submitted in response to a nationwide request for proposals (RFP) and site visits to the principal design and production facilities of six finalists, the National Park Service selected MetaForm/Rathe/D&P—The Liberty/Ellis Island Collaborative.

With combined exhibit budgets for the Statue of Liberty, Ellis Island, and Castle Clinton of over $16 million, the contract with the Collaborative is the largest exhibit contract in National Park Service history and the largest project contract managed by the National Park Service.

A number of challenges awaited the Collaborative. These included creating a permanent exhibit rather than a temporary one with a limited life span; providing optimum access for the disabled; developing the exhibit in a severely limited space, and operating within a complex political and organizational framework on an extremely tight time schedule.

The Collaborative's design for the exhibit developed in several phases following the issuance of the National Park Service's first work directive on March 18, 1985. The first and most basic phase was primarily devoted to research and culminated in a preliminary plan view and sketches that provided an early glimpse of the still-developing exhibit. Next, the designers created working models, first on a scale of 3/8 inch = 1 foot (10 millimeters = 0.3048 meter) and later on a scale of 1-1/2 inches = 1 foot (38.1 millimeters = 0.3048 meter). Finally, during the technical design phase, mockups of two typical elements provided one last opportunity for National Park Service comment and for the Collaborative to make necessary adjustments before production and installation.

FIGURE 1. *An early sketch of the replica of the Statue's face at the entrance to the exhibit. The project team hoped that replicas such as this would help visitors with visual and mobility impairments to understand the colossal proportions of the Statue.*

FIGURE 2. *Visitors are encouraged to touch the replica of the Statue's face. Standing 8 feet (2.4 meters) high, her nose is 4-1/2 feet (1.4 meters) long, her mouth 3 feet (0.91 meter) wide, and her eyes 2-1/2 feet (0.762 meter) across (photo by Alan Shortall).*

□ Visiting the Exhibit

The first visitors entered the Statue of Liberty exhibit on July 5, 1986, fewer than 16 months after the beginning of the basic design phase. Visitors gain access to the exhibit by taking the stairs from the lobby to the second floor of the museum within the Statue's base. Visitors with a disability may use an elevator. Visually impaired visitors may borrow from the lobby information desk an audio cassette containing a richly narrated description of the Statue of Liberty exhibit and a cassette player.

Before leaving the lobby, visitors may examine a tactile map of Liberty Island. The map is on a scale of 1 inch = 40 feet (25.4 millimeters = 12.19 meters) and sits on a 30-inch (762-millimeter) platform with a rounded edge accessible from all sides by wheelchair. The map allows persons with a visual impairment to understand the relationship of the Statue to its environs through the sense of touch.

Visitors may also view a video program that shows the trip to the Statue's crown from the lobby. The program provides an alternative experience for those who cannot or do not wish to make the trip themselves. The lobby's most prominent feature is the Statue's old torch, removed during the restoration. A small exhibit describing its evolution is located on the second floor mezzanine and may be viewed before or after visiting the Statue of Liberty exhibit.

Visitors proceeding to the exhibit enter through a dimly lighted, granite-walled chamber (Figure 1). Dominating the wall opposite the bronze entrance doors, and indeed the space itself, is a brightly lighted, full-scale copper replica of the face of the Statue of Liberty. Visitors are encouraged to examine the gleaming face closely. Standing 8 feet (2.4 meters) high, her nose is 4-1/2 feet (1.4 meters) long, her mouth is 3 feet (0.91 meter) wide, and each of her eyes is 2-1/2 feet (0.762 meter) across. Produced by the French metalworking firm Les Metalliers Champenois (Reims, France), this face and an exact replica of the Statue's left foot, which appears later in the exhibit, were crafted by the same repoussé technique used to create the Statue itself (Figure 2).

Leaving the replica of the face, visitors enter the main exhibit space. The exhibit addresses the two themes outlined in the interpretive prospectus—history and symbolism. Each of these broad themes is further divided into discrete topical units that may be viewed in sequence or individually. Formerly used for offices and other purposes, the area occupied by the exhibit is shaped like an inverted "U." As one looks down any of the three corridors, the wall to the right is the core wall; the wall to the left is the perimeter wall. The distance between the two walls is only 21 feet (6.4 meters), and the ceiling throughout is no more than 8-1/2 feet (2.6 meters). Each of the three corridors is approximately 120 feet (36.6

meters) long. The entire space is carpeted with a low-pile carpet and the narrowest passage is 4-1/2 feet wide—more than sufficient to accommodate a wheelchair.

The following label introduces the historical section:

The Statue of Liberty is more than a monument. She is a beloved friend, a living symbol of freedom to millions around the world. This exhibit is her biography. It is a tribute to the people who created her, to those who built and paid for her, to the ideals she represents, and to the hopes she inspires.

Most of the exhibits in this section are located against the perimeter wall (Figure 3). The comparatively lighter treatment of the core wall provides space for the free flow of visitor traffic. The titles of the various divisions of the historical section are screened on a continuous overhead panel, and titles of the topical units within these divisions and

FIGURE 3. *From the replica of the Statue's face, visitors are drawn to the historical section of the exhibit. Most of the elements in this section were constructed against the perimeter wall to allow for the free movement of visitors through this portion of the exhibit (photo by Alan Shortall).*

the major theme statements for the exhibit are screened on the wall. Object and graphic labels and anecdotal information appear on a continuous caption bar that runs the length of the historical section. At 23 inches (584 millimeters) high, the information on the caption bar is completely accessible to children and persons in wheelchairs. The typeface used throughout the exhibit is Century Old Style Bold. Cap sizes range from 1/2 inch (13 millimeters) to 5 inches (127 millimeters).

"The Idea" is the first major unit of the historical section. Located on the perimeter wall, it focuses on the personalities of Edouard de Laboulaye and Auguste Bartholdi. Laboulaye, the historian, is portrayed as "The Spirit Behind the Statue," and Bartholdi, the sculptor, is portrayed as one of the idea's most enthusiastic proponents. Among the objects exhibited in this section are an original bust of Laboulaye, sculpted by Bartholdi in 1865, and a copy of Laboulaye's book *Paris in America*, published in 1863.

Also exhibited here are replicas of Bartholdi's terra cotta study models (1867-68) for a different, unrealized, colossus—a lighthouse for the Suez Canal—reproduced from originals in the Bartholdi Museum in Colmar, France. Reproductions of a page of the diary he kept while visiting the United States in 1871 describing his choice of Bedloe's Island for the Statue and the sketch map of the harbor that he sent to his mother in France are also displayed. A Nathaniel Currier and James Merritt Ives view of New York Harbor shows how the harbor looked during the period of Bartholdi's visit.

To the right of "The Idea" is the component entitled "The Image." This unit focuses on the design development of the Statue and its iconography (Figure 4). One original and two replica working models are exhibited here. It was through such models that Bartholdi developed his ideas for the Statue. The original terra cotta in this group is dated 1875 (Figure 5). Another terra cotta figure [4 feet (1.2 meters) high] exhibited in this section is the best existing example of Bartholdi's definitive study model. All successive cast models were based on this *modèle d'étude*. Also illustrated here are some of the diverse sources from which Bartholdi incorporated ideas for his Statue of Liberty—Roman coins, historic paintings such as Delacroix's *Liberty Leading the People* and Janet-Lange's *The Republic En-*

FIGURE 4. *"The Image" is one of the eight components of the historical section. The exhibit outlines the design development of the Statue and explains its iconography (photo by Alan Shortall).*

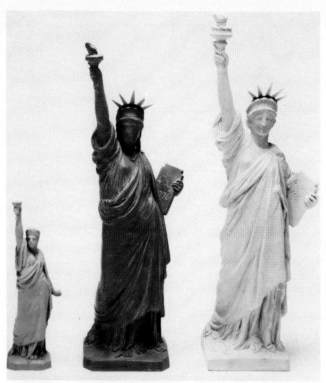

FIGURE 5. *Small working models such as these helped Bartholdi develop his ideas for the Statue from 1870 to 1875. These replicas were made for the Statue of Liberty exhibit from originals in the Bartholdi Museum in France.*

FIGURE 6. *An early sketch of the section entitled "Shaping the Colossus." Note that the replica of the foot is in place along the core wall, but the workshop area on the perimeter wall is still undefined. Note also that the caption bar shown at the ceiling was actually located 23 inches (584 millimeters) above the floor, where it can be easily read by children and persons in wheelchairs.*

lightening the World, the Freemasons, and perhaps most interestingly, the image of his mother's face.

At the end of the first corridor is a section entitled "Shaping the Colossus" (Figure 6). A 6-foot-8-inch- (2-meter-) wide replica of the left foot is located on the core wall. Visitors are encouraged to touch and even sit on the foot, making it the setting for numerous photographs. To the left of the foot on the core wall, a short video program using video recordings made during the reproduction of the foot explains the repoussé process. This and all videos in the exhibit are open captioned for the hearing impaired. Typeset captions are white with a thin dropped shadow outline that makes them easy to read against any background. Across the corridor, along the perimeter wall, a workshop environment has been simulated against a background of two 7-foot- (2.1-meter-) high photo enlargements of the Paris workshop of Gaget, Gauthier et Cie. to show the various stages of the repoussé process (Figure 7). Bartholdi's full-scale, 4-1/2-foot high plaster model of the Statue's left ear (on loan from the Bartholdi Museum in Colmar, France) is featured in this section. Also, the wood and lead molds, plaster models, and the actual tools used to fabricate the full-scale replica of the Statue's left foot are on display (Figure 8). Closing this section of the exhibit and the final element in the first corridor is one last photomural showing the plaster hand and arm in the workshop in Paris.

Around the corner in the second corridor, the first unit deals with "Engineering" and Gustave Eiffel's design of an innovative support system for the Statue. A photograph of a woman's dress form and a simple demonstration model on the perimeter wall illustrate the ingenuity of Eiffel's concept. Also on the perimeter wall is a series of photographs showing the Statue's rise over Paris prior to its formal presentation to the U.S. Minister on July 4, 1884 (Figures 9 and 10). An adjacent open area is used to display a floor-to-ceiling, three-dimensional, cut-away model of the Statue and pedestal that clearly shows the internal structure of both and their relationship to the exterior (Figures 11 and 12).

Directly across from the cut-away model is a section entitled "Raising Francs." A variety of artifacts are displayed in this part of the exhibit, which is devoted to chronicling the ways in which the Franco-American union sought to raise funds for the Statue. Among these is a 4-foot (1.2-meter) zinc model of the Statue produced with Bartholdi's stamp of approval by Avoiron et Cie., a Parisian foundry.

The next two sections of the exhibit deal with the pedestal and the efforts of the American Committee to raise funds for its construction and for erecting the Statue. The first component, "The Pedestal," describes the design development of the pedestal. A photomural and a 2-foot-9-inch- (0.84-meter-) high model of Richard Morris Hunt's final design and models of two earlier versions help to illustrate the process. "Raising Dollars," the second component, displays 6-inch (152.4-millimeter) and 8-inch (203.2-millimeter) statuettes sold by the American Committee, a handsomely engraved subscription certificate, an enlarged photo of the August 11, 1885, front page of Joseph Pulitzer's newspaper The World, and other artifacts of the American fund-raising campaign.

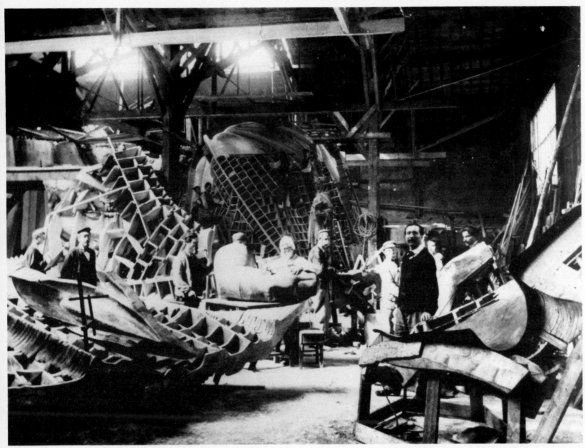

FIGURE 7. *One of two 7-foot (2.1-meter) photo enlargements of the Paris workshop of Gaget, Gauthier et Cie. that form a backdrop to "Shaping the Colossus."*

FIGURE 8. *Some of the wood and lead molds, plaster models, and actual tools used to fabricate the Statue's left foot are on display in "Shaping the Colossus." A video program nearby recounts the making of the replica foot (photo by Alan Shortall).*

Paralleling the exhibits on the perimeter wall are a number of exhibits on the core wall. These include a highly detailed and fully tactile 3-foot (0.91-meter) scale model of the Statue; a display of original armature bars removed during the current restoration; a computerized exhibit designed and donated by the American Society of Civil Engineers; a back-lighted panel describing the restoration; and a video program, "Packing Crates to Opening Day," which opens with the Statue's voyage across the Atlantic and closes with its dedication on Liberty Island (Figure 13).

The latter introduces the final component of the historical section "Complete at Last." Large graphic images of the Statue's assembly in the United States are shown as well as the July 4, 1886, dedication festivities on land and in the harbor (Figure 14). Tools used in the assembly are exhibited here— including a 5-foot- (1.5-meter-) long wrench used to tighten the bolts that anchored the Statue to the pedestal. Other displayed items include one of the commemorative Sèvres vases sent to the American Committee members by the French delegation to the dedication, a parade sword from the 1886 dedication parade, and a photograph of some of the 300 ships that crowded the harbor for the dedication (Figure 15). Turning from "Complete at Last," visitors enter the third and last corridor of the exhibit and the section devoted to the theme of the Statue's symbolism.

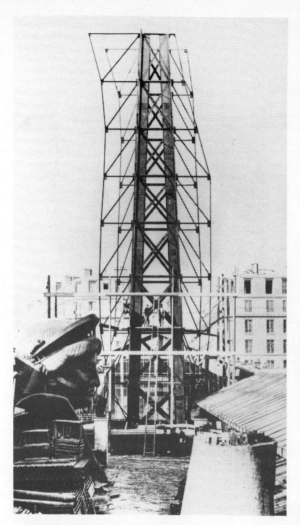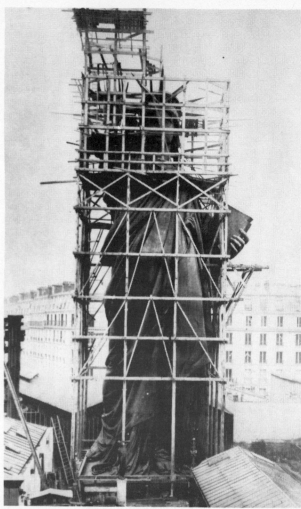

FIGURES 9, 10. *Two of five photographs in the section "Engineering" showing the Statue's rise over Paris prior to its formal presentation to the U.S. Minister on July 4, 1884. Figure 9 clearly shows Gustave Eiffel's internal support system for the Statue.*

☐ The Statue as a Symbol

A statement on the core wall introduces the theme of the Statue as a symbol:

> Liberty was born a celebrity, a towering monument to an historic friendship. While fame often fades quickly, Liberty has grown ever more renowned as the "Mother of Exiles," welcoming a flood of immigrants, and as a symbol of America itself. The price of this fame has been exploitation for commercial and political ends. Yet Liberty remains a proud and shining figure.

As with the preceding historical section, the symbolism theme is divided into a number of discrete topical units. Titles of the various divisions are screened on overhead panels, and major theme statements broadly characterizing the various objects and graphics are screened on the wall. With the exception of the section on popular culture, where a variety of objects on display require limited labeling, there are no object labels. Unlike the preceding section, exhibits occupy both the core and perimeter walls (Figure 16).

The first component, "Mother of Exiles," highlights the written and spoken words of immigrants inspired by the Statue. Located on the perimeter wall, this unit includes the original bronze plaque, dated 1903, of Emma Lazarus's stirring and world-famous poem "The New Colossus." Along with Lazarus's portrait, there is a continuous audio tape, transcribed for the hearing impaired, of immigrant voices recalling their first glimpse of the Statue and a representative sampling of "Dear Miss Liberty" letters sent to The Statue of Liberty-Ellis Island Foundation during the course of the restoration. Written by immigrants, the letters share family histories, send greetings, and tell of first glimpses of the Statue years earlier. One writer states: "I first saw you on the evening of May 4, 1908, from the deck of the Immigrant Ship that brought me from Norway. I was wondering, as I looked at you and the lights in all direc

FIGURE 11. *An early sketch showing the floor-to-ceiling three-dimensional cut-away model of the Statue and pedestal and the latter half of the second corridor of the exhibit.*

FIGURE 12. *Actual view of the same area in Figure 11 shows the cut-away model encased and lighted externally. The exhibits in the background are devoted to "Raising Francs" and "The Pedestal" (photo by Alan Shortall).*

FIGURE 13. *A highly detailed 3-foot- (9.14-meter-) high bronze model of the Statue that was copied from an 1886 casting of the Statue. Tactile exhibits such as this and the replicas of the face and foot allow visitors with visual impairments to "visualize" the Statue through the sense of touch.*

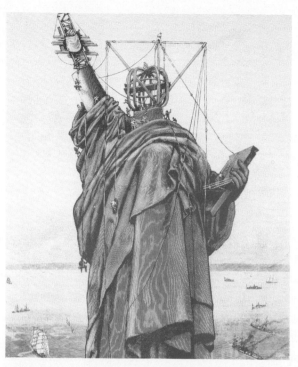

FIGURE 14. *This large graphic image of the Statue's assembly in the United States is included in the final component of the historical section, "Complete at Last."*

FIGURE 15. *This well-known photograph of some of the 300 ships of all sizes and kinds anchored off Bedloe's Island on October 28, 1886, is exhibited in the section devoted to the Statue's assembly and dedication in the United States.*

FIGURE 16. *An early sketch of the symbolism section. Note the pyramid of statuettes in the center of the corridor. In the actual exhibit, the statuettes are located in a case against the wall, and a mosaic of hundreds of postcards occupies the center of the corridor.*

■ 69 ■

(Continued on page 71)

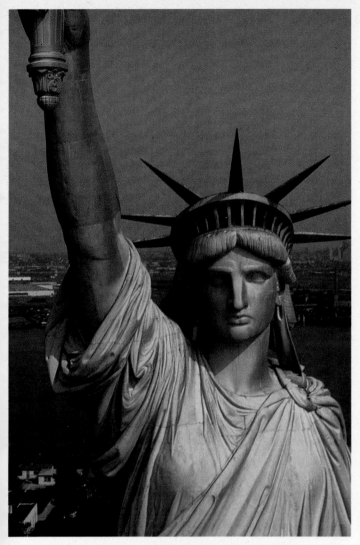

Plate 1

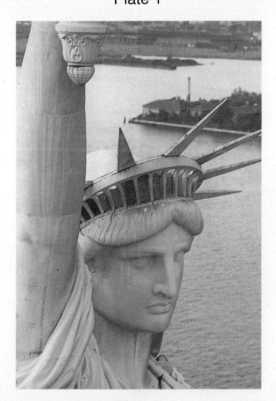

Plate 2

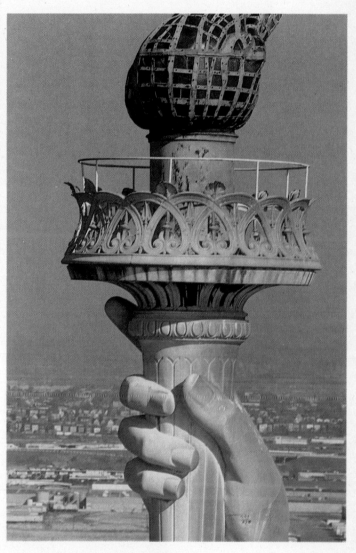

Plate 3

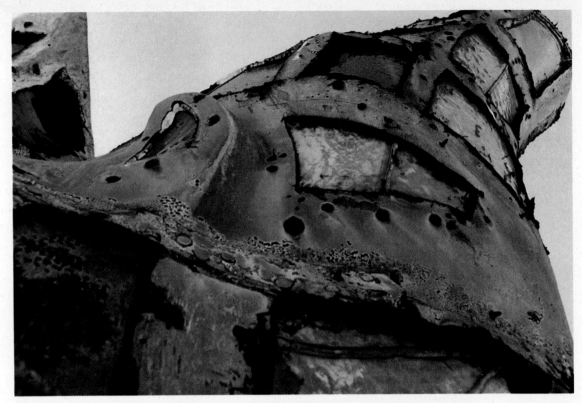

Plate 4

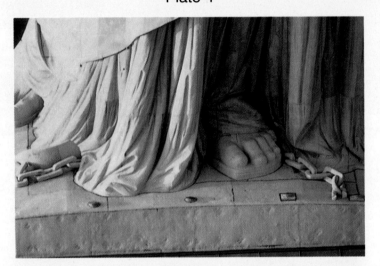

Plate 5

Plate 6

Plate 7

Plate 8

Plate 9

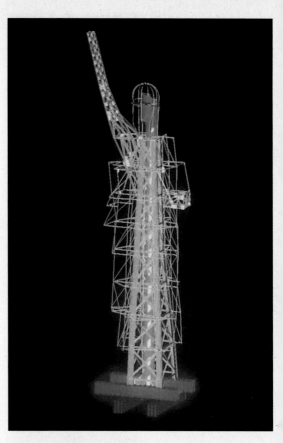

Plate 11

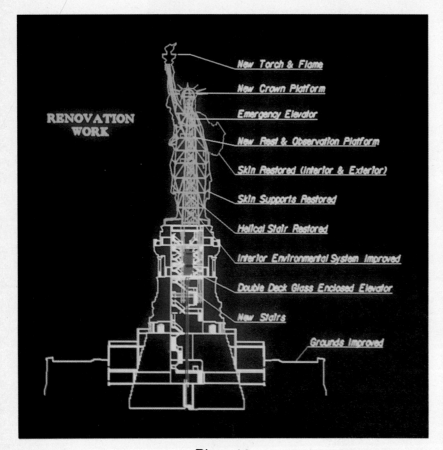

RENOVATION WORK

New Torch & Flame
New Crown Platform
Emergency Elevator
New Rest & Observation Platform
Skin Restored (Interior & Exterior)
Skin Supports Restored
Helical Stair Restored
Interior Environmental System Improved
Double Deck Glass Enclosed Elevator
New Stairs
Grounds Improved

Plate 10

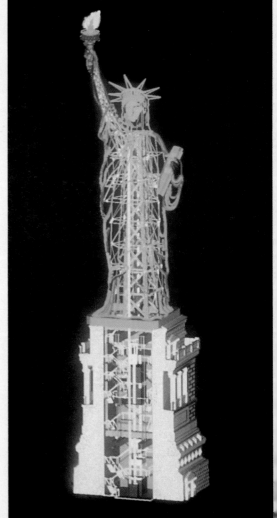

Plate 12

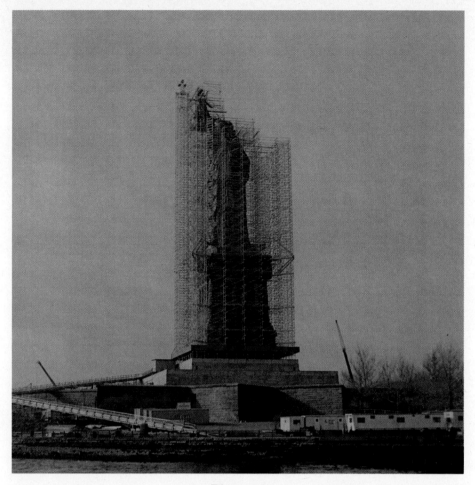

Plate 13

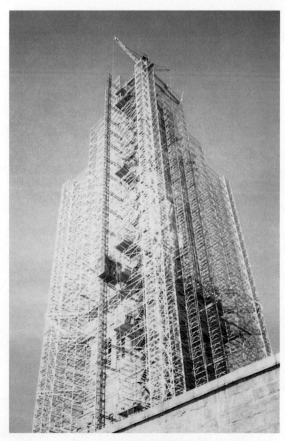

Plate 14

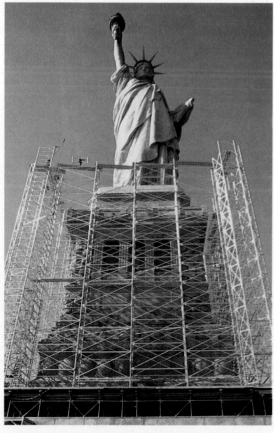

Plate 15

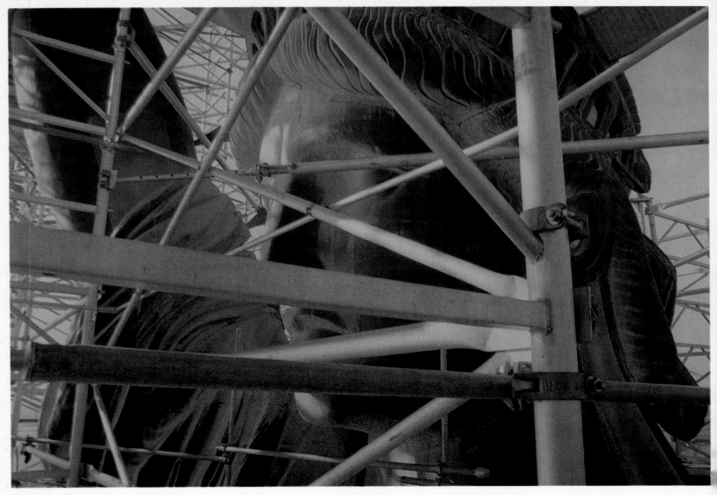

Plate 16

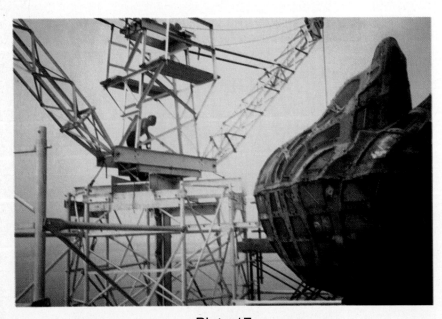

Plate 17

Plate 18

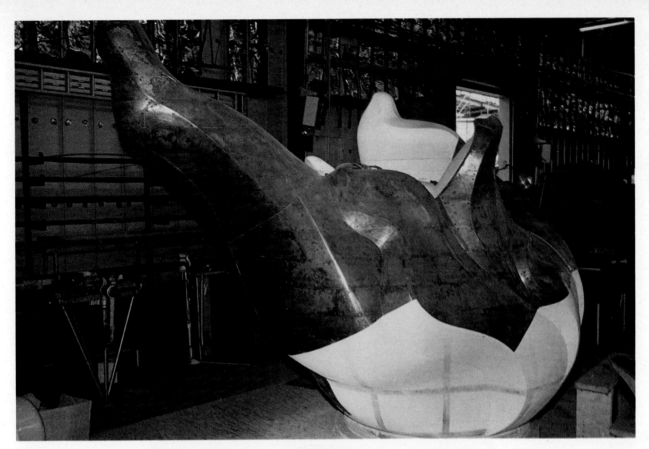

Plate 19

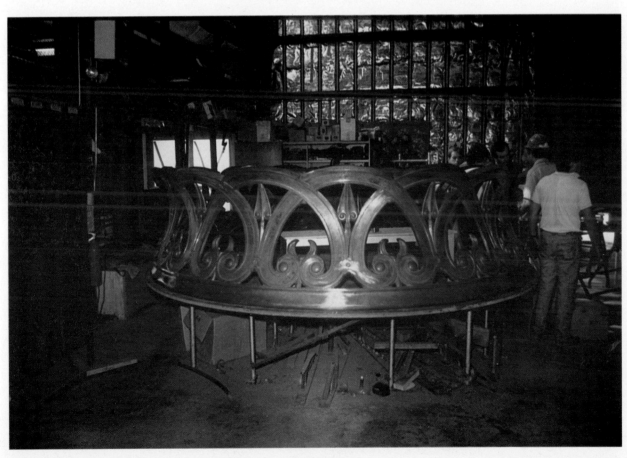

Plate 20

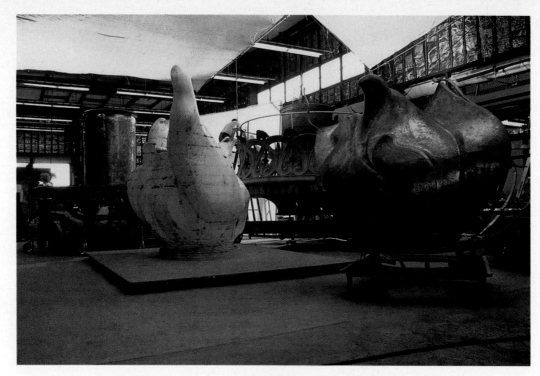

Plate 21

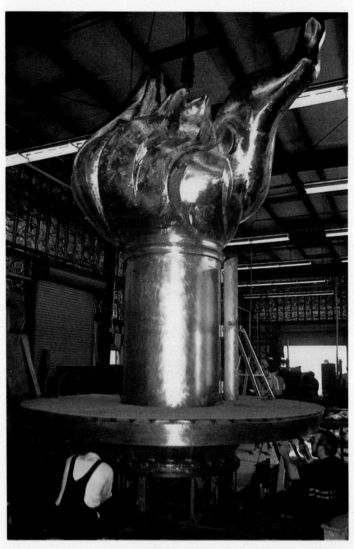

Plate 22

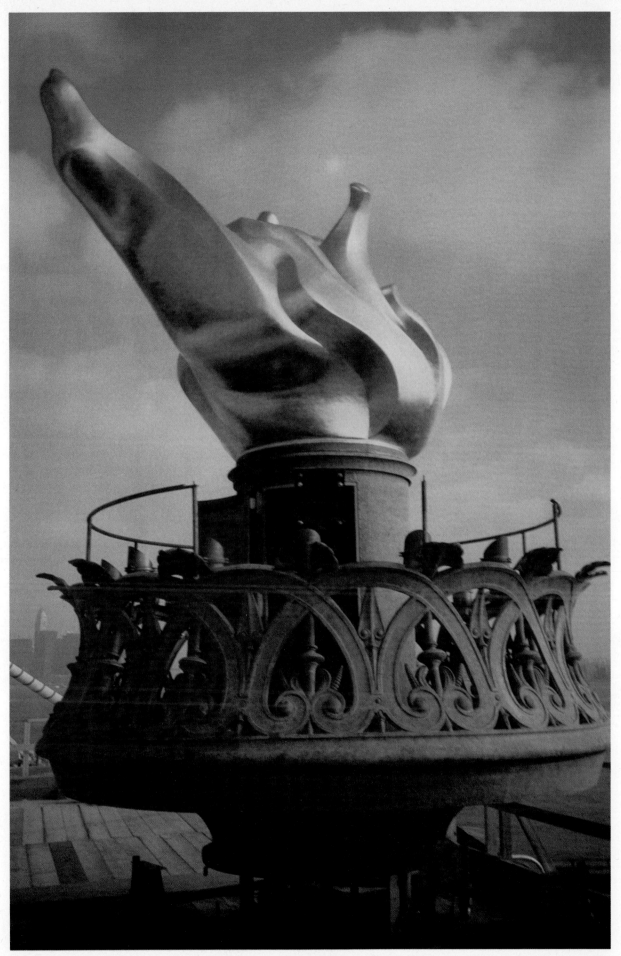

Plate 23

Plate 24

Plate 25

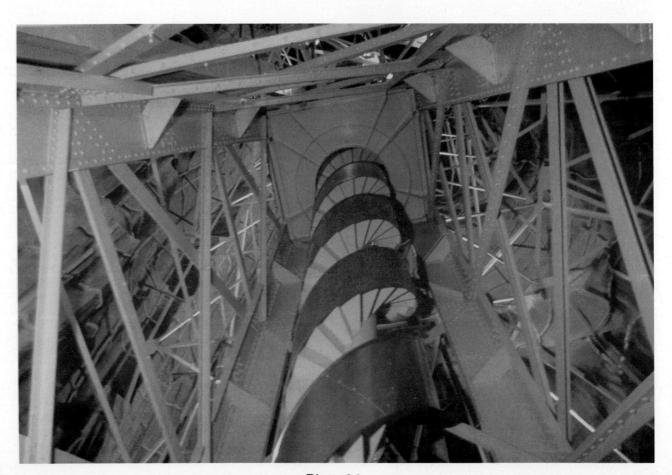

Plate 26

REPAIR OF CURL

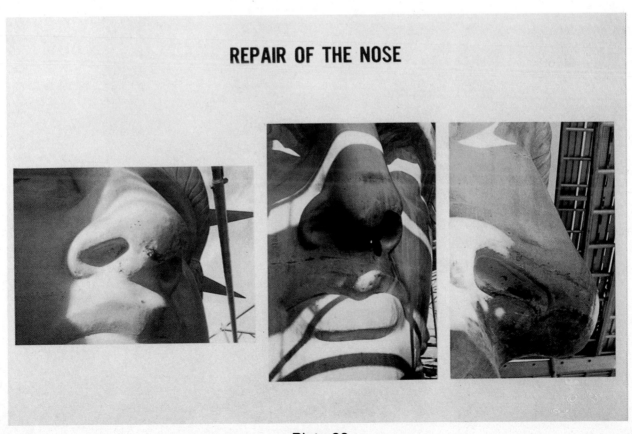

Plate 27

REPAIR OF THE NOSE

Plate 28

REPAIRS TO CROWN AREA

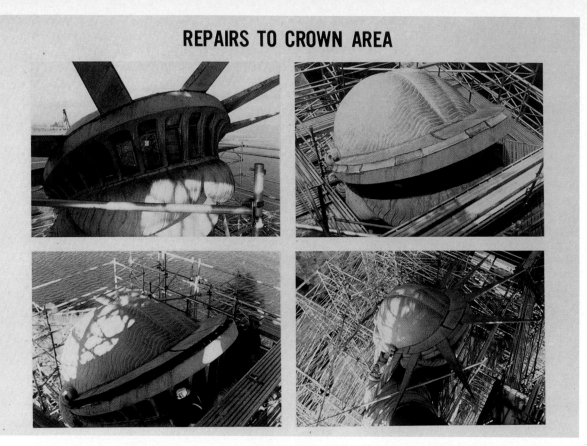

Plate 29

RIVETING SADDLE/ARMATURE REPLACEMENT

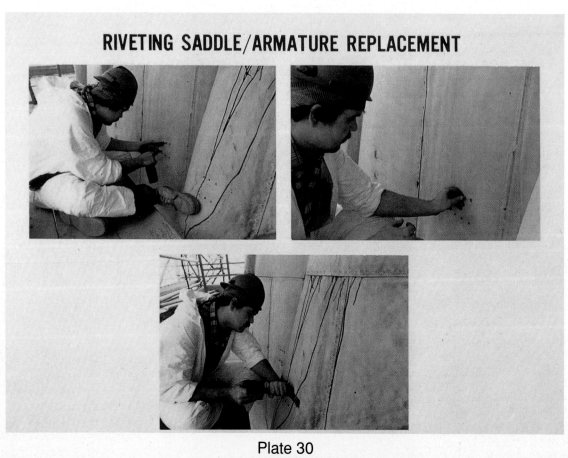

Plate 30

Plate 31

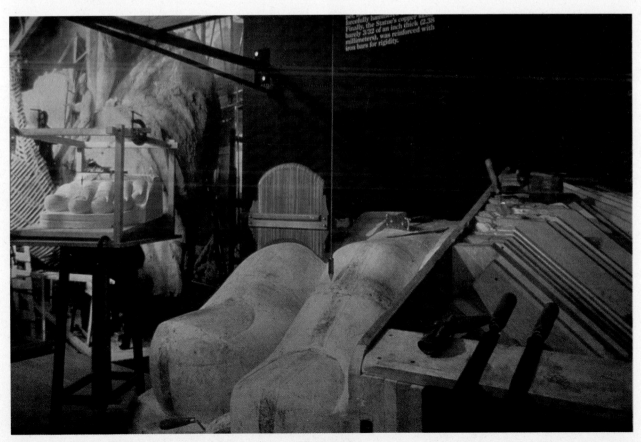

Plate 32

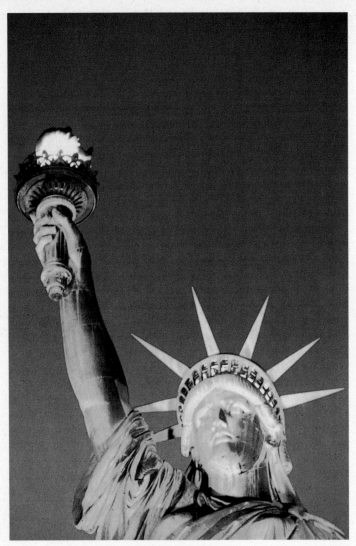

Plate 33

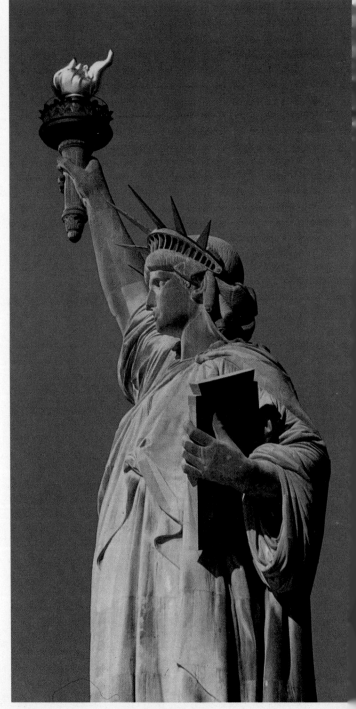

Plate 34

Plate 35

Plate 36

(Continued from page 69)

FIGURE 17. *The head and outstretched arm of the Statue of Liberty emerges from a mosaic of hundreds of postcard images of the Statue itself. To the right is a wall of miniature statuettes mirrored to infinity. Both components are a part of "A Century of Souvenirs."*

FIGURE 18. *A close-up view of some of the miniature statuettes mirrored to infinity in "A Century of Souvenirs" (photo by Alan Shortall).*

tions, 'What is going to happen to me in this vast, new land of America?'"

Another accounts for the years that followed: "I am now 81 years old. You have kept most of your promises and I have done the best I could. I have not grown rich, but have been happy—most of the time! I love you America and thank you!"

On the core wall directly across from "Mother of Exiles" is "The Statue of America." This unit relates the transformation of the Statue into a national symbol during the World War I period. Original Liberty Bond posters and sheet music of songs with a "Miss Liberty" theme show the Statue as a unifying symbol during those times. Other artifacts and a video program using early film footage show how U.S. forces reacted to the Statue as troop ships passed under her gaze on their way to and from Europe.

The next component occupies the center of the corridor, providing a break between "Mother of Exiles" and "The Statue of America" and the units that follow (Figure 17). As with any monument of this symbolic significance, the Statue of Liberty has spawned generations of keepsakes of every kind. Titled "A Century of Souvenirs," this unit features two types of souvenirs—statuettes and postcards, each displayed in a way that emphasizes the vast quantities in which these items have been produced and purchased.

An 8-foot by 10-foot (2.4-meter by 3.0-meter) free-standing wall is covered on each of two sides with mosaics composed of 400 Statue of Liberty postcards. On one side, lighter-colored cards form an image of the head and crown with its seven extended rays. On the other side, darker-colored cards form the image of Liberty from the waist up with arm outstretched. In an adjacent case, also 8 feet by 10 feet, four shelves of statuettes are mirrored to infinity (Figure 18). The statuettes differ from each other in color, dimension, and quality. Massed together, however, they represent an important aspect of collecting.

Leaving "A Century of Souvenirs," visitors encounter two more components along the core wall. The first of these, "The Statue as Stand-in," focuses on the Statue as an easily recognized image that quickly conveys a message. Featured here are a variety of political cartoons, some dating back to the 18th century; foreign and domestic illustrations commenting on American policies and attitudes; and film posters—including one from Eastern Europe. To the left is "The Image Exploited." This section deals with the Statue's exploitation for every conceivable political purpose, an exploitation that began even before the Statue's unveiling on Liberty Island (then Bedloe's Island). Exhibited here is an illustration of the Statue wearing Levi's, a Peace Corps poster showing the Statue with her arm outstretched and her finger pointing, with the caption "Make America a Better Place—Leave the Country," and a poster of the Statue in a T-shirt advertising "Real Rock Radio." A silent video program shows other images of the Statue—with an American Express Card, a can of Piels beer, a TV antenna, and as a waitress holding up a glass of orange juice.

Across the corridor on the perimeter wall is "The Statue in Popular Culture" (Figure 19). This section illustrates some of the ways in which the image of the Statue has been sewn, hammered, formed, red, printed, and painted onto all sorts of materials. Displayed here is a brass menorah with 9 small Liberty statues as candle holders, a large white quilt with the image of the Statue surrounded by a host of other American icons and symbols, a photo of a 30-foot (8.1-meter) statue made with Nebraska corn,

■ 71 ■

FIGURE 19. *"The Statue in Popular Culture" is one of the six components of the symbolism section. The exhibit illustrates some of the ways in which the image of the Statue has been sewn, hammered, formed, fired, printed, and painted onto all sorts of materials (photo by Alan Shortall).*

FIGURE 21. *The final element in the exhibit, a rear-illuminated transparency of the restored Statue closes the exhibit in the way it opened—with the powerful and familiar image of the Statue itself (photo by Alan Shortall).*

FIGURE 20. *"Miss Liberty" is the name given to this quilt by its maker, 85-year-old folk artist Lillie Short of Kentucky. Short says, "I tried to make the quilt talk by making the Statue of Liberty the central theme and placing the symbols of America around the Statue to let each symbol speak for itself." The quilt is exhibited in "The Statue in Popular Culture."*

■ 72 ■

oats, and wheat in 1885, a circle of 11 plates with the Statue's image, a mantel clock, a radio, a 3-foot-high origami statue cut and folded from a single sheet of heavy green paper, and two crystal statues, one by St. Gobain of France and the other by Waterford of Ireland (Figure 20).

To the right of "The Statue in Popular Culture," at the end of the third corridor, is a 7-foot 8-inch by 10-foot (2.4-meter by 3-meter) rear-illuminated transparency of the restored Statue holding her shining torch. Bordered on both sides by a number of quotations on the subject of Liberty by men and women from around the world, this final element brings the exhibit to a close in much the same way that it opened—with the powerful and familiar image of Liberty (Figure 21).

Reflecting back on the challenges identified at the beginning of this paper, one is entitled to ask if they were met. This is a difficult question for anyone closely involved with the project. The project was completed on time and within budget. Published reviews to date have been very positive. A major article in the September/October 1986 *Communication Arts* reserved special praise for the replica face and foot and the effort of the project team to include them in the exhibit.

The exhibit has also been well received by leaders of the disabled community. When asked if his accessibility goals had been met by the exhibit, one of those who had worked closely with the project team exclaimed, "More than met!" In the final analysis, however, it is the visiting public who must answer this question, and their response to date has been nothing less than heart warming. On any given day, the space is likely to be crowded with visitors—taking pictures, absorbing information, and favorably commenting on one aspect or another. May it continue to be so.

■ *Section III: Corrosion on the Statue of Liberty*

Corrosion on the Statue of Liberty: An Overview*

Robert Baboian
Texas Instruments Inc., Attleboro, Massachusetts

E. Blaine Cliver
National Park Service, Boston, Massachusetts

The Statue of Liberty was first assembled in Paris in 1884, then disassembled and reassembled in the United States at Bedloe's Island (now Liberty Island) on its American-built foundation and pedestal. Beginning in July 1981, a series of inspections was conducted by the National Park Service and by a consulting team of French and American engineers and architects in a project of the French-American Committee for the Restoration of the Statue of Liberty. Over a dozen problem areas needing attention were identified (Figure 1), the most important of which resulted from corrosion and included the following:

(a) Rust stains on the exterior copper skin;
(b) Severe corrosion of some small areas of the copper skin;
(c) Deterioration of the torch;
(d) Degradation in the crown area and spikes;
(e) Structural concerns in the shoulder of the torch arm;
(f) Corrosion of the iron armature; and
(g) Paint peeling on the interior copper skin and support structure.

□ Scope of the Restoration

To conduct the restoration work, interior and exterior scaffolding were required. The interior scaffolding was easily installed as an extension of the existing supporting structure. However, the 250-foot- (76.2-meter-) high scaffolding that wrapped around the exterior of the Statue without touching her required corrosion resistance and strength to withstand the environment of New York Harbor. Extruded aluminum was chosen for this structure, which supported the workers during the restoration program.

The 151-foot (45.72-meter) Statue has a framework of puddled iron. Her central support system is a pylon with four legs connected by cross bracing. A double-helix staircase rises within the pylon. Connected to the pylon is a secondary framework consisting of iron angle bars. This framework, connected by flat iron bars, provided support for the original armature, a network of 1850 puddled iron bars [2 by 5/8 inches (50.8 by 15.875 millimeters)] that conformed to the outer shape of the Statue. The copper skin is attached to the armature with about 1500 U-shaped copper saddles. The saddles fit around the armature on three sides and are flush riveted with copper to the copper skin. The 80-ton copper envelope [3/32-inch- (2.38125-millimeter-) thick copper] consists of 300 hammered sheets riveted together with about 300,000 copper rivets. The design of the skin armature attachment using saddles is a contemporary method of attaching the skin without its penetration.

Although the designers (Auguste Bartholdi and Gustave Eiffel) anticipated the effects of the environment, the severity of the marine environment, water seepage, and acid deposition has taken its toll on the Statue. In recent years, it was discovered that the head was not placed directly on the pylon's central axis, nor was the arm positioned properly. Contrary to Eiffel's design, the head is offset by 2 feet (0.6096 meters) and the shoulder and arm on the torch side are offset 1.5 feet (0.46 meters) from the central pylon. Thus, the underlying structure of the arm is weaker than Eiffel had intended, because it

■ 75 ■

This paper is an edited version of a series of four articles originally published in *Materials Performance* (Vol. 42, Nos. 3-6, 1986).

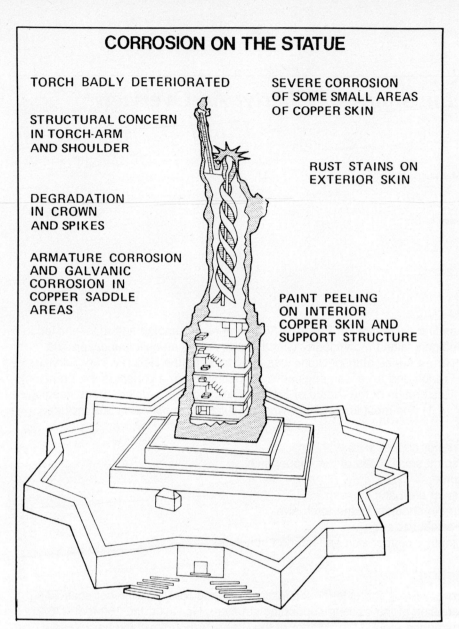

CORROSION ON THE STATUE

TORCH BADLY DETERIORATED

STRUCTURAL CONCERN
IN TORCH-ARM
AND SHOULDER

DEGRADATION
IN CROWN
AND SPIKES

ARMATURE CORROSION
AND GALVANIC
CORROSION IN
COPPER SADDLE
AREAS

SEVERE CORROSION
OF SOME SMALL AREAS
OF COPPER SKIN

RUST STAINS ON
EXTERIOR SKIN

PAINT PEELING
ON INTERIOR
COPPER SKIN AND
SUPPORT STRUCTURE

FIGURE 1. *The diagram points out the specific areas suffering from corrosion on the Statue of Liberty.*

■ 76 ■

does not carry the weight down directly to the central pylon. As a result of the misplaced head, a spike in the crown rubbed against the copper skin of the arm, causing a perforation.

The most visible change in the restored Statue was the torch, which was altered to serve as a beacon. The 1916 additions of colored glass inserts in the copper flame and extra lights were never made watertight, and rain and snow in the marine environment continuously leaked into the torch and down the inside of the arm. This, in addition to severe corrosion of the fine copper detail and the armature support, required that a new torch be constructed. However, instead of duplicating the existing torch, the new flame of the torch was fabricated in the original design, without the glass inserts or other modifications. This proved to be a difficult task because the original drawings were not available. French workers reproduced the design based on research conducted by the National Park Service, in which sketches and photographs of the original torch were studied (Figure 2).

The art of the repoussé, or hammered metal, technique used in the Statue's original construction was revived during the restoration by the French team of Les Metalliers Champenois (Reims, France) to fabricate the copper in the torch. In this technique, copper sheet is set against a mold and hammered to shape. In such areas as the gallery railing, extremely fine details (including ears of corn containing acorn-sized kernels) were reproduced. The repoussé work was lightly prepatined to produce a matching green appearance on the Statue after it was assembled.

To fabricate the flame, a full-sized plaster model was constructed and solid sheets of copper were again hammered to the shape of the original design. The copper was seam riveted, the rivets were ground flush with the copper, and the seams were soldered to seal the entire structure. The flame was then gilded by first etching the copper surface, coating it with three layers of varnish, and placing gold leaf on the top layer while it was still tacky. The use of gold leaf provided a brilliant effect, from the sun's reflection in the daytime and from artificial lighting at night. On November 25, 1985, the new torch was raised to the top of the Statue arm and secured in place.

□ Galvanic Corrosion Problems

The problem that most necessitated the restoration of the Statue of Liberty was galvanic corrosion of the iron armature in contact with the copper skin. Galvanic corrosion occurs when dissimilar metals are in electrical contact in the same electrolyte. The difference in electrochemical potential between the dissimilar metals (iron and copper) is the driving force for electrolysis, whereby the more active metal (iron) corrodes at an accelerated rate. The iron armature, forming horizontal and vertical ribs against the copper skin, and the attachment mechanism, whereby copper saddles (which are flush riveted to the copper skin) surround the iron armature, provided a configuration conducive to galvanic corrosion. Since all of the iron armature was interconnected, only one location of physical contact to the copper skin was necessary to provide electrical continuity to the copper throughout the Statue. This contact was ensured (because of the riveted design) at a large number of locations, even though attempts were made to isolate the iron and copper. A *Scientific American* article (November 20, 1886) published at the time of U.S. construction stated that for the Statue of Liberty, "There are five dangers to be feared, namely, earthquake, wind, lightning, galvanic action, and man." Against galvanic action, it was reported that ". . . an

FIGURE 2. *The restored statue features a new torch (photo by R. Baboian).*

ingenious insulation of the copper from the framework has been employed, the insulating material used being asbestos cloth soaked in shellac . . ." and that ". . . in no place do the two metals come in contact with each other." In actuality, the use of shellac-impregnated asbestos between the iron armature and copper skin did not interrupt electrical continuity but probably initially served to disrupt electrolyte continuity. However, with time, this "ingenious insulation" became porous and actually promoted electrolyte continuity by wicking because of capillary action.

The corrosive environment within the Statue was a result of several factors. First, the original design and early modifications to the Statue, such as in the torch flame, allowed seepage of marine salts, rain, snow, and, in recent years, acid precipitation. Second, wide temperature fluctuations in the absence of humidity control promoted condensation and at times precipitation on the inside. Third, the porous asbestos, paint disbondment, and poultice debris that had accumulated through the years all served to trap the corrosive electrolyte in areas where the iron armature was against the copper skin.

Galvanic corrosion of the iron armature was most severe in the copper saddle areas. In addition to providing a configuration for electrolyte entrapment, copper completely surrounded the iron there and provided an effective galvanic couple. The resulting expansive force of the iron corrosion products caused swelling, whereby the saddle rivets were pulled through the copper skin in a number of areas. Throughout the Statue, disfigurement of the copper skin from the effect of swelling was visible on the external surface (Figures 3 and 4).

The iron armature had also corroded in areas remote from the saddles. In some cases, half the thickness had corroded away, and at lap joints, iron bolts had corroded and failed. Extensive galvanic corrosion of iron occurred in the torch, torch arm and shoulder, and head. These areas were most susceptible to moisture seepage; for example, the iron crown ring and torch base ring were severely deteriorated.

Rust staining of the patina on the exterior copper skin was also a problem associated with the iron galvanic corrosion. Holes punched through the copper from the inside where water collected allowed rust to run to the outside. Rust stains on the neck, for example, were caused by galvanic corrosion of the iron armature bars at the chin/neck interface and draining of the rust-laden moisture through two holes in that location. However, in addition to drain holes, rust staining occurred in other areas of severe galvanic corrosion because of the riveted design of the Statue. Here, the most visible effects occurred in the crown and the torch (Figure 5).

Concerns for the structural integrity of the Statue were raised because of the severity of the iron armature galvanic corrosion. Because of these concerns, all of the iron armature was replaced with stainless steel.

■ 77 ■

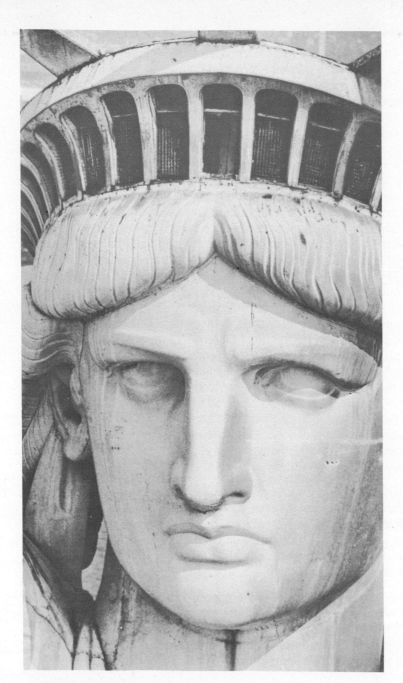

FIGURE 4. *The copper saddle in the left cheek is missing because of popped rivets. This occurred as a result of expansive forces of iron armature corrosion products.*

FIGURE 5. *The arrow shows a drain hole in the copper skin of the neck and chin area of the Statue where rust accumulated and ran onto the outer surface, causing stains.*

FIGURE 3. *Popped rivets in the cheeks and rust stains on the neck and crown of the Statue (photo by J. Maisel).*

☐ Copper Behavior

The magnificence of the Statue of Liberty is enhanced by the beautiful green patina that forms naturally on the exterior copper skin. This skin consists of 300 panels with over 600 sheets of copper of various sizes riveted together. The original thickness of the copper varied considerably throughout the Statue, partly because of the use of the repoussé technique in the fabrication. But thickness measurements and Statue records show that most of the copper is about 0.1 inch thick. The composition of the copper also varies throughout the Statue. For example, parts of the tablet and the crown rays have a visual appearance of yellow brass and have a high zinc content. Generally, though, the copper has a conventional appearance and a copper composition in the 95 to 98% range.

Of first and foremost concern is the corrosion behavior of the copper during the past 100 years. Fortunately, a large amount of data exists on the atmospheric corrosion behavior of copper in environments near or similar to the Statue of Liberty.[1-4] These independent studies show that over long exposure periods (up to 20 years, beginning at various times, as early as 1927) the copper corrosion rate is 0.04 to 0.06 mils/year. Measurements of thickness loss throughout the Statue are within this range (Table 1), indicating no unusual degradation process has occurred. These data were obtained by ultrasonically measuring the differential thickness between areas protected by coal tar streaks since 1911 and areas immediately adjacent to each streak. Table 1 shows copper corrosion rates on the Statue calculated in mils/year.

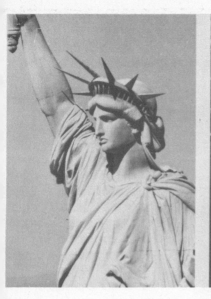

FIGURE 6. *Photographs showing the gradual darkening on the left side of the Statue of Liberty since 1965 (photos by J. Maisel).*

One of the factors affecting atmospheric corrosion rates for copper is the exposure configuration.[3] For example, panels exposed horizontally have a higher corrosion rate than vertically exposed panels. Table 1 shows this to be the case on the Statue. Corrosion of the horizontal base is greater than in the head, midsection, and lower section, where the exposure angle in measured areas was between 45 degrees and vertical. The data indicate that except for the horizontal base, there is no significant difference in corrosion rates either vertically or circumferentially.

It should be mentioned that in some areas, abnormally severe corrosion of the copper occurred on the Statue. These are areas where aqueous liquid collected because of improper drainage or where aqueous liquid run-off caused erosion corrosion of the copper. Patching of the copper was required in these locations.

Copper and its alloys have been used for centuries in architectural and cultural works. The stability of this metal in atmospheric environments results from the formation of the patina on its surface. This patina serves as a protective layer, reducing the corrosion rate of the metal as it is formed. In industrial and marine environments, the corrosion rate for copper in the first year is up to 4 times greater than that in the 10th year. Between the 10th and 20th year of exposure, no significant change occurs in the corrosion rate of copper in these environments. During the initial years of exposure, the patina is forming, and the corrosion rate is therefore higher. However, development of the protective patina reaches a stage in which its further development does not affect the copper corrosion rate.

The dynamic copper/patina system results from the interaction of the metal with the environment. Its thickness, composition, and appearance is therefore highly dependent on the metal composition and the nature of the environment.

Historical photographs of the Statue show that the green patina developed more uniformly on the Statue in earlier years than in recent years. Comparative aerial photographs taken in 1965, 1974, and 1983 show that since 1965, large areas on the left side of the Statue (facing northeast toward Manhattan) have darkened. Patina thickness measurements were made using the eddy-current technique.[5] The data in Table 2 shows that the thickness in the darker areas is 1/2 to 1/10 the thickness in adjacent green areas. Also, the patina is thicker on the right side and in sheltered areas unaffected by wind and aqueous run-off. It is interesting to note that when the outer green patina is removed mechanically, a dark layer is uncovered.

Photographs showing the darkening on the left side and the patina thickness measurements (Table 2) indicate that wind erosion and/or aqueous run-off are removing the outer green patina, exposing the underlying black layer. This effect has occurred because the rate of erosion exceeds the rate of formation of the green patina. On the other hand, the rate of formation of the black layer exceeds the rate of erosion of this layer, and therefore the stability and rate of corrosion of the copper has not been measurably affected (Table 1). If, however, the dynamics of this metal/patina system change, the corrosion rate of the copper could increase significantly in the future.

FIGURE 7. *John Robbins (left) and E. Blaine Cliver (right) of the National Park Service and Robert Baboian of Texas Instruments measure the patina thickness on the copper skin of the Statue.*

Changes occurring in the composition of the patina were first reported by Nielsen.[6] However, there is an important correlation of the patina composition with the appearance and thickness of the patina. Table 3 shows that the green patina has a high antlerite content (the less stable form of the patina) on the darkened left side of the Statue, whereas the green patina is predominantly brochantite, or the more stable basic copper sulfate, on the right side.[7] In addition, analysis of the patina on a copper piece removed from the Statue in 1905 showed no antlerite content. Therefore, it is felt that over the past few decades the stable form of the patina (brochantite) converts to the less stable form (antlerite), which is more susceptible to erosion. The reaction has occurred predominantly on the left side of the Statue. This side is susceptible to acid deposition effects from the northeast (Manhattan and several power plants) as well as the severe northeast weather patterns. Acid deposition and wind erosion could therefore be the cause of the darkening on the left side.

Although methods exist to protect copper patinas from the weathering effects of acid deposition, none of these is permanent, and periodic maintenance is therefore required. This is not possible on the Statue of Liberty because of the inaccessibility of most of the surface in the absence of the scaffolding.

Some interesting effects of copper composition have been observed on the Statue. The higher zinc content copper in the crown rays and the tablet have varying degrees of localized corrosion, including black scab and pitting, in addition to the formation of a green patina. This type of behavior in outdoor bronzes is referred to as "bronze plague" and is attributed to acid deposition. This non-uniform reaction on the yellow brass, compared to the uniform darkening of the copper panels on the Statue, is in agreement with the known behavior of these materials in similar environments throughout the world.

A second interesting effect of copper composition involves a single panel on the left side of the torch arm. This copper has retained its stable green patina (Table 3), while surrounding copper panels have become dark. This behavior is attributed to the composition and metallurgy of this panel (softer and purer matrix copper).

□ **The Statue Restoration**

When the decision was made to replace the iron armature on the Statue, the most important issues raised were (1) how to remove the paint and coal tar coatings, (2) what material should be used for the new armature, and (3) what replacement method should be used.

During the 100-year existence of the Statue, at least 10 coatings were applied directly to the internal copper skin. In 1911, a coating consisting of a coal tar waterproofing to seal joints and riveted seams was applied. Subsequently, layers of lead, aluminum, alkyd, and vinyl paints were applied, the last of these in preparation for the Bicentennial celebration in 1976. All of these coatings needed to be removed to expose the interior surface prior to replacing the iron armature.

A wide range of methods were tested for removing the coatings, including blasting with various materials, chemical stripping, application of heat, and cryogenic blasting. The requirements for the technique used were that it had to be safe, it could not damage the copper interior, and it could not bleed to the outside and damage the patina. Cold blasting with liquid nitrogen at −320°F (−196°C) met these criteria and was therefore chosen. The difference in thermal expansion of copper and paint, the embrittlement of the paint itself, and the force of the liquid nitrogen spray caused the paint to disbond and fall

TABLE 1
Copper Corrosion Tests on the Statue (mpy)

Vertical Location on Statue	Circumferential Location on Statue			
	Left	Right	Front	Rear
Head	0.051, 0.061	0.053	—	—
Midsection	0.046, 0.053	0.043	0.032, 0.039 0.050	0.041, 0.045 0.047, 0.059
Lower section	0.049, 0.053	0.057	0.049, 0.050	0.032, 0.045
Horizontal base	0.064	0.059	0.054	0.064

TABLE 2
Patina Thickness on Statue (mpy)

Location	Patina Thickness (mils)	Patina Color
Cheek	0.35 to 0.5	Dark
Left side	3.0 to 5.4	Green
Neck		
Left side	0.25 to 0.35	Dark
Left side	0.5 to 0.9	Slight green
Upper arm		
Left side	0.39	Dark
Right side	1.8 to 2.4	Green
Torch shank		
Left side	0.9	Dark
Right side	3.6	Green
Front	1.5	Green
Rear	1.8	Green
Arm at green panel		
Green panel	2.5 to 3.5	Green
Black adjacent panel	0.25 to 1.5	Black
Sheltered areas		
Under left curl	5.4	Green
Right arm/robe	3.1	Green

TABLE 3
Patina Analysis on the Statue

Location on Statue	Patina Content	Patina Color
Neck, left side	BRO > Cu_2O	Dark
Left cheek	BRO/ANT	Green
Left curl	BRO/ANT	Dark
Left curl (sheltered area)	ANT	Green
Chin, left front	No intensity peaks	Black
Left side (lower section)	BRO/ANT	Green
Left side of toe	BRO > ANT	Green
Right side, arm near torch	BRO	Green
Right side, lower arm	BRO	Green
Right side, lower section	BRO >> ANT	Green
Rear, lower section	BRO > ANT	Green
Rear, lower section (sheltered)	ANT	Green
Green panel on arm	BRO > Cu_2	Green
Black panel next to green panel on arm	No intensity peaks	Black
Copper sample removed in 1905	BRO/Cu_2O	Dark green

[A]BRO = Brochantite
[B]ANT = Antlerite

to the bottom of the structure. However, a layer bonded directly to the copper was largely unaffected by this treatment. This layer consisted of copper corrosion products that had reacted with the coal tar. To remove this tough adherent material, a vacuum blasting system with sodium bicarbonate was used. Sodium bicarbonate is mildly abrasive, so it removed the residual layer without attacking the copper skin.

The choice of replacement armature material was an important and difficult one. Severe galvanic corrosion of the original iron armature in electrolytic contact with the copper skin had occurred. Replacement of this corroded iron with a material of similar susceptibility to galvanic corrosion was not practical. However, the new armature material required mechanical and physical properties like those of the original and needed to be compatible with the copper skin so that galvanically accelerated corrosion of the copper would not occur.

Laboratory and atmospheric exposure corrosion tests were conducted on various candidate materials to determine their galvanic behavior in contact with copper. Because it is not possible to electrically isolate the armature bars from the copper skin, the new material had to be galvanically compatible with copper in the interior Statue environment. Results of these tests showed the higher alloy stainless steels met this criterion. A review of the mechanical properties of the stainless steels showed that no change in dimension of the bars (compared to the original iron) would be required. For example, the modulus of elasticity for the stainless steel and iron is similar; therefore, the approximately 1800 interconnected bars of the same dimensions would behave similarly under the action of wind, stress, and vibration. Because the physical characteristics of the bars (and therefore the dimensions) were the same, no new rivet holes were needed to attach the copper.

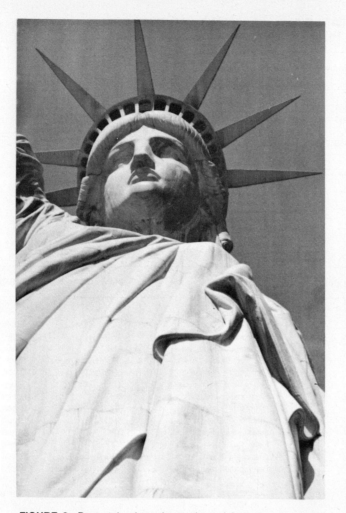

FIGURE 8. *Rust stains have been cleaned from the skin of the Statue.*

■ 82 ■

Based on previous experience with copper/stainless steel atmospheric exposure, results of specific laboratory and atmospheric exposure corrosion tests, and its mechanical and physical properties, type 316L stainless steel (UNS S31603) was chosen to replace the iron armatures on the Statue.[8]

All of the iron armature was replaced except for a few bars in the raised sole of the right foot. This area was in good condition and was preserved as an example of the original construction. To ensure the continuing structural integrity of the Statue, each iron bar was removed individually and duplicated in stainless steel. Each bar was bent (sometimes with heat) to the desired duplicate configuration. The type 316L bar was heat treated at 1900°F (1038°C) and water quenched. The surface of each bar was then sandblasted and passivated in nitric acid. Finally, the bar was installed with new copper saddles and rivets before the next iron bar was removed. Skived Teflon[†] was placed between the copper (skin and saddles) and stainless steel armature bars to interrupt corrosive electrolyte continuity. Under strictly atmospheric corrosion conditions, this isolation is not necessary between type 316L stainless steel and copper; it was added as a precaution in the event of a more aggressive environment.

Originally, the armature bars were connected to the secondary angle iron framework with flat iron bars. These flat iron bars have been replaced with a high-alloy duplex stainless steel. However, the angle iron framework has been retained. Corrosion protection has been provided by blast cleaning, application of a waterborne inorganic zinc primer, and a top coat consisting of an aqueous epoxy.

Concerns for the structural integrity in the torch arm and shoulder had existed for many years. As mentioned before, modification to the original design realigned the structure of the torch arm further from the central pylon than had been desired. Thus, additional stress was placed on the connection in this area. Although more strength members were added to compensate for the design change (during initial construction and in the 1930s), it was determined during the restoration project that additional work was needed. Therefore, while preserving those alterations that originated in Paris, modifications were made to provide increased strength to the shoulder area.

Many improvements to the Statue interior have been implemented, including (1) a hydraulic glass double-cab elevator in the pedestal for the general public, (2) new stainless steel treads to the circular stairs as well as an emergency elevator within the Statue, (3) a redesigned pedestal stairway in stainless steel to provide an excellent view of the interior and improve the visitor circulation system, (4) a refurbished lobby and a new museum, and (5) a humidity control system. The system to modify the inner environment of the Statue will reduce the humidity and provide a better environment for corrosion control.

An important question early in the planning of the restoration project involved the condition of the exterior copper skin (Figure 8). The existing patina that had formed on the copper during the 100 years was varied in appearance and was blemished with rust stains, coal tar streaks, and paint spots. Removal of the patina to expose bare metal would have brought the Statue back to a metallic copper appearance. However, the crucial role that the patina plays in the corrosion resistance of copper was well known. It was therefore decided not to disturb the existing patina but to clean the surface where major

†Trade name.

staining had occurred. For example, the rust stains on the neck were removed with sodium bicarbonate. Hosing the exterior skin with fresh water provided a final cleaning prior to removal of the scaffolding.

During the restoration project, every attempt was made to protect the exterior surface from damage and/or visual alteration of the patina. Even the copper rivets used to attach the stainless steel armature to the skin with the copper saddle configuration were prepatined. However, some areas on the skin were affected and are visible under close inspection. In areas where rust stains were removed, such as on the neck, a variation in the patina color exists. This also occurred in small areas where sodium bicarbonate used in the interior coating removal had bled to the outside. Part of the existing patina then converted to a thin copper carbonate when in contact with moisture but was washed away by further weathering. Within two to five years, all of these areas affected during the restoration process will blend in and become indistinguishable because of the dynamics of the copper/patina system and its reaction to the Statue of Liberty environment.

The corrosion problem that created the need for a major restoration of the Statue of Liberty will not reoccur, and if the copper corrosion rate for the first 100 years continues, the Statue will last for at least 1000 years. However, concern exists for the corrosion behavior of the copper skin in the aggressive acid deposition environment. The darkening of the left side of the Statue appears to be related to this changed environment position. Just as Bartholdi and Eiffel in 1886 could not anticipate future design and environmental changes, it is not possible to anticipate changes that will occur in the next 100 years. However, the Statue of Liberty is now ready to withstand the effects of the aggressive environment and continues to serve as our symbol of friendship and freedom.

☐ References

1. Symposium of Atmospheric Corrosion of Nonferrous Metals, Special Technical Publication 175 (Philadelphia, PA: ASTM, 1955).
2. R. Baboian, G. Haynes, P. Sexton, Atmospheric Corrosion of Laminar Composites Consisting of Copper on Stainless Steel, Special Technical Publication 646 (Philadelphia, PA: ASTM, 1978).
3. I.R. Scholes, W.R. Jacob, Journal of the Institute of Metals 96(1980): p. 272.
4. Metal Corrosion in the Atmosphere, Special Technical Publication 435 (Philadelphia, PA: ASTM, 1968).
5. Technique developed by H.E. Van Valkenburg, Automation/Sperry, Qualcorp.
6. N. Nielsen, Materials Performance 23, 4(1984).
7. X-Ray Diffraction Analysis conducted by R. Matyi, Central Research Laboratories (Attleboro, MA: Texas Instruments Inc.).
8. R. Baboian, Standardization News, March (1966): p. 34.

■ 83 ■

Corrosion Mechanisms on Historical Monuments

Jerome Kruger
Materials Science and Engineering, The Johns Hopkins University, Baltimore, Maryland

A wide range of corrosion reactions causes the degradation of historical monuments. Because corrosion is a major failure mechanism that the restorer or conservator of historical monuments must constantly confront, knowledge of the science and engineering principles that govern corrosion processes is essential in the development of conservation and restoration procedures. It is therefore necessary to describe in detail the mechanisms that are relevant to such important restoration projects as the Statue of Liberty.

The corrosion of metals in the gaseous and aqueous environments in which historical monuments find themselves involves the setting up of electrochemical corrosion cells. The corrosion produced by these cells is controlled by thermodynamic and kinetic factors. The thermodynamic factors determine the tendency of the monument to corrode; the kinetic factors determine how fast the corrosion will take place and is used in deciding whether the rate at which corrosion occurs is acceptably slow.

For most alloys, the corrosion rate is mainly dependent on the protective properties of the thin passive films that exist on the surfaces of these alloys. The quality of the protection afforded by passive films is related to their ability to resist chemical breakdown by damaging species and, once broken down, their ability to reform rapidly (repassivate). The interplay between breakdown and repassivation is important in determining whether or not historical monuments will suffer pitting, crevice corrosion, stress corrosion, or intergranular corrosion. Moreover, there are also useful forms of corrosion products (namely patinas) that can be used in the restoration of metallic monuments. (For a discussion of the atmospheric corrosion that results in the formation of patinas, see Graedel and Franey, "Formation and Characteristics of the Statue of Liberty Patina" elsewhere in this publication.)

This paper describes some of the science and engineering that underlies corrosion—a major cause of the deterioration of the Statue of Liberty during its first 100 years. The most important corrosion mechanisms that contribute to the degradation of such monuments are discussed, and the principles underlying the phenomenon of corrosion and the major forms of corrosion that may cause the deterioration of metallic sculptures are briefly described.[1,(1)]

☐ The Electrochemistry of Corrosion

Corrosion occurs on outdoor monuments because of the aqueous solutions present that contain dissolved salts, such as the ever-present sodium chloride, especially in sea atmospheres. It is therefore necessary to provide a detailed background of the electrochemical principles relevant to corrosion processes.

Corrosion Cells

A metal surface exposed to a conducting electrolyte of the sort provided by rainwater on monuments containing salts becomes the site for two chemical reactions: an oxidation or anodic reaction that produces electrons as, for example,

$$Cu = Cu^{++} + 2e^- \tag{1}$$

(1)A more detailed treatment of the fundamentals of corrosion can be found in textbooks such as that by Fontana and Greene (see Reference 1).

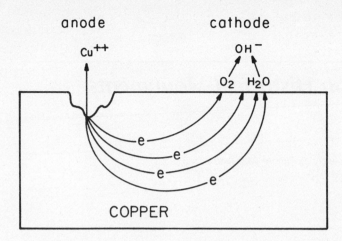

FIGURE 1. *The electrochemical cell set up between anodes and cathodes on a corroding copper surface.*

and a reduction or cathodic reaction that consumes the electrons produced by the anodic reaction, such as

$$O_2 + 2H_2O + 4e^- = 4OH^- \quad (2)$$

$$O_2 + 4H^+ + 4e^- = 2H_2O \quad (2a)$$

$$2H^+ + 2e^- = H_2 \quad (3)$$

The cathodic reaction represented by Equation (2) is usually the most relevant to monument corrosion, since such corrosion occurs at nearly neutral pH values, but Equations (2a) and (3) must sometimes be considered in confined areas (pits, crevices) where the pH can reach acidic values because of hydrolysis reactions, such as

$$Cu^{++} + 2H_2O = Cu(OH)_2 + 2H^+ \quad (4)$$

which produces hydrogen ions the concentration of which can become large because the H^+ ions cannot move out readily from the confined areas.

Because these anodic and cathodic reactions are occurring simultaneously on a metal surface, they create an electrochemical cell (battery) (Figure 1). The sites of the anodes and cathodes of the corrosion cell are determined by many factors. First, they are not necessarily fixed in location; they can be adjacent or widely separated. For example, if two metals are in contact, one metal can be the anode and the other the cathode, leading to galvanic corrosion of the more anodic metal. Variation over a surface in oxygen concentration in the environment can create anodes at those sites exposed to the environment containing a lower oxygen content. This results in corrosion by differential aeration (see next section). Similar effects can occur from variations in the concentration of metal ions or other species in the environment. Such differences in environment can result from the orientation of the corroding metal.

A vertical metal surface corrodes because gravity can change the concentration of environmental species near its bottom. Finally, variations in the homogeneity of the metal surface, because of the existence of inclusions, different phases, grain boundaries, stressed metal, and other causes, lead to the establishment of anodic and cathodic sites. At the anodic sites, the dissolution of metal as metallic ions in the electrolyte occurs. This destructive process is called corrosion. The flow of electrons between the corroding anodes and the noncorroding cathodes is the corrosion current. Its value is determined by the rate of production of electrons by the anodic reaction and their consumption by the cathodic reaction. The rates of electron production and consumption must be equal, of course, or a build-up of charge occurs.

The Tendency to Corrode—Corrosion Thermodynamics

A driving force exists that makes electrons flow between the anodes and cathodes of the corrosion cell. This driving force is the difference in tendency between the anodic and cathodic sites. The difference exists because each oxidation or reduction reaction has associated with it a potential determined by the

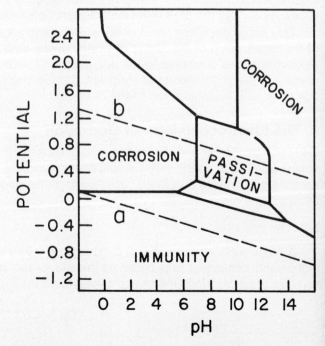

FIGURE 2. *The Pourbaix (potential–pH equilibrium) diagram for copper.*[2]

tendency for the reaction to occur spontaneously. The potential is a measure of this tendency.

An extremely useful way to study the relation of potential to corrosion is through an equilibrium diagram developed by Pourbaix[2] that plots potential vs pH, a parameter also of great importance to corrosion processes. Figure 2 shows a simplified Pourbaix diagram for iron. The potential plotted is the potential of copper as measured vs a standard hydrogen reference electrode.[2] The Pourbaix diagram allows one to determine whether or not a metal surface is in a region of immunity, where the tendency for corrosion is zero, in a region where the tendency for corrosion is high, or in a region where the tendency for corrosion may still be present but where there is a tendency for a protective corrosion product film to form. This film does not affect the tendency for corrosion, but it can affect the rate of corrosion, and, in a practical way, stop it. Rate of corrosion and protective films (passivity) will be discussed later. Lines A and B in Figure 2 represent, respectively, Equations (2) or (2a) and (3). Their positions are controlled by the concentration of oxygen or hydrogen in solution. Lines A and B describe the variation of potential with pH for solutions in equilibrium with one atmosphere of either oxygen or hydrogen. Lines drawn parallel to A but lower would give the variation of potential with pH for a solution containing less oxygen than that represented by A. The potential of a specimen can thus give some measure of the oxygen concentration in the environment. The difference in oxygen concentration between different sites on a metal leads to the differential aeration corrosion mentioned above. The Pourbaix diagram is, therefore, a corrosion "road map" that guides one to the potential–pH regions where there are tendencies for corrosion, immunity passivation. The diagram also allows one to estimate the influence of limited or ready access of oxygen to the corrosion process.

The Rate of Corrosion—Corrosion Kinetics

If one determines corrosion tendencies from the measurement of potentials, it is still necessary but not sufficient to ascertain whether or not a metallic monument will suffer corrosion under a given set of environmental conditions, because, while the tendency for corrosion may be strong, the rate of corrosion may be very low and may not be a problem. To understand how corrosion rates are determined, it is necessary to describe the experimental method used to measure them. A simple version of the apparatus used is shown in Figure 3.

A current from the battery (A) is applied to the metal surface (B) being measured in an environment of interest (C), for example, seawater, by means of the use of an inert auxiliary electrode (D). The flow of electrons supplied by the battery via the auxiliary electrode causes the potential of the metal (B) to change from the value it exhibits at open circuit (open-circuit potential or rest potential). The potential of (B) is determined vs the potential of a reference electrode (E) by using a high-impedance voltmeter (F); the current is measured by an ammeter (G). When the potential of the metal surface is changed by the flow of current to it, it is said to be polarized. If it is polarized so that the potential increases, it is said to be anodically polarized; a decrease in potential occurs when it is cathodically polarized. The anode of a corrosion cell is negative and the cathode positive. Figure 4 shows why the signs of the anode and cathode of the corrosion cells are, respectively, negative and positive. The ends of the dashed lines approach the values of the potentials for the reversible anodic and cathodic reactions [Equations (1) through (3)]. These reactions determine the fact that the anode potential is negative to the cathode potential. The degree of polarization (the degree of potential change as a function of amount of current applied) is a measure of how the rates of the anodic and cathodic reactions are retarded by environmental and surface factors. Using the apparatus shown in Figure 3 to determine the variation of potential as a function of current (a polarization curve) allows one to study the effect of these factors on the rate at which anodic or cathodic reactions can give up or accept electrons. Hence, polarization measurements allow one to determine the rate of the reaction that is involved in corrosion— the corrosion rate.

Figure 4 shows in a simplified way how the corrosion rate can be obtained from anodic and cathodic polarization curves. Initially, the metal surface being measured is at the open-circuit or rest potential, and no current is

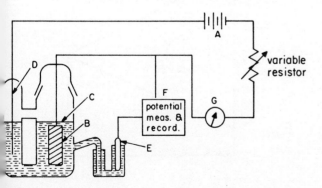

FIGURE 3. *Schematic diagram for apparatus used to determine polarization curves for metals in electrolytic solutions: A—battery, B—specimen, C—test environment, D—auxiliary electrode, E—reference electrode, F—high-impedance voltmeter, and G—ammeter.*

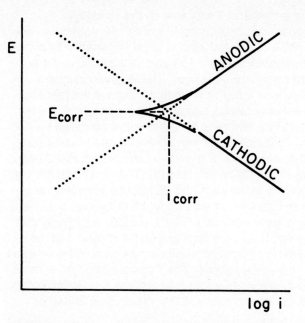

FIGURE 4. *Schematic plot of potential, E vs current density log i curve, polarization curves, produced by making the metal surface measured an anode first and then a cathode. The extrapolations of the anodic and cathodic curves (dashed lines) produce the Evans diagrams given in Figure 5.*

being applied. This open-circuit potential for metal in an aqueous environment is also called the corrosion potential (E_{corr}) because it is the potential at which corrosion is occurring.

At the corrosion potential, the rate of the anodic reaction is equal to that of the cathodic reaction, and these rates are equal to the corrosion rate. As pointed out earlier, the flow of electrons (the current between the anodic and the cathodic sites) is the corrosion current, and this current is directly proportional to the corrosion rate (i_{corr}), which has current density units (A/cm^2). To determine i_{corr}, one produces an anodic polarization curve (A) by applying a series of positive currents and determining the potentials that the surface exhibits for each applied current value. The cathodic polarization curve is produced in a similar manner by applying a series of negative currents. When the potential is plotted as a function of the logarithm of the current [or, more correctly, current density (A/cm^2)], a portion of the polarization curve will usually be linear, and it is possible to extrapolate the anodic and cathodic linear portions of the polarization

curves to the corrosion potential (E_{corr}), where, under ideal conditions, they should intersect. The value of the currents at their intersection will be the rate of corrosion (i_{corr}). These extrapolated linear portions can be extrapolated further until the anodic line reaches the reversible potential (the potential where the metal is in equilibrium with its ions) of the anodic reaction and the cathodic line, the reversible potential of the cathodic reaction. Such an extrapolation produces the diagram shown in Figure 5, called an Evans diagram.

□ Passivity

While all metals have a region in their Pourbaix diagrams labeled "passivity," a region where corrosion product films have a tendency to form, only certain metals exhibit the phenomenon of passivity. The passivity exhibited by these metals is a crucial factor in controlling the rate of corrosion. This is especially so for the more modern alloys (stainless steels, titanium, aluminum) that are used in more recent sculptures. A great deal of research (which has resulted in considerable controversy) has been involved in answering the question, "What is responsible for the phenomenon of passivity?" (See Reference 3 for an extensive treatment of the passivation phenomenon.) In this paper, it is sufficient to characterize the passivity as the conditions existing on a metal surface because of the presence of a protective film that markedly lowers the rate of corrosion, although from thermodynamic (corrosion tendency) considerations one would expect active corrosion. Figure 6 depicts an idealized anodic polarization curve for a metal surface that can be passivated and can serve as a basis for defining passivity.

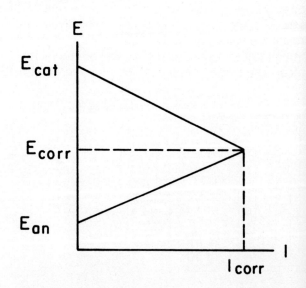

FIGURE 5. *Evans diagrams produced from the extrapolation shown in Figure 4, where E_{an} and E_{cat} are, respectively, the reversible (equilibrium) anodic and cathodic potentials.*

A surface that does not exhibit passivity has an anodic polarization curve that looks like the anodic curve of Figure 4.

For such a surface, as the potential (corrosion tendency) of the surface is increased, the current (corrosion rate) also increases. In Figure 6, however, the anodic polarization curve is that of metal that exhibits an ability to become passive. Here, the current initially rises as the potential rises, but when the potential reaches the value of the passivating potential (E), the critical current density for passivation is reached, and a significant drop in current density is observed. Passivity has commenced and, even if the potential rises higher, the current density (corrosion rate) will remain at the low passive current density (i_p). The potential cannot be increased indefinitely because at sufficiently high values the current density begins to rise, and either pitting ensues or the transpassive region is entered. In the transpassive region, oxygen evolution, and possibly increased corrosion takes place. The corrosion potential of a metal surface is determined, as mentioned above, by the intersection of the anodic and cathodic polarization curves, where the anodic and cathodic reaction rates are equal. Therefore, although metal may be capable

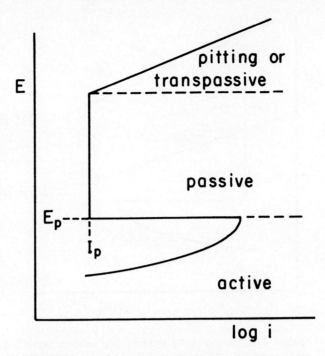

FIGURE 6. *A schematic anodic polarization curve for passive metal. Three different potential regions are identified. E_p is the potential above which the system becomes passive and exhibits the very low passive current density (i_p).*

of exhibiting passivity, its corrosion rate will depend on where the cathodic polarization curve intersects the passive metal anodic curve of the type shown in Figure 6. Figure 7 shows three possible cases. If the cathodic reaction produces a polarization curve such as (A), which is indicative of oxidizing conditions, the corrosion potential will be located in the passive region, and the system can exhibit a low corrosion rate. If the cathodic reaction produces Curve (B), which is indicative of reducing conditions, the corrosion potential will be in the active region, and the corrosion rate can be high. Curve (C) represents

an intermediate case where passivity, if it exists at all, will be unstable, and the surface can either exhibit an active or a passive state. Figure 8 shows the possibility of a fourth cathodic curve—one leading to a pitting situation.

□ Types of Corrosion

The mechanisms of the various types of corrosion depend on the principles just described. These different forms of corrosion can be divided into two groups: general corrosion and localized corrosion.

General Corrosion

General corrosion is usually predictable because it results from electrochemical reactions that occur uniformly over the entire surface of a metallic object and can thus be measured more reliably than localized corrosion. The damage caused by uniform corrosion, sometimes called wastage, is usually manifested in the progressive thinning of a metallic sheet, such as that used in the Statue of Liberty, until it virtually dissolves away or becomes a delicate lace-like structure.

Galvanic corrosion—Two metals having

FIGURE 7. *The intersection of three possible cathodic polarization curves (straight lines A, B, C) with an anodic polarization curve for a system capable of exhibiting passivity. The corrosion rate depends on the current density at the intersection. Curve A produces a passive system, Curve B an active system, and Curve C an unstable system that can exhibit both low and high corrosion rates.*

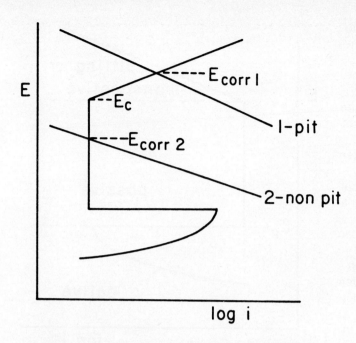

FIGURE 8. *Example of pitting and nonpitting systems, depending on whether or not E_{corr} is located above or below E_c, the critical potential for pitting.*

different potentials in a conducting electrolyte results in the galvanic corrosion of the more anodic metal. In galvanic corrosion, the anodic and cathodic sites of the corrosion cell exist because of the electrical contact of two different metals, rather than because of differences existing on the surface of the same metal.

The value for the differences in potential between two dissimilar metals is usually obtained from a listing of the standard oxidation potentials [reaction of the type given in Equation (1)] for the various metals. Since the standard oxidation potentials assume bare metal surfaces in a standard solution containing their ions at unit activity, they are not reliable guides to the corrosion tendencies of the anodic member of a corrosion cell produced by two coupled dissimilar metals. However, metals used have films on their surfaces and are exposed to nonstandard environments. A much more reliable guide is the practical galvanic series of potentials for metals in seawater.[4]

The corrosion suffered by the iron armature pieces coupled to the copper sheathing in the Statue of Liberty was probably galvanic corrosion.

Dealloying or parting corrosion—When one component of an alloy is selectively removed by corrosion (resulting in an increase in the concentration of the remaining components), parting corrosion, or dealloying, occurs. This type of corrosion is also called selective leaching, or dezincification form of corrosion (after the most common example, the selective leaching out of zinc from brass art objects). This leads to a mechanically weak, sometimes crumbling metal object. Graphitization is another important and somewhat misleading name for a form of selective etching suffered by gray cast iron when iron is selectively leached out, leaving behind a graphite matrix.

Localized Corrosion

An effective passive film must keep the corrosion current on a metallic surface at an acceptable level. To remain effective, such a film must resist the breakdown processes that lead to the forms of localized corrosion that are some of the major deterioration mechanisms for outdoor monuments: pitting, crevice corrosion, intergranular erosion, and stress corrosion. The breakdown processes lead to the disruption of the passive film and the exposure of discrete bare sites on the monument surface to an environment in which the tendency for attack is very high. Two kinds of breakdown processes exist: chemical and mechanical. The mechanism of chemical breakdown is poorly understood. A description of the various modes proposed for chemical breakdown has been given by Kruger.[5] Among the mechanisms proposed for chemical breakdown are desorption of the species (for example, oxygen) responsible for the passive film by a damaging species, penetration of the passive film by a damaging species, and a chemomechanical rupture of the passive film by mutual repulsion of adsorbed damaging species. It should be noted that all of these mechanisms involve a damaging species. Unfortunately, one of the major species causing breakdown of passivity is the chloride ion, a damaging species abundantly available in outdoor environments. Mechanical breakdown occurs when the passive film is ruptured as a result of applied or residual stresses on artistic metallic structures. Fortunately, competing with the breakdown processes are repair processes, or repassivation. Thus, a corrosion-resistant alloy would be one the surface of which not only forms a passive film that resists the processes leading to breakdown but that is also capable of repassivating at a rate sufficiently high that once a breakdown has occurred, exposure to a corrosive environment is minimal. This competition between the breakdown and repair processes of passive films is a useful basis for discussion of the forms of localized corrosion affecting outdoor metallic monuments.

Pitting corrosion—The initiation of a pit occurs when a chemical breakdown process exposes a defect on a metal surface to chloride ions. The sites where pits initiate are poorly understood, but some possible locations are at surface compositional heterogeneities (inclusions), scratches, or places where

environmental variations exist. The pit will propagate if rapid repassivation does not prevent the production of a high local concentration of metal ions produced by dissolution at the point of initiation. If the rate of repassivation is not sufficient to choke off the pit growth, two new conditions develop. First, the metal ions produced by the breakdown process are precipitated as solid corrosion products [see Equation (4)], which usually cover the mouth of the pit. This covering over of the pit restricts the entry or exit of ions in or out of the pit and allows the build-up of hydrogen ions through a hydrolysis reaction of the sort given by Equation (4). Also, the chloride ion concentration builds up because a diffusion of chloride becomes necessary to maintain charge neutrality in the pit. In the highly acidic, high chloride ion and high metallic ion concentrated solution in the pit, repassivation becomes even more difficult and pit penetration accelerates. The pit is the anode of a corrosion cell, and the cathode of the cell is the nonpitted surface.

Since the surface area of the pit is a very small fraction of the cathodic surface area, all of the anodic corrosion current is involved with a very small surface area. Thus, the anodic current density becomes very high, and penetration of the metal skin of a monument such as the Statue of Liberty can be rapid.

Crevice corrosion—Crevice corrosion occurs when a portion of a metal surface is blocked in such a way that the shielded portion has limited access to the surrounding environment. The surrounding environment must contain aggressive corrosion species, usually chloride ions. A typical example of a crevice corrosion situation would be the crevice formed at the area where two metallic parts come together. Because the electrolyte (rainwater containing chloride ions) in the crevice has limited access to the surrounding electrolyte, reactions of the sort given by Equations (1) through (4) cause a build-up, over a considerable induction period, of metallic ions and hydrogen ions (lowering of pH) and a decrease in oxygen (O_2) concentration. Because hydroxide ions are used up by Equation (4), chloride ions are forced to migrate into the crevice to maintain charge neutrality. Other negative ions such as hydroxide have lower mobility than chloride, and an increase in chloride ion concentration results, thereby also increasing the concentration of this damaging species in the crevice solution along with the concentrations of metal ions and hydrogen ions (see Figure 9). The environment that eventually forms in the crevice is similar to that formed under the precipitated corrosion product cover in a pit. Likewise, the interior of the crevice, because its oxygen concentration is lower than that in the surrounding medium, is the anode of the corrosion cell it forms with the more cathodic unshielded surface. This combination of being the anode of a corrosion cell and existing in an acidic, high-chloride environment where repassivation is difficult makes the crevice interior subject to corrosive attack (Reference 1).

Intergranular corrosion—All metals used for sculptures are made up of small crystals or grains, the surfaces of which join the surfaces of other grains to form grain boundaries or small regions adjacent to the boundaries can under certain conditions be considerably more reactive (by being more anodic) than the interior of the grains. The resulting corrosion at the boundaries is called intergranular corrosion. It can result in a loss of strength of monumental structure or the production of debris (grains that have fallen out).

Erosion-corrosion—Erosion-corrosion results from a disruption of protective passive films by erosive or abrasive processes. In the case of erosion, protective films are removed by the rapid movement of a corrosive fluid, liquid or gas, with and without solid abrasive particles. An example of the kind of situation that would cause the erosion-corrosion of metallic monuments would be the abrasion by sand carried by a strong wind and rain. As with the number of other forms of localized corrosion, the rate of repair (repassivation) of these protective films determines whether or not erosion-corrosion is a serious problem.

Stress corrosion—Stress corrosion cracking (SCC) is a form of localized corrosion defined as a process that produces cracks in metals by the

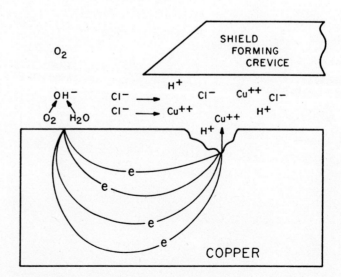

FIGURE 9. *Example of crevice corrosion of copper showing the acidification mechanism in the shield-forming crevice.*

simultaneous action of a corrodent and sustained tensile stress. Because of the necessity for the application of stress, the breakdown of the passive layer on a metal surface in SCC is generally ascribed to mechanical causes. A number of mechanisms have been proposed to explain SCC. Chief among these mechanisms are the following:

(a) *Stress-sorption mechanism:* This mechanism proposes that a specific species adsorbs and interacts with strained bonds at a crack tip, causing a reduction in bond strength.

(b) *Film rupture–metal dissolution mechanisms:* This mechanism proposes that the protective film normally present on a metal surface is ruptured by continued stress at the base of a scratch where the area of the exposed metal becomes a very small anodic region at which metal dissolution takes place. The rest of the metal surface, especially the walls of the crack, acts as a cathode. Susceptibility depends on the rate at which the metal exposed by film rupture is repassivated as compared to the rate of metal dissolution.

(c) *Hydrogen embrittlement mechanisms:* In this mechanism, fracture results from the production of a brittle region at the crack tip because of the introduction of hydrogen into the alloy via cathodic reactions such as that given by Equation (3).

A detailed discussion of the chemistry, metallurgy, and mechanics involved in these mechanisms of SCC and the tests used to determine susceptibility to it is beyond the scope of this paper. (See Reference 6 for a detailed review of SCC.)

□ References

1. M.G. Fontana, N.D. Greene, Corrosion Engineering, 2nd ed. (New York, NY: McGraw-Hill, 1978).
2. M. Pourbaix, Lectures on Electrochemical Corrosion (New York, NY: Plenum Press, 1973).
3. R.P. Frankenthal, J. Kruger, Passivity of Metals (Pennington, NJ: The Electrochemical Society, Inc., 1978).
4. M.G. Fontana, N.D. Greene, Corrosion Engineering, 2nd ed. (New York, NY: McGraw-Hill, 1978), p. 32.
5. J. Kruger, Passivity and its Breakdown on Iron and Iron-Base Alloys, ed. R.W. Staehle, H. Okada (Houston, TX: National Association of Corrosion Engineers, 1976), p. 91.
6. H.L. Logan, The Stress Corrosion of Metals (New York, NY: John Wiley & Sons, 1966).

■ *Galvanic Corrosion on the Statue of Liberty*

Robert Baboian
Texas Instruments, Inc., Attleboro, Massachusetts

Iron and copper have a long history of use in artistic and historic works. On the Statue of Liberty, the iron armature provided support for the copper skin. Since the two metals were in electrical and electrolytic contact, this was an ideal configuration for galvanic corrosion. Corrosion of the iron was therefore accelerated up to one thousand times, leading to serious reduction in the armature support's ability to function properly. As a result of the galvanic corrosion process, rivets were pulled from the skin of the Statue because of the exfoliating forces of the corrosion products (rust).

Replacement of the iron armature was a necessary and important part of the restoration process. The choice of armature material was a difficult decision. Based on previous expriences with copper/stainless steel atmospheric exposure, results of specific laboratory and atmospheric exposure corrosion tests, and its mechanical and physical properties, type 316L (UNS S31603) stainless steel was chosen to replace the iron armature on the Statue. This paper presents results of atmospheric exposure tests performed at Kure Beach, North Carolina.

As previously mentioned, the configuration of the iron armature in contact with the copper skin of the Statue of Liberty provided a classic situation for galvanic corrosion. This type of degradation occurs when two or more metals are electrically coupled in the same electrolyte.[1] The rate of attack of one metal is usually accelerated, and the corrosion rate of the other is usually decreased. Factors affecting galvanic corrosion include (1) the difference in electrochemical potential between the metals, (2) the polarization behavior of the metals, (3) the physical and chemical nature of the environment, and (4) the geometric relationship of the component metals. All of these factors contribute to the problems of galvanic corrosion on the Statue of Liberty.[2-6]

In an aqueous sodium chloride (NaCl) environment, the difference in electrochemical potential for iron and copper is 400 mV.[1] This is a significant driving force for galvanic corrosion of iron in that environment. The polarization curves for iron and copper in 5% NaCl at 30°C are shown in Figure 1. These curves are used to demonstrate the magnitude of the problem through the use of the mixed-potential theory. The data in Figure 1 include the electrochemical steady-state potentials for each metal. Values of current density at these potentials are directly proportional to the corrosion rates for iron (i_{corr}, Fe) and for copper (i_{corr}, Cu) as determined from the polarization curves. The mixed potential for the coupled metals can be used to determine the galvanic corrosion rates for the metals from the polarization curves. The data in Figure 1 show that for equal areas of exposed metal in a galvanic couple yielding a mixed potential (E'_{corr}), the copper corrosion rate is reduced to i'_{corr}, Cu, and the corrosion rate of iron is increased to i'_{corr}, Fe. Thus, the corrosion rate of iron is increased by a factor of

■ 93 ■

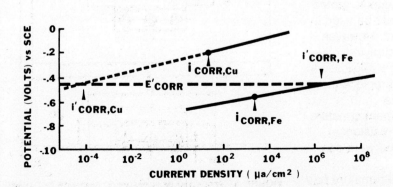

FIGURE 1. *Polarization curves and corrosion behavior of copper and iron in 5% NaCl solution, 30°C.*

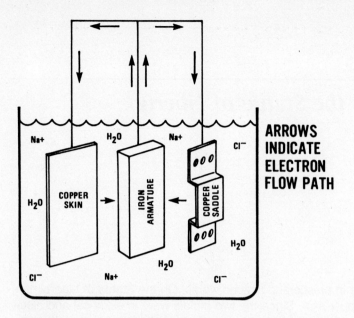

FIGURE 2. *Mechanism of copper/iron armature galvanic corrosion.*

100 in the galvanic couple with copper at equally exposed areas. The accelerating factor is even greater for copper/iron area ratios greater than unity.

The location of the Statue of Liberty in New York Harbor provides an aggressive environment for metallic corrosion.[2,3] The formation of seawater aerosols combined with deposition such as acid rain, snow, fog, dew, and dry acid deposits produce this environment. Drainage of this aggressive electrolyte into the Statue's interior occurred because it is not a sealed structure. In addition, wide temperature fluctuations within the Statue promoted condensation and precipitation.

The configuration of the over 1800 iron armature bars, which conformed to the copper skin of the Statue, provided an ideal geometric relationship for galvanic corrosion.[4] This was especially true in areas where the armature bars were attached to the copper skin through the use of copper saddles and copper rivets. In these areas, galvanic corrosion occurred by the mechanism shown in Figure 2. Copper completely surrounded the iron, and the resulting expansive forces (jacking) of the iron corrosion products caused the saddle rivets to be pulled through the copper skin in a large number of areas. The presence of shellac-impregnated asbestos placed between the iron and the copper to isolate the two metals compounded the problem, because this "ingenious insulation" served to absorb and trap corrosive electrolytes in the most critical areas where the iron was in close proximity to the copper. The high copper/iron area ratio throughout the Statue also increased the accelerating factor for the galvanic corrosion of iron.

The results of galvanic corrosion of iron on the Statue of Liberty were therefore very serious. First, rust stained the exterior skin because of drainage. Second, armature bars were weakened (for example in the torch, arm, shoulder, and crown). Third, copper saddle rivets were pulled through the copper skin by iron corrosion product jacking. Fourth, paint integrity could not be maintained in the armature areas. The problem was so serious that restoration work was necessary; an effort was therefore made to find a solution.

Methods of controlling galvanic corrosion include the use of (1) proper materials, (2) proper design, (3) electrical isolation, (4) electrolyte isolation, (5) transition materials, (6) cathodic protection, and (7) chemical inhibitors.[7] Several of these are not practical solutions to the Statue of Liberty problem. For example, the armature system designed by Eiffel could not be changed. Since only one contact point throughout the whole Statue would provide electrical continuity, it was considered impractical to electrically isolate the armature bars from the copper skin. Also, cathodic protection and chemical inhibitors could not be used in the indoor atmospheric environment. However, proper materials selection and electrolyte isolation were considered practical in this application. Therefore, a decision was made to replace the iron armature throughout the Statue.

In choosing a suitable replacement armature material, both chemical (corrosion resistance) and physical (mechanical) properties were considered.

The corrosion resistance of the armature bar/copper skin system includes two factors: (1) the

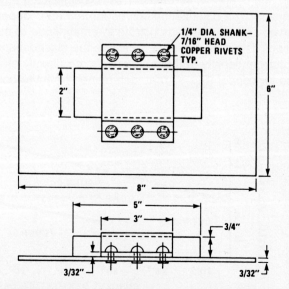

FIGURE 3. *Schematic of atmospheric corrosion test specimen for galvanic corrosion of armature materials.*

TABLE 1
Materials Used in Atmospheric Exposure Tests

Material	Metal	Source
Skin and Saddle	OFHC Copper	A.J. Oster
Rivets	Standard Copper	Local Supplier
Armature	Cold-Rolled Steel (C-1018)	Local Supplier
Armature	Aluminum Bronze (CA 61300)	AMPCO Metal
Armature	Cupro-Nickel, 70-30 (CDA 715)	Revere
Armature	Type 316L Stainless Steel (UNS S31603)	ARMCO
Armature	Ferralium (F-488E)	Cabot Corp.

TABLE 2
Retrieval Schedule for Panels in Armature/ Copper Skin Atmospheric Corrosion Study

Exposure Date	Exposure Period	Panels Removed
03/16/84	0	—
05/04/84	0	—
06/16/84	3 months	S1,B1,F1
08/04/84	3 months	C1,SS1
09/16/84	6 months	S2,B2,F2
11/04/84	6 months	C2,SS2
April 1986	2 years	S3,S4,B3,B4,C3, C4,SS3,SS4,F3,F4,F5
November 1988	4.5 years	S5,S6,B5,C5,SS5 F6,F7
November 1991	7.5 years	S6,B6,C6,SS7,F8, F9
April 1999	15 years	S7,S8,B7,B8,C7, C8,SS8,F10,F11,F12

S = Steel SS = 316L stainless steel
B = Aluminum bronze F = Ferralium
C = 70-30 cupro-nickel

■ 95 ■

TABLE 3
Results of Atmospheric Exposure Tests

	Fe		Al Bronze		Cu-Ni		Ferralium		316L	
	Fe	Cu	Al-Br	Cu	Cu-Ni	Cu	Ferral	Cu	316L	Cu
3 months	R	VVLG	SC	VLG	B	VVLG	B^2	VLG	B	VLG
6 months	TR	RP	SC	VVLG	SC	LG	B^2	VVLG	B	LG
2 years	ER	RP1,3	SC	LG	SC	VLG	B^2	VLG	B	LG
4.5 years	ER	RP1,3	SC	VLG	SC	VVLG	B^2	VLG	B	VLG

[A]Copper deformed.
[B]Rust on edge from iron "pickup."
[C]Near armature.

R = Rust LG = Light green
TR = Thick rust V = Very
ER = Exfoliating rust B = Bright metal
RP = Reddish-purple SC = Superficial corrosion

FIGURE 4. *Test specimens at atmospheric exposure test site, Kure Beach, North Carolina.*

inherent corrosion resistance of the armature metal and (2) the galvanic compatibility of this metal with the copper skin in the Statue of Liberty environment and configuration. To determine the suitability of various candidate armature-bar materials, TexasInstruments Incorporated (Attleboro, Massachusetts), in cooperation with the U.S. Department of the Interior National Park Service, conducted an atmospheric exposure test at Kure Beach.

The test consisted of five different armature materials attached to copper sheet using copper saddles and rivets. This configuration duplicates the one used on the Statue of Liberty and is shown schematically in Figure 3. A list of materials used along with alloy designations and sources is given in Table 1. The armature materials chosen for this study included cold-rolled steel, aluminum bronze, 70-30 cupro-nickel alloy, type 316L stainless steel and Ferralium.[†] These materials were chosen based on known mechanical properties and some knowledge of their corrosion behavior.

The test panels were fabricated and assembled in Texas Instruments Electrochemical and Corrosion Laboratory and are shown in Figure 4 during exposure at the INCO Ltd. LaQue Center for Corrosion Technology atmospheric test site at Kure Beach. This site faces the ocean at a distance of 80 feet (25 meters) and its accelerating effect on corrosion of materials is well documented. The inspection and retrieval schedule for the test panels is shown in Table 2. The test was initiated in two stages: on March 16 and on May 4, 1984.

A summary of the inspections of the atmospheric exposure test are listed in Table 3, and photographs of retrieved panels for exposure periods 3 months, 6 months, 2 years, and 4.5 years are shown in Figures 5 through 8. The behavior of steel armatures in this test is important in determining the validity of the atmospheric exposure in duplicating corrosion mechanisms observed on the Statue of Liberty. In fact, after only three months' exposure, the steel had rusted over the entire surface with some "rundown" onto the copper surface. During this period, only a slight acceleration was observed for the steel in the copper-saddle area. At the end of six months, severe corrosion of the steel armature was observed. Some undercutting of the steel in the saddle area indicates that galvanic corrosion was occurring. At the end of 2 years, jacking is observed, resulting from the very severe steel galvanic corrosion. Initial signs of distortion because of steel corrosion products beneath the copper saddle is observed in the 2-year specimens. At the end of 4-1/2 years, severe deformation of the copper panel and saddle occurred in the steel/copper test specimens. The corrosion of the steel is so severe that the thickness has been reduced up to 1/3, as observed in Figure 9.

The degree of corrosion observed in the test panels with steel armatures after 4-1/2 years appears to be similar to that observed in the more severe areas on the Statue of Liberty iron armature–copper skin after 100 years. Therefore, in the more corrosive areas on the Statue, the atmospheric exposure test at the Kure Beach 80-foot (25-meter) lot has an accelerating factor of about 22. The factor is much greater in less corrosive areas on the Statue.

After 3 and 6 months of exposure, the results for aluminum bronze, cupro-nickel, type 316L stainless steel, and Ferralium were similar. No accelerating effects on either the armature material or the copper saddle and skin were observed. With an accelerating factor of 22, the 6-month exposure period represents 11 years on the Statue of Liberty.

The results after 2-year and 4-1/2-year exposures were the same as the shorter exposures in that no accelerated corrosion resulting from galvanic effects was observed. Both the aluminum bronze and cupro-nickel armature bars had superficial corrosion typical of these materials and showed excellent corrosion resistance. Both type 316L stainless steel and Ferralium were bright after these exposure pe-

[†]Trade name.

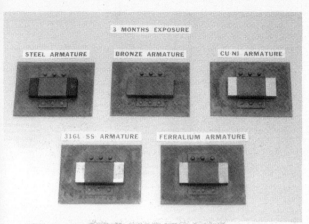

FIGURE 5. *Test specimens after 3 months of exposure.*

The compatibility of type 316L stainless steel with copper can be explained by the polarization curves in Figure 10. Unlike the polarization curve for iron in Figure 1, type 316L stainless steel exhibits a wide range of potentials in which the corrosion current is invariant and very low. Thus, the stainless steel corrosion rate in the range of the type 316L stainless steel/copper mixed potential is very low when isolated or galvanically coupled to copper.

The choice of type 316L stainless steel to replace the iron armature was based on its mechanical properties as well as its corrosion resistance. Its strength and ductility provide characteristics that match those of iron, so the dimensions of the replacement bars are the same as the original iron bars.

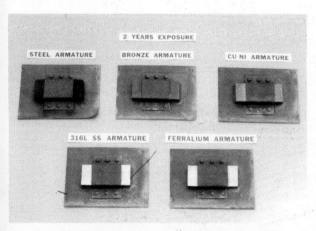

FIGURE 7. *Test specimens after 2 years of exposure.*

riods. Some rust stains were observed on the edges of the Ferralium, but this resulted from iron "pickup" from the cutting tools during fabrication.

During the exposure periods, the copper saddles and panels developed a light green patina of varying intensity evenly over the surface (except with cold-rolled steel). The compatibility of copper with aluminum bronze, cupro-nickel, type 316L stainless steel, and Ferralium is demonstrated by this result. The magnitude of the galvanic incompatibility of steel and copper is demonstrated by the decreased tendency towards patina formation on the copper in the area of the steel armature. This observation is in compliance with galvanic corrosion principles whereby the corrosion of the more active metal (steel) is accelerated and corrosion of the more noble metal (copper) is retarded.

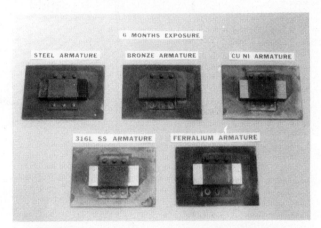

FIGURE 6. *Test specimens after 6 months of exposure.*

The actual configuration used on the Statue is shown in Figure 11. This design incorporates the use of skived Teflon[†] between the copper and thestainless steel to interrupt the electrolyte continuitybetween the copper and the stainless steel in case the environment becomes severe inside the Statue in the future. This can break the electrolyte bridge between the two metals. In addition, the Teflon provides a property of lubricity between the copper and armature during periods of relative movement due to wind and other weather factors.

□ **Summary**

Atmospheric exposure tests have demonstrated the incompatibility of steel when galvanically coupled to copper in the copper-saddle/armature-bar/copper-skin configuration of the Statue of Liberty. The test also shows that other materials, including aluminum bronze, cupro-nickel alloy, type 316L stainless steel and Ferralium, have low corrosion rates and excellent compatibility with copper in the atmosphere. The magnitude of the corrosion observed in the test indicates that for the worst locations on the Statue of Liberty, the accelerating factor is about 22 for galvanic corrosion. Therefore, 6 months of exposure in this test is equivalent to 11 years on the inside skin of the Statue.

[†]Trade name.

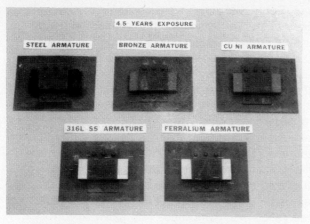

FIGURE 8. *Test specimens after 4.5 years of exposure.*

FIGURE 9. *Steel/copper specimen after 4.5 years showing exfoliating rust.*

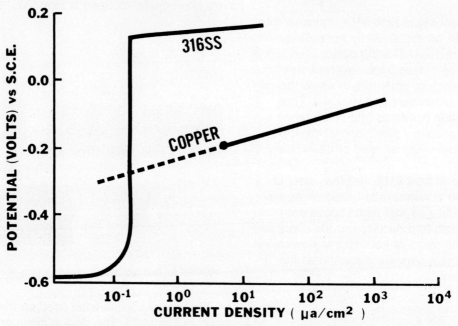

FIGURE 10. *Polarization curves and corrosion behavior of copper and 316L stainless steel in 5% NaCl solution, 30°C.*

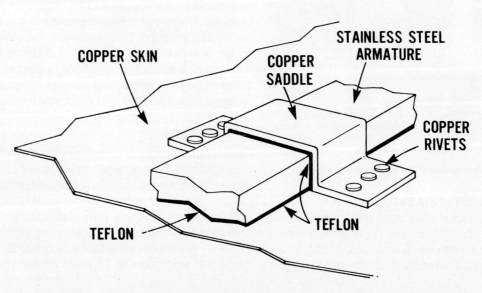

FIGURE 11. *Configuration of stainless steel armature with copper skin, saddle, and Teflon.*

The atmospheric exposure test results after 6 months (simulating 11 years of exposure on the Statue) showed that the candidate armature materials consisting of aluminum bronze, 70-30 cupro-nickel alloy, type 316L stainless steel, and Ferralium were suitable from a corrosion-resistance standpoint.[1] The type 316L stainless steel was chosen to replace the iron armature on the Statue of Liberty not only because of its excellent corrosion resistance and compatibility with copper, but also because of its strength, ductility, and ability to be fabricated.

□ References

1. R. Baboian, Controlling Galvanic Corrosion, Machine Design Oct. 11(1979).
2. R. Baboian, Standardization News March(1986): p. 34.
3. R. Baboian, E.B. Cliver, Materials Performance 25, 3(1986): p. 80.
4. R. Baboian, E.B. Cliver, Materials Performance 25, 4(1986): p. 74.
5. R. Baboian, E.B. Cliver, Materials Performance 25, 5(1986): p. 80.
6. R. Baboian, E.B. Cliver, Materials Performance 25, 6(1986): p. 80.
7. R. Baboian, Galvanic Corrosion, Chapter 3, in Forms of Corrosion—Recognition and Prevention, (Houston, TX: National Association of Corrosion Engineers, 1982).

[1] Subsequent retrievals after 2 years and 4-1/2 years as reported in this paper and representing over 100 years' exposure in the Statue of Liberty confirmed the behavior observed at the 6-month exposure period.

■ Formation and Characteristics of the Statue of Liberty Patina

Thomas E. Graedel and John P. Franey
AT&T Bell Laboratories, Murray Hill, New Jersey

The aesthetically pleasing and protective green patina that forms on copper when it is exposed to the atmosphere is complex, and its formation mechanisms are poorly understood. Using modern analytical techniques, 16 patina samples from the Statue of Liberty and elsewhere in the New York City metropolitan area have been examined in detail. A number of new components of copper patinas have been revealed. The analytical results, combined with atmospheric chemical information, have been used to deduce detailed mechanisms of the patina process. The relative abundances of the minerals that are the primary patina components are shown to be a consequence of the chemical constraints imposed on the system by thermodynamics and by the atmospheric concentrations of reactive species. The growth of the patina on the Statue of Liberty is deduced to have been initially constrained by the supply of atmospheric sulfur, at intermediate times by the rate of cementation of patina components, and at later times by the rate of diffusion of copper ions through the evolving patina layer.

When the Statue of Liberty was erected, its copper skin was the dull brown shade of an old penny. Over the years, the interactions of this copper skin with the atmosphere created a greenish-blue patina. This color change implies the existence of complex and interesting physical and chemical processes.

With the goal of determining the atmosphere-surface mechanisms responsible for the formation of the patina, we studied two sets of copper patina samples. The first set (nine samples) consisted of fragments from various locations on the copper exterior of the Statue of Liberty, made available as a consequence of the centennial restoration project. The second set (seven samples) came from several copper roofs installed over a period of nearly a half century at AT&T Bell Laboratories (Murray Hill, New Jersey). The exposure times of the combined set of samples ranged from 1 to 100 years. The samples constituted an unparalleled set of copper patinas of wide exposure range, common geographic vicinity, and essentially undefiled nature. These samples have been subjected to many experimental analyses and the results interpreted in light of the chemistry of the atmosphere to which the samples were exposed. This paper summarizes the results of these studies.

⬚ Analytical Chemistry of the Patinas

The principal constituents of the Statue of Liberty and Murray Hill patinas are similar to those observed on other copper and bronze samples following extended exposure. We list them in Table 1, together with their chemical formulas. Brochantite is generally the most abundant of the minerals in these samples. On some samples from the Statue of Liberty, however, antlerite or atacamite predominate. Cuprite, the normal form of oxide on copper exposed to the atmosphere, is present on the exteriors of several of these samples. Chemical equilibrium analyses indicate that these minerals are the most stable under atmospheric conditions.[4,5] An interesting find is the mineral posnjakite. The component was detected on the roofing copper cupola temporarily installed at the Statue of Liberty during 1984-1985 while the old torch and flame were removed and the new torch and flame were being fashioned. Posnjakite has also been seen on copper exposed for one year at Murray Hill, but not to any degree on samples exposed for longer periods of time. Because posnjakite differs from brochantite only in having water of hydration and in forming weakly bound, sheet-type crystals, posnjakite is probably a precursor to the formation of brochantite in the patina.

STATUE OF LIBERTY

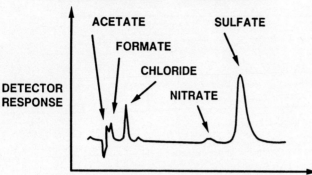

FIGURE 1. *A chromatogram for soluble ions in the patina from the Statue of Liberty. The data are from Reference 3.*

CHLORIDE AS HCl

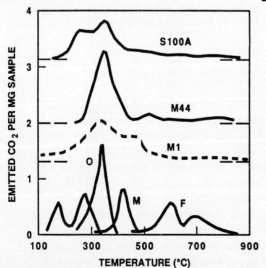

FIGURE 3. *Emitted gas analyses for chlorine (as hydrogen chloride) in several samples of copper patinas (adapted from Reference 1).*

CARBON COMPOUNDS AS CO$_2$

FIGURE 4. *Emitted gas analyses for carbon (as carbon dioxide) in several samples of copper patinas (adapted from Reference 1).*

■ 102 ■

DEPTH PROFILES
OF PATINA COMPONENTS

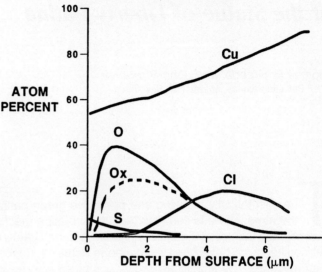

FIGURE 2. *An Auger spectroscopy depth profile for major elements in the patina of copper from the Statue of Liberty.[7] Carbon, which is abundant near the surface and much less abundant as depth increases, is not shown. The curve labeled "OX" is the oxide profile, derived by assuming the sulfur to be present as brochantite and subtracting the brochantite oxygen from the "O" curve.*

In addition to these minerals, Table 1 lists the minor components found in the Statue of Liberty patinas, several discovered for the first time in any patina samples. The list includes three carboxylic acid salts, copper nitrate, a number of fatty acids, and small amounts of malachite and other trace minerals.

The mineral components of the patina were determined by x-ray diffraction analysis and confirmed by emitted gas analysis (EGA). To detect soluble ions, the surface of the Statue was wiped with sections of filter paper treated with water or acetone. Subsequent extraction of the filter paper followed by characterization of the extract by ion chromatography revealed the presence of several ionic constituents. A typical ion chromatogram is shown in Figure 1.

Auger electron spectroscopy was used to study the relative concentrations of the major elements in the patinas as functions of depth. Traces of carbon and substantial amounts of sulfur were found; each was concentrated near the surface. Chlorine was abundant in nearly all samples (probably as chloride, though the analysis revealed the presence but not the chemical environment of the element) and was largely present within the patina rather than on its exterior. This pattern is shown by the depth profile in Figure 2. Atmospheric chlorine is almost always present in soluble form, and the depth profiles thus suggest that chlorine-containing precipitation or

TABLE 1
Components of the Statue of Liberty Patina[1-3]

Major[A]	Cuprite	[Cu_2O]
	Brochantite	[$Cu_4(SO_4)(OH)_6$]
	Antlerite	[$Cu_3(SO_4)(OH)_4$]
	Atacamite	[$Cu_2Cl(OH)_3$]
	Posnjakite	[$Cu_4(SO_4)(OH)_6 \cdot H_2O$]
Minor	Malachite	[$Cu_2(CO_3)(OH)_2$]
	Copper (II) formate	[$Cu(O_2CH)_2$]
	Copper (II) acetate	[$Cu(O_2CCH_3)_2$]
	Copper (II) nitrate	[$Cu(NO_3)_2$]
	Copper (II) oxalate	[$Cu(C_2O_4) \cdot xH_2O$]
	Fatty acids	
	Trace minerals	

[A]Present in at least one sample at an abundance of 10% or more by volume.

TABLE 2
*Surface Densities of Copper Patina Components,
New York City Metropolitan Area[A]*

Component	Density[B]	Reference
Solid Phase:		
S	190	9
Cl	1150	9
O	1900	9
Soluble ions:		
SO_4^{2-}	30	2
NO_3^-	0.2	2
Cl^-	3	2
$HCOO^-$	5×10^{-3}	2
CH_3COO^-	0.2	2
Organics:		
$C_{20}-C_{30}$ alkanes	1×10^{-2}	2
Olefinic acids	2×10^{-3}	2
Alkanic acids	1×10^{-3}	2

[A]These data are derived from sample M44.
[B]Atoms, ions, or molecules per A^2.

sea salt was absorbed into the porous patina and became trapped there when drying occurred.[6]

The chemical form of the chlorine can be examined by EGA, in which a powdered sample is heated in vacuum and the emitted gases are analyzed by mass spectrometry. The results of an EGA analysis on some of the copper patinas are shown in Figure 3, together with the EGA pattern for atacamite. Because most of the chlorine is emitted at temperatures different from the temperature range typical of atacamite, the results indicate that much of the chlorine is not present in mineral form and support the suggestion that dried sea salt and noncrystalline forms of chlorine may be present.

EGA can also be applied to the patinas to search for inorganic and organic carbon compounds. Typical analyses of this type are shown in Figure 4. The EGA curves indicate the presence of malachite (the common carbonate) and oxalate in most of the samples, though at differing relative amounts. Formate is not revealed in these data, and its signature in the ion chromatographic analysis is thought to be related to its high solubility rather than to its high concentration in the patina.

It has often been suggested that the development of copper patinas could be markedly influenced by the details of sample orientation or exposure (e.g., 8). We have attempted to examine this suggestion but have had too few samples to determine if the different crystalline components or trace species are strongly related to altitude, direction of exposure, inclination, solar radiation, or other physical factors.

In addition to the qualitative analysis of patina constituents, we and our colleagues derived quantitative information on constituent abundances.[9] A typical analysis appears in Table 2. Oxygen is the most abundant solid-phase component, but chlorine is also abundant. The sulfur concentration is about one-tenth that of oxygen. (Note that each brochantite stoichiometric unit requires 1 sulfur atom and 10 oxygen atoms.) Of the soluble ions, sulfate is by far the most abundant. Despite its recently increasing concentrations in precipitation, little nitrogen (as nitrate) is retained in the copper patinas. The surface densities of the organic compounds do not seem very high, but the lipid-like molecules tend to be large. It is estimated that the densities are the equivalent of about 50 monolayers of molecules of surfactant character. These molecules might well play a role in the bonding of the patina minerals to each other.

☐ Stages of Copper Patina Formation

The evolution of the brochantite-rich patina layer is considered a sequential process, as shown in Figure 5. In the first stage, a thin, fragmented layer of cuprite is formed by the reaction of atmospheric oxygen with the bare copper in the presence of adsorbed water. In the second stage, copper ions permeating through the cuprite layer into the aqueous surface film meet and combine with sulfate ions originating in precipitation or in atmospheric particles. Alternatively, dissolved sulfur dioxide transforms into sulfate by oxidizers such as hydrogen peroxide. Ultimately, in the third stage of development, crystals of brochantite

COPPER PATINATION
STAGE 1

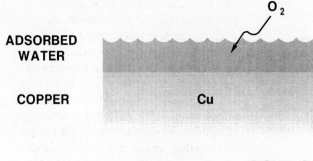

$$Cu + O_2 \ \text{-}\text{-}\text{-} \rightarrow \ Cu_2O$$

COPPER PATINATION
STAGE 2

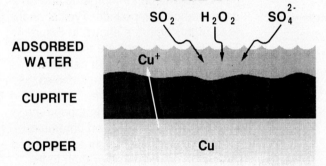

$$Cu^{2+} + SO_2 \xrightarrow{\ H_2O_2\ } CuSO_4$$

$$CuSO_4 \xrightarrow{\ Cu^{2+},\ H_2O\ } CuSO_4 \ x \ Cu(OH)_2$$

COPPER PATINATION
STAGE 3

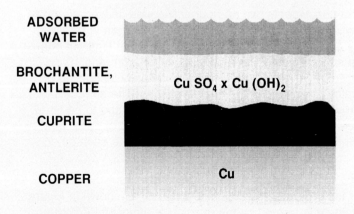

FIGURE 5. *Schematic diagrams of the various stages of the copper patination process. In Stage 1 (a), the surface color is coppery; in Stage 2 (b), it is brownish-black; and in Stage 3 (c), it is greenish-blue.*

■ 104 ■

and other minerals are nucleated at the solid-solution boundary. These crystals are then cemented into place by surface bonding, perhaps involving organic compounds as copper complexing agents. This latter suggestion arises because of the presence of organic compounds within the patina layer and from the observation that the patina exfoliates when wetted with acetone and rubbed with an abrasive pad, but not when rubbed with an abrasive pad after wetting by water or alcohol.

The kinetics of patina growth are reasonably well established for the New York City metropolitan area and elsewhere. In most cases, the growth of the terminal patina layer occurs rapidly during the first few years of exposure and becomes much slower thereafter. Such behavior is typical of a process the ultimate limit of which is diffusional in nature.[10]

What limits the growth of copper patinas? To answer this question, the rates of a number of potentially limiting physical and chemical processes in the modern atmosphere have been studied in detail. Since atmospheric corrosion requires the presence of surface water, an initial assessment was made of the duration of time when surface water is present on copper in New York Harbor as a result of high humidity, dew, fog, or active precipitation. The results of the assessment are shown in Figure 6. Adequate surface water is present during more than a third of all hours in a typical year. Thus, water availability poses no serious constraint to patina formation on copper in the New York Harbor.

A second possible constraint is the supply of copper ions required for the formation of the crystalline patina components. The copper ions are provided by permeation from the bulk copper through the overlying cuprite layer. Measurements of permeation fluxes through defect-laden crystals such as atmospherically formed cuprite are not available, but limits to the diffusion constants applicable to the process can be made;[9] they are shown in Figure 7. Initially, the diffusion constant will be that of copper ions in aqueous solution adjusted for the fractional volume of the patina estimated to be composed of absorbed water; the value is 10^{-9} to 10^{-8} cm^2 s^{-1}. As the patina grows, the diffusion is increasingly impeded by the new patina and the diffusion constant drops by about three orders of magnitude. Figure 7 also shows the

minimum range required for the value of the diffusion constant for the patina layer to grow at the rate that is observed. The conclusion is that the copper ion flux will be at least two orders of magnitude in excess of the requirements during the initial period of patina growth. However, at later stages of diffusion through progressively thicker patina layers, the flux will decrease sharply and will eventually limit patina growth.

A third potential patina growth constraint is the supply of sulfur from the atmosphere needed in the formation of the copper sulfate species. This sulfur is furnished to the copper surface as gaseous sulfur compounds, particulate sulfate, and sulfate ions in precipitation. The most abundant of the gaseous sulfur compounds are hydrogen sulfide (H_2S), carbonyl sulfide (COS), dimethyl sulfide (CH_3SCH_3), and sulfur dioxide (SO_2). The first three of these compounds would be expected to form sulfide minerals on the copper. These minerals have not been detected. In addition, the low aqueous solubilities of the reduced sulfur gases suggest that their concentrations in the evolving wetted patina layer would be very low. As a consequence of these circumstances, the sulfur incorporated into copper patinas seems to come primarily from sulfur dioxide or its oxygenation products. Given the concentrations of atmospheric sulfur dioxide, the particle deposition rate, and the chemical analyses of precipitation in its various forms, the sulfur supply to the surface can be calculated. Analyses of the patinas at different stages of their growth provide information on the rate of uptake of the sulfur. When this information is combined, it forms the basis for the patina sulfur budget shown in Figure 8. It is apparent that the sulfur supply is ample during the initial patina growth period. The supply is even more munificent at later stages of patina evolution, during which incorporation of atmospheric constituents is markedly reduced.

It is theoretically possible that the formation of copper patinas could be inhibited by the oxidation state of the sulfur atoms supplied to the surface. If most of the supply were in the form of sulfur dioxide, for example, sufficient oxidizers would have to be present to convert the sulfur dioxide to sulfate. Figure 8, however, shows that most of the sulfur is not supplied in gaseous form but in the preoxidized state. In any case, theoretical studies of the chemistry of water droplets exposed to the atmosphere[11] indicate that ample oxidizing power is present. We conclude that the sulfur valence state does not limit the rate of formation of the copper patinas.

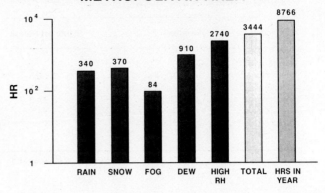

FIGURE 6. *The duration of moisture on surfaces in the New York City metropolitan area.*

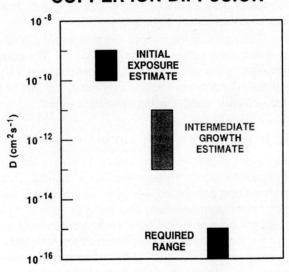

FIGURE 7. *Estimates of the initial diffusion constant for cuprous ions through the fragmented cuprite layer.*

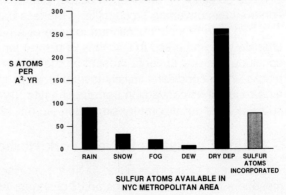

FIGURE 8. *The supply of sulfur atoms from the atmosphere to the copper surface, as assessed for initial patina growth under 1984 conditions.*

TABLE 3
Mineral Stabilities in Solutions of Different pH(A)

Compound	Formula	Stable pH Range
Cuprite	Cu_2O	>4
Brochantite	$Cu_4(SO_4)(OH)_6$	3.5-6.5
Antlerite	$Cu_3(SO_4)(OH)_4$	2.8-3.5
Atacamite	$Cu_2Cl(OH)_3$	3.8-4.3
Gerhardite	$Cu_2(NO_3)(OH)_3$	4.0-4.5
Malachite	$Cu_2(CO_3)(OH)_2$	>3.3

(A)These ranges are derived from information presented in Reference 5.

The acidity of the surface water is largely established by the chemistry of precipitation. Although the acidity will not limit the patina growth, it will determine which crystals are stable and which are not. Table 3 gives the stability ranges of the most common patina minerals. As can be seen, the pH of rain in the New York Harbor area, currently averaging about 4.3 on an annual basis, is consistent with a patina composed primarily of brochantite. Fogs, which are generally more acidic than rain, may favor the formation of antlerite instead.

Two final factors providing a potential limit to the rate of patina growth are nucleation and cementation of the crystalline patina components. The details of the nucleation process are not well understood, but arguments have been presented to indicate that patina component nucleation under atmospheric conditions is expected to be rapid.[9] The same is not true for cementation of the crystals once they have been nucleated. A common observation is that copper roofing and bronze statuary (and the Statue of Liberty) are characterized by green deposits at their bases resulting from the "rundown" of uncemented patina components.

Estimates of the copper-ion budget for patinas[9] indicate that a substantial fraction of the ions is washed away rather than being retained. We conclude that the low rate of cementation of patina constituents is the growth-limiting process during the early stages of patina development. At later times, as the patina becomes increasingly thick, the flux of permeating copper ions is decreased to the point that the available copper limits the patina growth.

□ Experiments with Simulated Rain

Many of the processes of interest in patina formation and growth are difficult to study from analyses of the patinas alone. To augment our analytical work, several experiments were undertaken to expose unpatined and patined copper and several of the copper minerals to simulated rain of various ionic concentrations and acidities. The techniques and detailed results appear elsewhere,[12] but some of the results will be mentioned here. Perhaps foremost is the finding that patined copper was essentially unaffected by extended exposure to the simulated rain, provided the pH was greater than (i.e., less acidic than) 2.5. At 2.5 and below (levels that are rarely encountered in the atmosphere), the patina layer was stripped from the copper in a few days. Posnjakite converted to brochantite at acidities higher than about 2.5 in several days. As wetted surfaces dried, our chemical analyses indicated increasingly concentrated ionic solutions and lowered pH levels. Conductivity measurements on corroding samples some years ago indicated that increased corrosion occurred during the drying-out period; this observation is completely consistent with our data.[13]

The detection of antlerite on copper patina surfaces has led to the suggestion that acidic precipitation may be converting brochantite to the less basic antlerite.[14] To examine this suggestion, we exposed pure brochantite mineral to several simulated rain solutions. Even in experiments in which brochantite was immersed in solutions of pH 2.5 for one month, conversion to antlerite did not occur. We conclude that any antlerite present on the Statue of Liberty was formed there from crystalline building blocks under conditions initially favorable for its stability (e.g., pH < 3.5), rather than its being present as a result of its conversion from brochantite. (We note, however, that the natural environment is more complex than our laboratory simulation, so our results are not conclusive.)

□ Patina Formation in New York Harbor

The Statue of Liberty has stood in New York Harbor for 100 years, and during that time the harbor atmosphere has undergone substantial changes. As a result, some of the potential growth-limiting factors have undergone changes as well. For example, various copper samples from the metropolitan area make it clear that the time required for the green patina to form has decreased from about 20 years in the late 19th century to about 8 years today (Figure 9). Theoretical reconstructions of the major atmospheric constituent concentrations over that period of time demonstrate that sulfur dioxide concentrations have risen markedly and then declined (Figure 10), but the patterns of patina development and

GREEN PATINA DEVELOPMENT TIME
NORTHEAST USA

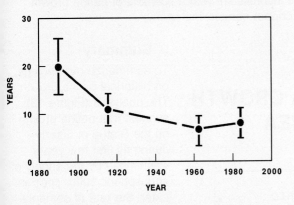

FIGURE 9. *The time needed at different epochs for development of green patina on copper in the eastern United States (adapted from Reference 15).*

ESTIMATED HISTORICAL ACIDITY
NYC METROPOLITAN AREA

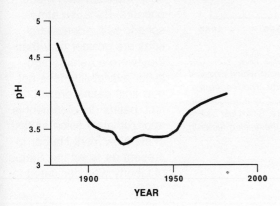

FIGURE 11. *The estimated pH of rainfall in the New York City metropolitan area, 1880 to 1980.[9]*

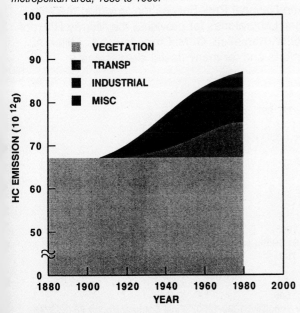

FIGURE 12. *Emission of volatile organic compounds within the continental United States.[9]*

ESTIMATED HISTORICAL SO$_2$
NYC METROPOLITAN AREA

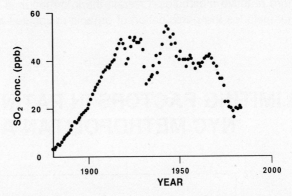

FIGURE 10. *Sulfur dioxide concentration determinations for New York City. For 1880 to 1980, the data are from Reference 16. For 1981 to 1984, the data were measured at the representative monitoring site nearest the Statue of Liberty.[17]*

sulfur dioxide concentration do not track each other particularly well. When sulfur budgets of the type shown in Figure 8 are constructed for different epochs of the lifetime of the Statue of Liberty,[9] the results show that only during the initial decade or so of the Statue's existence in New York Harbor has the supply of sulfur been a constraint to the growth of its patina.

It is therefore of interest to assess the acidity of precipitation over the 1880 to 1980 period. Such an assessment combines measurements made in recent times with informed estimates for earlier periods. The result is pictured in Figure 11, which shows that the pH was in the stable brochantite range during most of the Statue's lifetime. During the 1920s, however, the rain may have been sufficiently acidic to favor the formation of antlerite; it is of interest that antlerite is seen in several places on the Statue.[14] Because fogs are generally more acidic than rain, they would be more likely to favor the formation of antlerite throughout much of the century. In addition, individual events are doubtless more acidic on occasion than the averages indicated here, though the sparse data available for the New York City metropolitan area preclude a definitive analysis.

It was suggested earlier that organic compounds might be involved in the process of binding the newly formed copper minerals into the patina layer. Although the evidence for this involvement remains circumstantial, it is of interest to examine the emissions of organic compounds to the atmosphere over the years. Figure 12 shows such data, which indicate that the organic compound flux to the atmosphere increased along with that of sulfur dioxide during the industrialization of the New York Harbor environs, but that this flux has stabilized rather than decreasing. In addition, a very strong natural hydrocarbon component is present.

Most of the hydrocarbon emissions from vegetation and perhaps from the upper layer of the ocean are of large molecular weight fatty acids and other lipids, while the anthropogenic sources emit smaller, more reactive molecules. Overall, the information is not inconsistent with a scenario of patina growth that includes the participation of organic molecules as copper complexing agents.

□ Summary

To summarize our findings on historical patina growth: The analyses (Figure 13) suggest that patina growth on the Statue of Liberty during its first few years was limited by the supply of atmospheric sulfur species. Later, the rate of cementation of patina components was the constraint to growth. Once a thick patina had formed, its growth became ion-diffusion limited, as is the case with modern coppers. Because atmospheric sulfur concentrations are greater now than they were a century ago, sulfur availability does not now limit patina growth; in fact, patina development is approximately twice as fast in the New York Harbor at present as when the Statue of Liberty was dedicated in 1886.

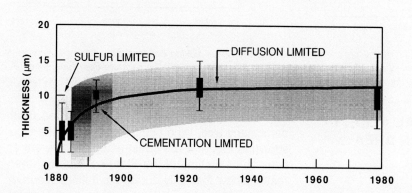

LIMITING FACTORS IN PATINA GROWTH NYC METROPOLITAN AREA

FIGURE 13. *Copper patina thicknesses as a function of time in the New York City metropolitan area.[9] Superimposed on the diagram are the periods during which physical and chemical constraints limited patina growth on the Statue of Liberty. The inadequate sulfur supply limited growth during the earliest period. This was followed by a transition to an epoch in which the rate of mineral cementation was the limiting factor. Since just before the turn of the century, the slow rate of copper ion diffusion has been the limiting factor in patina growth.*

■ 108 ■

□ Acknowledgment

We would like to thank E.B. Cliver and J. Robbins of the National Park Service for providing the samples from the Statue of Liberty; A. Lavornia of AT&T Bell Laboratories for providing the Murray Hill roof samples; and our colleagues M. Davis, P. Gallagher, G.W. Kammlott, C. McCrory-Joy, A.E. Miller, A. Muller, K. Nassau, and R.L. Opila for their analytical efforts and for many useful discussions.

□ References

1. K. Nassau, P. Gallagher, A.E. Miller, T.E. Graedel, Corros. Sci. 27(1987): p. 669.
2. A.J. Muller, C. McCrory-Joy, Corros. Sci. 27(1987): p. 695.
3. T.E. Graedel, C. McCrory-Joy, J.P. Franey, J. Electrochem. Soc. 133(1986): p. 452.
4. E. Mattsson, Materials Performance 21, 7(1982): p. 9.
5. T.E. Graedel, Corros. Sci. 27(1987): p. 721.
6. J.P. Franey, M. Davis, Corros. Sci. 27(1987): p. 659.
7. R.L. Opila, Corros. Sci. 27(1987): p. 685.
8. W.H.J. Vernon, J. Inst. Metals 52(1933): p. 93.
9. T.E. Graedel, Corros. Sci. 27(1987): p. 741.
10. K. Hauffe, Oxidation of Metals (New York, NY: Plenum Press, 1965).
11. T.E. Graedel, M.L. Mandich, C.J. Weschler, J. Geophys. Res. 91(1986): p. 5205.
12. K. Nassau, A.E. Miller, T.E. Graedel, Corros. Sci. 27(1987): p. 703.
13. F. Mansfeld, J.V. Kenkel, Corros. Sci. 16(1976): p. 111.
14. R. Baboian, E.B. Cliver, Materials Performance 25, 5(1986): p. 80.
15. T.E. Graedel, K. Nassau, J.P. Franey, Corros. Sci. 27(1987): p. 639.
16. R. Husar, D. Patterson, "SO_2 Concentration Estimates for New York City, 1880-1980," Final Contract Report 68-02-3746, Center for Air Pollution Impact and Trend Analysis, Washington University, 1985.
17. "New York State Air Quality Report," Report DAR-85-1, Division of Air Resources, Department of Environmental Conservation, 1985.

■ *Section IV: Construction and Restoration*

■ Construction Management

Philip Kleiner
Lehrer/McGovern Inc. Construction Managers, New York, New York

For those of you who aren't familiar with the term, a construction manager is hired by an owner to get the job done. He is different from a general contractor in that he acts as the owner's agent in finding, recommending, hiring, and supervising the subcontractors that perform the many parts of the project that make up the whole. It is his job to orchestrate the performance so that the end product is what the owner wants, at the time he wants it. In this case, we weren't sure *what* was wanted, but we knew July 4, 1986, was positively *when* it was wanted.

What might be termed normal procedure for a construction manager is to be given a set of drawings and specifications for a project by an owner and directions to go out and build it. To most construction managers, a more satisfactory situation (which does actually happen) is to be retained when the owner has only an idea of what he wants to build, usually with only a conceptual design prepared. The construction manager then joins the team of architect/engineer and owner in developing the final design, using his expertise and experience. The design is prepared in the order that the work will be installed. For a building, the order would be the foundation, structure, skin, etc., and contracts are awarded as each segment of the design is completed or is nearly completed. This is the "fast track" approach. The construction management of the Statue was the ultimate fast track project.

Lehrer/McGovern joined the team in the fall of 1983. At that time, a report had been issued by the French–American design team indicating some of the problems they had detected, such as the distress in the torch and flame and the armature. They also outlined some of the amenities under consideration, such as new stairs in the pedestal and improvements to the quality of the air in the pedestal and Statue.

We were a long way from plans or specifications, and we joined the team of architect/engineer and owner in finding ways to accomplish tasks, such as replacing the armature bars, cleaning and recoating the iron structure, and removing all of the coatings from the inside surface of the skin. None of these had been done before, but specifications had to be prepared and contracts awarded for the work to be done. The various authors in this book have described some of the solutions and how they were accomplished. Most of these people are the contractors that took on these unusual tasks.

As the specifications and plans for a particular phase of the work were completed by the design team, they went out for bids. Every contract that was given out was unusual in some way. If it wasn't a once-in-a-lifetime task, such as making a new flame or cleaning the interior of the copper skin, it was stairs or elevators with very special conditions. We found that in some cases many contractors thought that they were able to perform the work, but in reality they could not. In other cases, only a few contractors were willing to get involved in this out-of-the-ordinary project. In the former cases, we had to cull out those we thought incapable. In the latter cases, we coaxed and cajoled contractors that we knew could perform to get involved. On two contracts, we played matchmaker and actually introduced contractors to each other with marriage in mind. They did the work as joint venturers.

What were some of the concerns that we and the subcontractors had in getting the work done? One was that the Statue is on an island. The first part of the solution was to contract for the rehabilitation of an old pier that was on the opposite end of the island from the Circle Line pier. Keep in mind that for the first 1-1/2 years of the restoration tourists were still visiting the Statue.

For personnel, small tools, and material, a contract was signed with a marine contractor to furnish first one launch and then three as the workload increased. These launches ran between the island pier and a pier at the Coast Guard station at Battery Park. The hours were as required.

■ 111 ■

For heavy material and equipment, an arrangement was made for barges and tugs that ran between the island and Liberty State Park in New Jersey. In some cases, such as ready-mix concrete, trucks were run onto the barges. This required timing deliveries with the tides.

There was a limited amount of space inside the Statue and the pedestal, and limited access. Some of the work, because of its nature, such as blasting and painting, meant exclusive use of the available space. Our field personnel performed magic, juggling the work going on at any time, along with the judicious use of overtime and shifts, sometimes going 24 hours a day.

What were some of the aspects not related to the nature of the work itself that made this project different? One was the media. At all times, there was a constant flow of television, radio, magazine, and newspaper people on the job site. Since the money for the work was coming from donations and it was all so much in the public eye, there was no denying them. They came from all over the world and after awhile became part of the construction ambiance. One labor foreman, who was born in Italy, became a media hero, with write-ups in several national magazines and appearances on several TV specials.

The attitude of all of the people on the job was influenced by the Statue as a symbol. Everyone felt it, and all knew that they were involved in something special. The unions were more liberal in their interpretation of the work rules, and we felt that more than the usual effort was being put out by most of the workers.

Several million dollars' worth of material and equipment was donated. All of the copper for the new torch and flame, the stainless steel for the armature bars, the abrasives used to blast the iron and the copper, air compressors, and the rivets used to attach the saddles were some of the donations made. The window contractor donated the value of the field labor required to install the 25 new windows in the crown. The fact is that hundreds of offers to donate had to be turned down because the materials or equipment were not needed.

Other papers in this book describe the work of what might be termed "glamour" contracts. These are done by specialists not usually found on a construction project. Following is a brief summary of the more common trades that were dealt with during the construction work:

(a) The structural steel contract included the framing for the new platforms in the pedestal and Statue, the bracing of the shoulder, and tightening of the tie rods.
(b) The concrete contractor poured the elevator pits, mechanical equipment room, and the outside light pits. He stabilized large masses of concrete that remained after the rearranging of the lower portion of the pedestal and removed 16 feet (4.88 meters) of solid concrete for the elevator pits.
(d) Separate contracts were awarded for the double-deck tourist elevator and the two-person emergency elevator. The emergency elevator was manufactured in Sweden; the double-decker was manufactured in New Jersey.
(e) The stair contract included completely replacing the pedestal stairs and replacing parts of the spiral staircase, all in stainless steel and with a special peened finish.
(f) Demolition work included completely gutting the interior of the pedestal and removing the old elevator, elevator shaft, and stairs. It also included chopping out an intricate network of chases, or grooves, in the pedestal walls to bury all of the mechanical and electrical conduits.
(g) A group of interior packages included painting, flooring on the platforms and stair treads, interior masonry, gunite finish of walls, and hardware.

It should be mentioned that with all of the uncertainties, the contracts that were awarded were competitively bid upon and were given out on a lump-sum basis. It was not an easy job and the pressure was great, but everyone involved agrees that it was the career experience of a lifetime.

■ *Scaffolding and Rigging for the Statue's Restoration*

Alan Shalders
Universal Builders Supply Inc., Mount Vernon, New York

The scaffolding contract for the Statue of Liberty restoration was awarded to Universal Builders Supply Inc. on December 14, 1983, with a required completion date of April 27, 1984, approximately 133 days later. The constraints of this time scale, the effects of working through the worst winter weather on an exposed island, and the problems of gaining access in a safe and structurally sound manner to 100 percent of the interior and exterior of the Statue are discussed here together with the rigging challenge of removing the original torch and its replacement with a new one.

□ Scaffolding Design Criteria

Our project had to incorporate the following basic requirements:

(a) A free-standing scaffold for the top 160 feet (48.768 meters) of the Statue's 240-foot (73.152-meter) overall height. No attachments to the Statue could be made, only to the granite-clad pedestal;

(b) External work platforms that were no closer than 1.5 feet (0.46 meter) to the copper skin. This clearance was needed to allow for the movement of the Statue in severe wind storms;

(c) The ability to withstand hurricane forces based upon the 100-year wind-recurrence velocity;

(d) Transportation for the workers and material to the museum roof, the base of the scaffold [about 60 feet (18.29 meters) above ground level];

(e) An external elevator service that would go to the highest point of the scaffold;

(f) Two independent stair towers;

(g) Protection for the public at the 3P and 6P balcony levels;

(h) Prevention of all horizontal and vertical forces overloading, damaging, or marring the existing structure;

(i) A design for removal and replacement methods for the torch and flame;

(j) Sufficient capacity to support the weight of the upraised arm should the shoulder joint need replacing; and

(k) As much visibility as possible for the Statue during the restoration program.

□ The Solution

The time scale restricted us to a design that used proven standard components. Of the 19 weeks available, 6 were allowed for design, organization, and primary manufacture; the remaining 13 were to be used for erection. The solution adopted used high-capacity aluminum components, including tower panels, girts, and cross braces of various standard sizes, all fabricated from alloy 6061 T6 (UNS A96061). Aluminum eliminated possible rust staining of the copper patina.

The necessary structural strength was achieved by designing a system that resembled a medieval fort, with four massive octagonal corner towers to support the faces of the scaffolding (Figure 1). The overall size of the structure was 81 feet (24.6888 meters) square by 240 feet high. The welded panels were spaced 14 feet 9 inches (4.4958 meters) apart on the faces and 11 feet (3.3528 meters) apart to form the corner towers. This configuration was sufficient to resist the wind forces, achieve good visibility to the Statue, and eliminate the need for external guy wires. It further provided good anchorage for the secondary walls of scaffolding that stepped in to roughly follow the contours of the Statue. Final access to the copper skin was provided by a series of movable and retractable platforms that cantilevered out from the secondary structure.

It was decided that a 420-foot-(120.02-meter-) long ramp would be used to haul the workers and their materials from ground level up over the fort wall to the museum roof. From this level, a 4000-pound (1814.40-kilogram), or 20-person capacity, rack-and-pinion hoist was attached to the structure of the scaffold, providing service up to torch level, some 305 feet (92.964 meters) above sea level.

Scaffolding for the interior of the Statue was built using a system of interlocking pipes held together with friction clamps and resting on the top spanning beams that anchored the central support pylon. It was not feasible to use frames in the restricted interior. The scaffold was tied and braced into the secondary angle-iron structure surrounding the pylon. Planked working decks were provided every 6-1/2 feet (1.9812 meters) vertically.

Newly made components were chosen for this project. An extensive manufacturing program was organized to produce them within the available time. Problems of union jurisdiction, transport, and barging to Liberty Island were quickly resolved, and the first barge load of equipment was

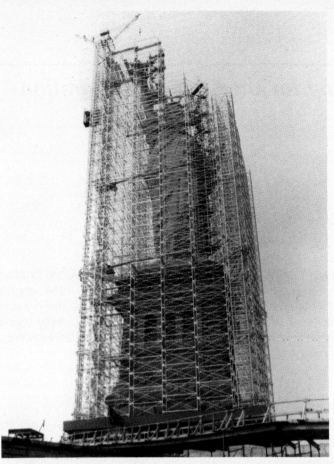

FIGURE 1. *Aluminum scaffold structure with access ramp.*

unloaded on January 23, 1984. A site fence was promptly installed to contain the restoration activities and to keep the inquisitive general public safely outside.

Construction began with the access ramp. This was made from 10 K shoring components with a deck of planks supported on aluminum ledgers. The ramp was designed to carry loaded fork-lift trucks. Once this was in place, material could be taken up to the museum roof and level 3P, where an aluminum sidewalk shed was constructed to protect the visitors. The interlocked bases of the scaffold system were laid out on the roof of this shed. The aluminum structure was then built up to the level of the top of the pedestal, where a second overhead protection was constructed over the 6P balcony. The aluminum was braced against the pedestal using screw jacks, isolated from the granite by neoprene, and pulled to the pedestal by tensioned 1/2-inch- (12.7-millimeter-) diameter steel cables that were passed completely around it at four levels. Over 10,000 feet (3048 meters) of cable was used.

While the tie backs were being installed, the hoist was delivered. Its base rested on spanning beams, the museum roof being inadequate to support it. The hoist was initially commissioned to serve the roof of the 6P protection level. This served as the staging area for the major part of the work still to follow.

The interior scaffolding was installed when the wind and snow made it impossible to continue on the outside. Time was running out, but patiently, on schedule, and despite the often appalling weather conditions, the erection crew of some 20 men worked cheerfully and diligently on, going ever higher, pride and patriotism spurring them ever upward.

Up past the tablet, past the serene face, up to the very torch itself, as it swayed some 6 inches (152.4 millimeters) in the ever-present sleet-filled 40 mph gusts of that never-to-be-forgotten spring. With understandable emotion, the topping out ceremony was held, as promised, on April 27, 1984. The scaffolds were proudly handed over to the restoration team.

□ Rigging for the Torch and Flame

A jib crane, rather than a trolley beam method, was chosen to reach the torch and flame. A crane could be designed to put only vertical loads into the southeast corner tower of the scaffold and eliminate hori-

FIGURE 2. *Self-balancing luffing crane.*

zontal forces into the top of the free-standing structure. All machinery could remain safely at the base of the scaffold. Such a device could be adjusted easily to locate the exact center of gravity of the old torch, a vital requirement to achieve clean separation. Finally, it would give good clearance from the scaffolding to lower and raise the torch assemblies.

The design solution comprised twin luffing jibs set to oppose each other at 45 degrees from a vertical axis through their center of rotation. A single part line was used to load each jib in direct compression; the resulting horizontal components canceled one another out, thus putting vertical force only into the top of the scaffold (Figure 2). The descending side of the load line was terminated in a flying block that changed the system into a two-fall winch. This passed through a ground trolley, terminating one end at a 125 horsepower gas-powered winch; the other end at a 15-ton hand winch. On the platform at the top of the ramp, two 40-foot- (12.19-meter-) long steel beams were bolted down. The powered winch was fixed to one end, the hand winch to the other, with the trolley running between. This kept the descending rope from the counter jib vertical as the load jib slewed out, bringing the torch from the inside to a corresponding position on the outside of the scaffold, ready to be lowered to the platform above the museum roof.

The original torch was rigged by removing the stained glass octagonal pyramid above the flame and lowering the crane lifting hook in through the opening. The hook was connected to an adjustable lifting yoke that was, in turn, bolted to the four main vertical angle-iron members of the torch drum, just below the flame, well above the center of gravity of the section to be removed.

On either side of the proposed separation point, slightly above the hand, two pairs of spreader bars linked with vertical rigging screws and diagonal turnbuckles (used for torsional stability) were bolted. To separate the old torch, the four main angles and four minor iron bars were cut through, and a circumferential joint located between the base of the torch balcony and the hand was opened by removing some 250 rivets. With the lifting winches attached for safety and an in-line dynamometer to record the loads, the spreader bars were slowly jacked apart using the rigging screws. On July 4, 1984, accompanied by great ceremony, the final separation was made. The hand winch was used to gradually transfer the torch weight from the rigging screws to the crane line. Once this tricky operation was complete, the rigging screws were detached from the lower spreader bars. As the newly freed torch lifted clear, a bar with two tag lines was fitted, and the assembly was lowered and guided down to the base platform where a specially designed cradle mounted on eight wheels was waiting to receive it. The rigging screws were reattached to a pair of spreader bars on the cradle that were identical to those that remained in the hand. These remaining bars were used to prevent the residual part of the handle from distorting and to provide an anchorage for the rain cover that was to remain in place for the next 16 months.

The old torch was later removed from the museum roof by mobile crane and put on temporary display adjacent to the fort wall until the construction of the workshop facilities needed to produce the replica were completed. The new torch has a gilded sheet-copper flame, without a convenient hole for lift-

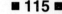

■ **115** ■

ing purposes. To raise the new assembly, a different method was needed.

The solution was to produce a large "C" hook the upper end of which was attached to the load line of the crane. The lower end passing through the open door of the torch balcony was to be attached to the four main angles as before. To facilitate handling, a removable stub was fitted to the lower end of the "C" hook with a four-bolt flange joint. This enabled all connections to be made on the outside of the torch, rather than in its very confined interior. A secondary winch was incorporated on the "C" hook to keep it level under its own weight as well as under the weight of the torch and flame. The new assembly was wheeled out of the workshop on a second carriage, similar to the first, on which it had been built. It was hoisted up to the museum roof by mobile crane and then transferred to the jib crane for raising the additional 260 feet (79.248 meters) to the waiting hand of Liberty on November 25, 1985. The final precision lowering of the new torch was accomplished by skillful use of the power winch; the new skirt was gradually eased over the flange of the lower joint ready for permanent bolting and re-riveting.

□ Conclusion

To the best of our knowledge, the scaffolding and rigging performed their designated tasks without serious incident or personal injury. The *Guinness Book of World Records* pronounces it the largest free-standing scaffold yet built. It is a project that will be proudly remembered by those of us who were associated with it.

□ Acknowledgment

To everyone who contributed to this project, thank you.

■ Removal of Coatings from the Interior Copper at the Statue of Liberty

Frances Gale
ProSoCo, Inc., Kansas City, Kansas

John Robbins
formerly of the National Park Service, Boston, Massachusetts

T he Statue of Liberty National Monument, an historic site managed by the U.S. Department of the Interior National Park Service, is located on Liberty Island in New York Harbor. The Statue, which is part of the monument, was given to the people of the United States by the people of France in celebration of the centennial year of American independence. The completed statue of *Liberty Enlightening the World*, which has become a symbol to people everywhere, was dedicated on October 28, 1886.

Sculptor Auguste Bartholdi began work on the Statue in France in 1876. The copper skin designed by Bartholdi is an envelope of approximately 300 sheets of red copper fastened together with rivets. The iron skeleton of the Statue supporting the copper envelope was designed by French engineer Gustave Eiffel. The copper skin is secured with copper saddles to an armature of iron bars. The armature is supported by iron flat bars and T- and angle-shaped structural members that transfer structural and environmental loads to a central iron pylon.

In preparation for the 100th anniversary of the completion of the Statue of Liberty, a joint French-American team studied the condition of the Statue before directing necessary restoration work. One part of the study evaluated coatings applied to interior metals.

Because of Its location in the harbor, the Statue's copper and iron have been especially vulnerable to deterioration. Soon after the Statue's construction, coatings were applied to interior metals in an attempt to prevent water intrusion and to minimize corrosion.[1] Evaluation of the existing coatings indicated that they no longer contributed to preservation of the Statue. They were thick, in poor condition, and, in some instances, concealed serious corrosion and structural problems. As part of the restoration of the Statue, removal of the coatings from the interior metals was undertaken. To begin this task, investigations of appropriate coatings removal methods were initiated by the National Park Service's North Atlantic Historic Preservation Center in October 1983.

□ Interior Coatings

To determine the nature of existing coatings, samples were taken from copper and iron substrates for preliminary analyses. Coal tar was the first coating present on all of the samples removed. An aluminum flake paint followed the coal-tar layer, after which most samples showed four to five layers of lead-containing paints. The familiar blue-green vinyl paints, applied in 1975, were the topmost layers. In some locations (particularly near the Statue's crown), the sequence of the more recently applied coatings was somewhat varied; however, the application of early coatings appears to have been uniform throughout the interior. Total film thicknesses on iron and copper (measured with an eyepiece micrometer) were between 0.02 and 0.04 inch (0.508 and 1.016 millimeters).

[1]Coatings were never applied to the exterior copper of the Statue.

☐ Investigation of Methods

Difficulties in removing the thick accumulations of paint layers from interior metals of the Statue were anticipated at the outset of the project. The differences in composition of the various layers and the relative softness and thinness of the 0.1-inch- (2.54-millimeter-) thick copper sheets were troublesome. The production of toxic materials during removal of lead-containing paints and the difficulties of waste removal from the island and their disposal elsewhere added to the complexity of the project.

Initially, three categories of coating removal methods (thermal, abrasive, and chemical) were investigated. Chief among the criteria used in selecting an appropriate method (or methods) were the preservation of historic features at the site, observance of health and safety standards, and the efficiency of the method in removing interior coatings. A request for proposals for testing all methods was issued in December 1983, outlining the general considerations of the project and describing the specific precautions to be taken during the execution of each method. Selection of the appropriate method or methods was based on the results of the small-scale tests executed on site.

Because of the possibility of hidden corrosion, no attempt was made to save and restore existing coatings. All coatings on iron were removed and the surface properly prepared for repriming.[2] Abrasive removal, or blasting, was chosen because it was the most efficient method tested and it best prepared the iron for repainting. Other methods used in the small-scale tests either did not work or produced toxic wastes. Of the low-dusting abrasives considered (aluminum oxide, copper slag, silicon carbide, and zircon), aluminum oxide was selected for the project along with a blasting head that vacuums the dust while simultaneously applying the aluminum oxide.

☐ Removal of Paint from the Copper

Selecting a method for removing paint from interior copper was problematic. Blasting with aluminum oxide was rejected because it would damage the copper substrate. Although this danger could have been avoided using walnut shells or corncobs, the softer aggregates were not effective in removing all paint layers, particularly the vinyl top coat. (The longer soft abrasives were trained on the vinyl as it became warmer, more pliable, and abrasive resistant, the less effective they became.) The application of heat (hot air or steam) to the surface endangered the exterior surfaces of the Statue. Coal tar, softened at relatively low temperatures, could seep through lap joints and other breaks to the exterior surface of the copper envelope. Chemical removers generally couldn't penetrate the multiple layers of paint in a reasonable time period without large volumes of chemicals and water. Also, long "dwell times" needed to remove paint could lead to seepage of solubilized material to the exterior. Additionally, most chemical removers are highly flammable and their reactions with some of the paint layers produce toxic fumes. Since these methods were not effective or were unsuitable, the use of an unconventional method (cryogenic removal using liquid nitrogen) was considered for removing paint from interior copper.

Liquid nitrogen is one of several widely used cryogenic, or low-temperature, materials. At ordinary temperatures, nitrogen is an inert gas that makes up 78% of the earth's atmosphere. In its liquid form, at temperatures below −320°F (−196°C), nitrogen is extremely effective in cooling other materials. In fact, 85.7 BTUs are absorbed from its environment when a pound of liquid nitrogen vaporizes.[3] Although there are references to such "super-cooling" techniques in coatings removal literature, the use of liquid nitrogen in large-scale coatings removal was somewhat innovative.[4] Indeed, liquefied atmospheric gas producers and their customers in the chemical, metallurgical, medical, and electronics industries consider the coatings removal properties of liquefied gases to be maintenance problems.

Cryogenic removal was feasible at the Statue of Liberty because there were multiple layers of pliable coatings adhered to the copper, an excellent conductor of heat. This method's success can be explained in simple terms. Contact between extremely cold liquid and paint layers resulted in rapid changes of temperatures at both inner and outer surfaces. Since the physical properties of the layers were somewhat different, responses to the cryogenic material varied. Embrittlement of some or all of

[2] Coatings were removed to "white metal" as defined by the Steel Structures Painting Council (Pittsburgh, Pennsylvania) with a surface profile of 2 mils peak to valley.

[3] Information about liquid nitrogen is taken from *Nitrogen Data Book*, a technical leaflet available from the Linde Division of Union Carbide, Old Ridgebury Road, Danbury, CT 06817.

[4] Cryogenic removal of asphalt from the exterior of a copper dome at the U.S. Customs House (New York, New York) was suggested by Norman R. Weiss in 1982. His tests using liquid nitrogen were largely unsuccessful.

the layers caused cracking and a loss of paint adhesion to the copper substrate.[5]

Before full-scale cryogenic removal of the coatings from the copper was attempted, the safety and feasibility of the method were further investigated. It was estimated that more than 3500 gallons (13,247.5 liters) of liquid nitrogen would be required to remove paint from the approximately 11,000 square feet (3352.8 square meters) of interior copper.[6] Precautions were taken for the safe handling and storage of the large quantity of cryogenic material. Metallurgists consulted about the possible risks to the metal provided assurance that use of the extremely cold liquid would not damage the copper skin.

The Linde Division of Union Carbide Corporation (Danbury, Connecticut), the largest producer of liquid atmospheric gases in the United States, assisted the National Park Service and the Statue of Liberty-Ellis Island Foundation, Inc. in planning and executing full-scale cryogenic coatings removal. Linde donated the liquid nitrogen and supervised design and fabrication of the equipment required, including a wand-like sprayer for discharging the nitrogen at approximately 150 psi. With this system, it was possible to remove paint from 1 square foot (0.3048 square meter) of copper in 10 to 15 seconds (Figure 1).

Workers under the direction of Lehrer/McGovern Inc. Construction Managers (New York, New York), the Foundation's construction manager, were trained by Linde in the safe operation of the equipment. With crews of four to six persons, the coatings were removed from all copper surfaces in fewer than three weeks. Most labor was spent on filling, moving, and removing the small liquid nitrogen tanks required by the confined spaces of the Statue's interior. During paint removal operations, oxygen levels inside the Statue were monitored to ensure that breathable air was not displaced by the rapidly vaporizing nitrogen. Safety goggles, gloves, and protective clothing were worn by the workmen to guard against the severe frostbite that can be caused by contact between the nitrogen and skin. Since no toxic materials were produced, waste disposal was simplified.

◻ Conclusion

A final step in this operation was removing residual coal tar from the copper skin. After considering both chemical removal and soft-abrasive blasting methods, blasting with sodium bicarbonate beads was finally selected as the best method available for this difficult task. (This subject is discussed elsewhere in this book.) Completion of this step and the necessary measures for weatherproofing have restored the interior copper skin of the Statue to its original, uncoated condition.

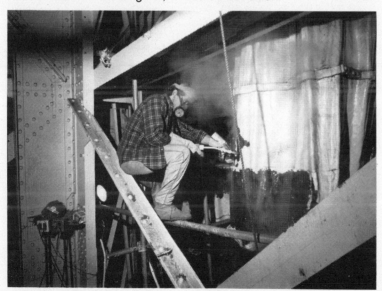

FIGURE 1. Linde Liquid Nitrogen Gives the Statue of Liberty a Chill (*Union Carbide press release, June 21, 1984, p. 4*). *The worker is using a specially designed wand to spray liquid nitrogen onto the painted interior skin of the Statue. The dark area is coal tar, from which the paint was removed; the light area is the painted surface. The fog near the work area is primarily water vapor in the air, which condenses when hit by the extreme cold of the liquid nitrogen.*

[5] Paint removal was successful down to a residual coal-tar layer on the copper.

[6] Liquid nitrogen's ability to remove coatings from the interior copper at the Statue may represent an unusual situation. Tests using this medium were unsuccessful at removing paint from structural iron at the Statue, paint from a wooden baluster at Women's Rights National Historical Park (Seneca Falls, New York) and asphalt from exterior copper at the U.S. Customs House.

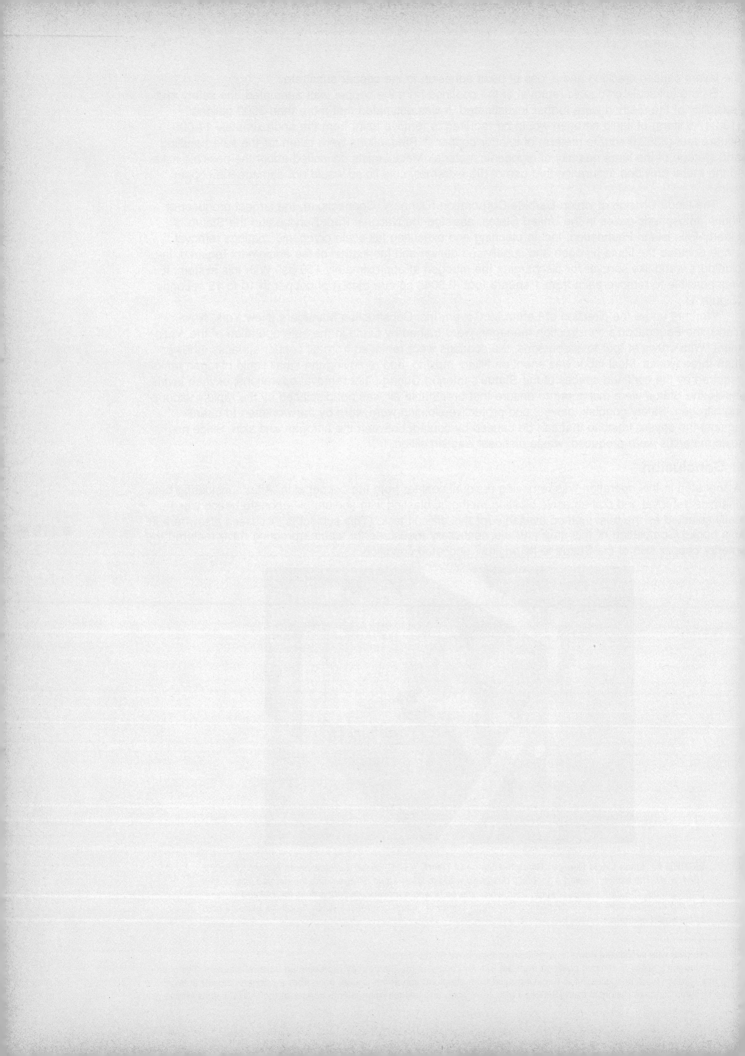

■ *Coating Removal from the Statue's Interior*

Victor Strauss
Ben Strauss Industries, Inc., New York, New York

Techniques for cryogenic removal of paints using liquid nitrogen have been described elsewhere in this book. This paper describes some unconventional techniques that were developed to complete the cleaning job—removing the layer of coal tar that was closest to "the lady's" inside copper skin. The coal tar layer stubbornly remained despite being sprayed with liquid nitrogen at 150 psi and being exposed to extreme cold.

Among the limitations and problems that existed were the following:

(a) Poor ventilation;
(b) Prohibited use of flammable and/or toxic materials;
(c) Irregular surfaces and shapes;
(d) Tight quarters and virtually inaccessible areas;
(e) Dust (creating the risk of explosion and uncontrollable spreading); and
(f) Difficult clean-up and removal of materials.

Two items were necessary to work around these problems: a new sandblasting tool and a gentle, yet effective, blasting medium.

□ Blast and Vac:

To prevent dust build-up and possible explosion within the confined space of the Statue's interior, a tool was required that would sandblast and vacuum simultaneously. The machine had to be small enough to be maneuverable in tight spaces yet have enough power to do the intended job efficiently. Together with the engineers of the Blast and Vac Company from Bolivar, Ohio, we were able to design a tool to meet the requirements. We used a circular brush at the end of the blasting nozzle, enabling it to go over nuts and bolts and still contain the blasting material. An existing tool was modified to be lighter and smaller, with a handle shaped like a futuristic space pistol and a trigger to turn it on and off. Basically, we installed a standard blasting nozzle inside a vacuum cleaner head that would allow blasting material to be emitted from one end and vacuumed out at the other end simultaneously.

□ Sodium Bicarbonate

The next problem was to find a cleaning agent that was abrasive enough to remove the coal tar but gentle enough to prevent damage to the Statue's thin layer of copper.

The restoration engineers provided samples of copper that were the same thickness as those on the Statue, plus a copper saddle covered with coal tar that was removed from the Statue itself. We blasted these samples with cherry pits, corncobs, polyester plastic pellets, walnut shells, powdered glass, salt, rice, and sugar. However, they were all unsatisfactory, being either too abrasive or too mild.

Then we recalled that the telephone company used sodium bicarbonate, commonly known as baking soda, as an abrasive to remove stubborn material from an electrical transformer that had to be handled delicately. People use it to clean their teeth and wash their clothes and for other household cleaning jobs. Museum curators use it to clean and polish priceless artifacts and to shine dinosaur bones. Would it work on coal tar? Could we use it as a mild blasting agent?

The next step was to acquire the baking soda. We called a producer, Church & Dwight Co., Inc. (Princeton, New Jersey), and the company's technical service people immediately volunteered to lend a

hand. They indicated that their Arm & Hammer[†] brand baking soda is used as a mild abrasive in some applications. In fact, a special granulation is now being tested by dentists with the air-powdered equipment used to clean teeth professionally. They also mentioned that it was unlikely that baking soda would corrode any of the metals with which it came in contact, because its pH is 8.3—nearly that of the seawater mist that pervades the inside of the Statue. Baking soda is generally regarded as safe by the U.S. Food and Drug Administration (FDA) when used as a food ingredient, and its use would not introduce any environmental problems other than dust control. Test blasting with sodium bicarbonate at 60 psi removed the coal tar and did not harm the copper.

Now we turn to cleaning the coal tar layer from the inside of the Statue. Something unforeseen occurred: The baking soda was very hygroscopic, which means that it absorbed moisture from the air and thus tended to cake up and clog the blast equipment. Our people were able to solve this problem by teaming up with some refrigeration engineers, who devised a cooling system to dry the exit air from the compressor. The system worked as long as we were able to get dry air leaving the compressor at 100 to 125 psi through 300 feet (91.44 meters) of hose with a vertical lift of as much as 150 feet (45.72 meters), while maintaining 60 psi at the spray nozzle. The mild abrasive action of the baking soda stripped off the coal tar layer as we worked around the clock to clean the inside skin.

□ Unexpected Results

Some unexpected effects resulted from using sodium bicarbonate. As we removed the coal tar, cracks and openings between the thin copper sheets and some of the empty rivet holes were exposed and a small amount of blasting powder leaked outside. When a light rain fell, the powder reacted with the existing patina on the external copper surface, and some small sections of the outer skin turned blue-green. As soon as we realized what was happening, workers were stationed on the Statue's exterior opposite the portions being blasted from inside; they immediately washed away any escaping powder. This blue-green color has since weathered and the green patina is restored.

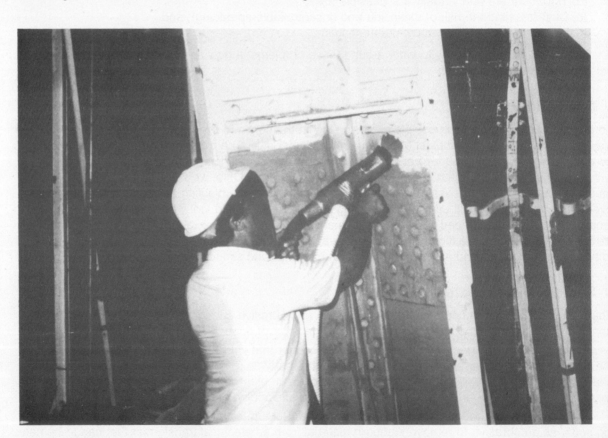

FIGURE 1. *Blast and Vac remove paint from iron (1985).*

■ 122 ■

[†]Trade name.

Coatings and Sealants on the Statue's Interior

Gregory P. Smyth
GSGSB, Architects and Engineers, New York, New York

Following the installation of interior scaffolding, a careful and thorough inspection of the existing interior coatings was performed. It was evident that the coatings applied to the structural iron members and the interior copper cladding were deteriorated and required removal. Consequently, it was necessary to choose a coating system that would provide ultimate protection for the intricate network of iron that composes the primary and secondary interior structural support system. A sealant also had to be chosen for application to the interior copper seams to replace a deteriorated coal-tar emulsion previously applied to the interior copper cladding as a watertight membrane. The intricate, restrictive configuration of the interior was a challenge to the restoration team, which had to choose a sealant and coatings that would provide maximum protection while ensuring the safety of the Statue, the workers, and the environment. Months of investigative work, testing, and analysis passed before the appropriate coatings and sealants were determined.

Preceded by a near-white metal blast, 6 mils of a water-based, self-curing inorganic zinc was applied to the structural iron as a primary base coat. Developed by NASA, this water-based inorganic zinc, characterized by a high silicate-to-alkali ratio, uses zinc chemistry to provide ultimate protection for the structural iron substrate. Limited areas inaccessible to blasting machinery were coated with an organic, zinc-rich coating. In addition to offering excellent adhesion to the existing coatings and water-based inorganic zinc, this organic zinc-rich coating provides maximum protection for the existing and newly applied coatings interface, as well as for areas not able to be blasted. However, because of high volatile organic compounds (VOC) emissions, this coating was used in limited quantities and under carefully monitored conditions to ensure the safety of the Statue and the workers. A two-component waterborne polyamide epoxy was applied as a top coat. Application was performed in three consecutive coats, obtaining a total thickness of 5.5 mils. The epoxy chosen provides excellent adhesion to all previously applied coatings and obtains an extremely hard surface, which ensures superb chemical, graffiti, and abrasion resistance.

Following removal of the coal tar from the interior copper cladding, a one-part, moisture-cured silicone sealant was carefully applied to each seam. The sealant adhered very well to the cleaned copper surfaces, offering a flexible, durable, waterproof seal, eliminating wind-driven rain from entering the Statue through the copper seams.

□ Introduction

The primary and secondary interior structural support system for the copper-clad "lady" of the New York Harbor is an intricate network of iron. One hundred years' exposure to a highly corrosive marine environment has taken its toll. Wind-driven rain, seeping into the interior through copper seams, rivet holes, and deteriorated copper cladding, supplied additional electrolytes, which promoted accelerated galvanic corrosion. Although a base of red lead primer and six top coats that were applied through the years provided excellent protection for the structural iron, localized corrosion occurred. Likewise, the coal-tar emulsion applied to the interior copper cladding to provide a watertight membrane had deteriorated and was no longer effective.

Using modern coatings technology and unique coating removal techniques, original coatings were removed and state-of-the-art, long-lasting protective coatings were applied. Deteriorated copper was replaced, rivet holes closed, and sealant applied to each copper seam.

TABLE 1
Test Data for Water-Based Inorganic Zinc Base Coat

Coat
 1 coat 3-mil dry-film thickness (dft)
 minimum

Condition in Container
 Mixes easily
 Does not liver
 No apparent viscosity changes
 No objectionable properties

Application Characteristics
 Readily applied by brush
 Readily applied by spray
 Leveling—good
 Intercoat adhesion—excellent

Drying Time
 Between coats—15 minutes
 For service—2 hours
 To top coat—2 hours

Adhesion
 Excellent

Recoatability
 Excellent

Appearance of Coating
 Smooth

Toxicity
 No toxicological effect

Flash Point
 None

Hardness
 Excellent 1/2 hour after application.
 Tabor Abrator Test Results—CS17 wheel, 1000 grams
 at 1000 cycles
 —2 hours after application—weight loss = 0.0573 grams
 —24 hours after application—weight loss 0.0462 grams;
 duplicate 0.0531 grams weight loss
 Coating thickness loss approximately 0.6 mils dft

Flexibility
 Passes bend 180° over 1/2-inch mandrel

Resistance to Aviation Fuel and Water at 90°F
 Change in appearance—none
 Film failure—none
 Loss of hardness—slight
 Loss of adhesion with knife—slight

Salt Fog—7000 Hours
 Rusting in scribe—none
 Pinhole rusting—none
 Coating failure—none

■ 124 ■

TABLE 2
"In-Field" Test Results for Water-Based Inorganic Zinc Base Coat
(Long-Term Exposure Data)

Kennedy Space Center, Florida	Six coated Tator panels have been exposed on the beach since June, 1976. All panels, including welds and corners, are perfect.
Astoria Birdge, Astoria, Oregon	A single coat applied in 1977 over both commercial and near-white blast sections are in perfect condition.
Golden Gate Bridge, California	A coated T-bar was hung from the bridge in 1976. When inspected 6 years 1 ter, there was no sign of corrosion, including one end, which had been damaged 4 years previously.
South Pacific Islands	The 531 formula was applied to radar antennae on Canton Island and Hawaii. After 2 years of salt air and heavy rain, the applications were in excellent condition.

The general approach used by the restoration team was to choose the best material available for a specific application, while ensuring that the historical integrity of the Statue was maintained. Care was taken not to introduce substances that could detrimentally affect the Statue.

☐ Criteria for the Coating System

Following the removal of the coatings on the structural iron, it was necessary to choose a coating system that would effectively protect the iron of the Statue's interior. The coating system chosen had to provide the following:

(a) Optimal long-term protection against corrosion in a marine environment;
(b) Nontoxic zero-low VOC emissions, to ensure the safety of the workers, the Statue, and the environment;
(c) Adequate adhesion to the substrate, to protect against long-term corrosion debonding;
(d) Easy application procedures, to accommodate the extremely limited accessibility within the Statue;
(e) Chemical resistance;
(f) Abrasion resistance; and
(g) Graffiti resistance.

Many coatings were carefully investigated by the restoration team. When the number was reduced to those that most closely adhered to the criteria developed, samples were prepared and comparisons made. Based on these criteria, the coatings were chosen.

Primary Under Coat (Base Coat)

The coating used as a base coat, applied to the Statue's iron interior, is a water-based inorganic zinc coating. Developed by NASA, this inorganic zinc is characterized by a high-ratio potassium silicate formula [5.3 to 1 (SiO_2:K_2O)]. NASA's unique formula enables the vehicle to remain stable, even with reduced alkali. The high silicate content offers advantages over other silicates, such as increased adhesion, fast-drying characteristics (approximately 30 minutes), and, most importantly, a fast, self-curing, hard film upon drying. This feature was very important for this particular application because of the moisture and dust problems and because other trades required access to the areas being coated.

Adhesion and Curing Mechanisms

Adhesion ultimately determines the effectiveness of a coating. The inorganic zinc applied to the Statue's interior iron structure provides the most effective type of bonding, a chemical bond. An oxygen atom from the silicate matrix of the inorganic coating bonds directly to an iron atom on the metal surface. This bonding mechanism provides protection against undercutting, which results when water seeps between the coating and substrate interface and reacts with the substrate, resulting in disbonding of the coating.[1]

Evaporation of the water results in a somewhat porous, reactive, silicate-zinc mixture. Reaction begins immediately with environmental constituents, such as condensed moisture and CO_2 from the atmosphere. Sacrificial ionization of the zinc metal (less noble than iron) occurs at the surface and within the porous structure of the inorganic zinc system. This reaction provides electrons that migrate through the conductive matrix to the iron metal surface to provide cathodic protection. Areas where scratches or abrasions occur, resulting in exposure of the iron substrate, are protected by this galvanic cell action. In small exposed areas, corrosion is completely prevented; in larger areas, corrosion is greatly retarded. Furthermore, zinc-reaction products form and fill the pores of the system over a period of time, creating a dense, hard, abrasion-resistant film.[2]

Table 1 contains laboratory test data information for IC531,[1] the water-based inorganic zinc used as a primary base coat on the Statue's iron interior. Examples of "in-field" test results can be found in Table 2.[2]

[1] IC531 test results compiled by Inorganic Coatings, Inc., from reports submitted by DL Laboratories, SRI International, KTA Tator Laboratories, and several DOTs. The inorganic zinc mentioned in this paper is marketed as IC531 by Inorganic Coatings, Inc., 5 Great Valley Parkway, Suite 317, Malverne, PA 19355.
[2] "Field Test" results furnished by Inorganic Coatings, Inc.

TABLE 3
Typical Solvents Used in Cleaning Graffiti

Aromatic Hydrocarbons	Ketones	Chlorinated Solvents	Propylene-Based Glycol Ethers	Detergents
Toluene Xylene Super-high-flash Naptha	MEK (Methyl Ethyl Ketone) MIBK (Methyl Isobutyl Ketone)	Methylene chloride Trichloro ethane	(PM) Butyl cellosolve (PM) Cellosolve acetate	Triton X100 Sodium phosphate

TABLE 4
Chemical Resistivity Test Results
for Waterborne Epoxy Polyamide Top Coat

Reagent	Result
Gasoline	No effect—6 months (immersion)
Water ،	No effect—6 months (surface exposure)
10% Hydrochloric Acid	Good up to 24 hours
MEK	No effect—1 months (immersion)
10% Sodium hydroxide	No effect—3 months
Xylene	No effect—3 months
Aviation fluid (Skydrol B)	No effect—2 weeks (immersion)

Test Data Results[A]

Tensile hardness	H
Cross-cut adhesion	Excellent
Impact resistance, in—16 (direct hashmark reverse)	Excellent

[A]All test results based on a 14-day cure schedule at 23°C with relative humidity of 50%.

■ 126 ■

□ Application

Surface Preparation

Maximum adhesion was provided by careful monitoring of the surface preparation. The structural iron members were blasted with an aluminum oxide medium to a SSPC-SP-10[2] near-white metal blast. Each area blasted was carefully inspected prior to application of the inorganic zinc coating. The two components of the inorganic zinc, a potassium silicate vehicle and zinc dust, were thoroughly mixed and continuously agitated throughout the application procedure. Using a Speeflo[†] airless spray machine, 6 mils of inorganic coating was applied within a specified 8-hour time period following sandblasting. Using a magnetic mil gauge, inspectors ensured that the 6-mil minimum specification was obtained. Areas that were blasted and not coated within the 8-hour time frame were surface blasted again before application of the inorganic zinc was permitted.

The inorganic zinc's nonadhesion to organics and uncleaned surfaces proved to be beneficial. Overspray did not adhere and was easily vacuumed away as it dried and fell from unblasted surfaces. Consequently, areas that were inaccessible to blasting, such as around bolts and nuts, horizontal and vertical interfaces, and confined areas where structural iron members were located close to the copper skin and proper protection could not be implemented, were easily identified.

Secondary Base Coat

Following the application of the inorganic zinc coating, areas that could not be sandblasted were scraped of scaling material, cleaned, and coated with a two-component, solvent-based, organic zinc-rich coating. In addition to offering zinc chemistry protection, this organic zinc-rich coating exhibited excellent

[†]Trade name.

adhesion to both the inorganic zinc and the existing coatings and therefore provided an excellent corrosion-resistant base coat for inaccessible areas. However, being a solvent-based coating, the organic zinc-rich base coat was used in limited quantities and under carefully monitored circumstances, because it has relatively high VOC emissions and a low flash point of 70°F (21.1°C). The organic zinc-rich base coat was applied by brush and roller for two reasons: to reduce the possibility of a fire or explosion hazard and to protect the copper skin from overspray.

Top Coat

Having provided the Statue's interior structural members with an excellent corrosion-resistant protective film, the restoration team began research into locating a top coat. Although the inorganic zinc coating is sufficient to protect the structural iron from corrosion,[3] a graffiti-resistant, aesthetically pleasing top coat was desired. The top coat had to be resistant to chemicals, mild acids, and alkali solutions, as well as solvents that may be used to remove unwanted graffiti. (Table 3 lists common solvents used for cleaning graffiti.) The top coat also needed to be abrasion-resistant to provide a long-lasting, graffiti-resistant coating, especially where traffic is heavy, such as in the spiral staircase and crown area. Once again, adhesion to the inorganic zinc and to the solvent-based organic zinc-rich coating was of primary concern. Many test plates were prepared, sandblasted, and coated with 6 mils of inorganic zinc, as well as the organic zinc-rich base coat. A variety of water-based and 100% solid top coats was tested for adhesion. Top coats that are 100% solid, despite offering excellent properties, usually exhibited short pot life, and solvents were required to clean the equipment. For this reason, it was not feasible to use 100% solid epoxies in this particular application.

Diamonite,[†] a two-component waterborne epoxy polyamide manufactured by Amsterdam Color Works, Inc. (Bronx, New York), was applied as a top coat. This high-molecular-weight epoxy provides an extremely hard, durable surface, and adheres excellently to the inorganic zinc and the organic zinc-rich base coatings. Reaching full cure in 7 days, an extremely resistant film is obtained that provides excellent resistance to corrosion from chemicals, water, alkali, solvents, and many acids. A tightly arranged structure with gloss readings in excess of 90% at 60 seconds reduces the penetration of graffiti. This, coupled with excellent resistant properties, allows light graffiti to be cleaned from the surface. Table 4 contains laboratory test results for the epoxy polyamide.[4] Areas with heavy graffiti will, of course, stain with time, and recoating may be desired for aesthetic purposes. The area to be recoated must be slightly sanded to increase adhesion, then coated with an acrylic block-out coating, which is specifically formulated to lock in graffiti, eliminating bleed-through to the top coat. This acrylic block-out coating is formulated as a part of this graffiti-resistant system and exhibits excellent adhesion to the waterborne epoxy top coat. Although the waterborne epoxy polyamide is not a pure water-based system, it remains within the criteria for choosing coatings for use within the Statue by offering low VOC emissions [less than 0.5 pounds per gallon (59.90 grams per liter)]. This coating system is currently used by the New York City Transit Authority for application on subway cars, where low VOC emissions were a major factor in its acceptance.

Application

Component A, which contained epoxy resins, was thoroughly mixed with Component B, which contained the catalyst, polyfunctional polyamido amines. The mixture was allowed to stand for a 20-minute induction period before remixing and application. The epoxy was applied in three top coats. The first coat was a specified 2.0-mil wet film thickness, and the next two top-coat layers were specified at a 2.0-mil dry film thickness each, providing a total dry mil thickness of 5.5 mils.

Test results proved that optimal, immediate adhesion was obtained by a relatively thin first-coat application of the epoxy, allowing it to flow into the porous structure of the inorganic zinc base coat. Upon drying, two additional top coats were applied to obtain a protective dry mil build of 5.5 mil. The Statue's interior structural iron consists primarily of vertical surfaces, and using this thin-coat application technique provided equal distribution of the coating, resulting in a sag-free finish. The application was performed by brush and roller; this was specified to limit the possibility of overspray on the recently cleaned copper surfaces.

■ 127 ■

[3]The protective qualities of the inorganic zinc were evident during the time between base-coat and top-coat applications.
[†]Trade name.
[4]Tests performed by D.H. Litter Laboratories for Amsterdam Color Works, Inc., 1546 Stillwell Ave., Bronx, NY 10461.

The crown area was the only portion of the Statue's copper interior to receive a coating. This was done to provide a graffiti-resistant, cleanable surface, protecting the copper underneath. An acrylic primer coat was applied to the copper, followed by three top-coat applications of high-gloss, waterborne epoxy.

Sealant

Following removal of the coal tar from the interior copper skin, application of a sealant at each copper seam was necessary to obtain a watertight seal. A variety of sealants was investigated and tested for adhesion to the copper substrate. Samples simulating the copper seams within the Statue were prepared and adhesion tests performed. One of the major difficulties encountered was the existence of residual coal-tar emulsion within the seams. This, coupled with a requirement that a thin bead of sealant be applied to the interior seams with no allowance for overlap on either side of the seam, demanded that maximum adhesion be obtained between the limited bonding surface area of the copper and sealant. Bonding between the coal-tar emulsion and the sealant was also a requirement; however, this was considered a secondary bonding mechanism because cohesive failure of the coal tar with time is likely. The sealant applied to the interior copper seams is a one-part, moisture-cured, noncorrosive silicone sealant. This silicone sealant exhibits excellent adhesion to both the copper and coal-tar emulsion. Incorporating multiple adhesion mechanisms, involving rebondable reactions, chemical adhesion is ensured throughout a variety of environmental changes, such as varying temperatures and humidity. The continuing flexible property associated with this silicone sealant enables it to accommodate expansion and contraction of the copper skin.

□ Conclusion

The ultimate goal of the restoration team was to choose the best available material for a specific application, while retaining the highest level of safety for the Statue, the workers, and the environment. Many months of research effort were involved in choosing a coating system and sealant for application to the Statue. During the course of the coatings and sealant investigations, it was a pleasure to interact with the chemists, scientists, and engineers whose efforts have provided such technologically advanced materials as those used on the Statue of Liberty. (Having been a part of the inspection team located on Liberty Island, I can attest to the professional, proud manner of the workers, both in the preparation of surfaces and the application of the materials.) The Statue of Liberty has received new, state-of-the-art coatings to protect her structural iron support system. A technologically advanced sealant ensures that wind-driven rain does not enter her interior through copper seams. These materials, along with others used in the Statue's restoration, ensure that the "lady in the harbor" will continue to stand with pride for the years to come.

□ Acknowledgment

The author would like to acknowledge the contributions of all those involved in the restoration of the Statue of Liberty: Park Schaffer, president of Inorganic Coatings, Inc., for his help in the preparation of this paper; Morris Williams, vice president of Amsterdam Color Works, for his contribution to this paper, as well as his continuing support throughout the restoration project; Doug Walker, technical representative for Dow Corning's Sealant Division, for his guidance and technical support throughout the project; and E.L. Bellante, GSGSB, for his dedication to all aspects of the restoration project. The devotion of Blaine Cliver and John Robbins, historical architects for the National Park Service, is also acknowledged. Special thanks to George Evans, Angelo Michilli, William and Mark Zsidisin, and Vincent Mingoia of the GSGSB inspection staff, whose efforts ensured quality workmanship. To Dr. Robert Condrate, professor of spectroscopy at Alfred University, a sincere thank you for your professional consultations and analysis, which provided information used to ensure the continuing safety of the workers during the restoration project.

□ References

1. C.G. Munger, "Surfaces, Adhesion, Coatings," CORROSION/83, paper no. 29 (Houston, TX: National Association of Corrosion Engineers, 1983).
2. Charles G. Munger, "Good Painting Practice," Steel Structures Painting Manual, 2nd ed. (Pittsburgh, PA: Steel Structures Painting Council, 1982), p. 132.

Armature Replacement on the Statue

Milton Einbinder
NAB Construction Corporation, College Point, New York

The decision was made by the project engineers to replace all of the original iron bars with 2- by 3/4-inch (50.8- by 19.05-millimeter) type 316L (UNS S31603) stainless steel bars. The replacement was implemented by a joint venture of Nab Construction Corporation (College Point, New York) and P.A. Fiebiger, Inc. (New York, New York). The logistics of how this was accomplished, the problems we encountered, and our solutions to those problems are the subject of this paper.

Replacement of the iron bars was a challenge. There were over 1800 pieces to replace, each with an individual shape. In addition, the integrity of the Statue had to be maintained while the bars were removed, and, because of the deadline, time was of the essence. Some of the most important aspects of this project were as follows:

(a) Mapping, locating, and identifying each piece of armature bar;
(b) Designing and fabricating a system of bracing to maintain the support of the skin at each location while individual bars were removed;
(c) Developing procedures to perform the exact replication of the bars;
(d) Handling the work-hardening problem by devising an annealing process to overcome it;
(e) Dealing with the asbestos problem;
(f) Passivating the bars; and
(g) Reinstalling the new bars.

To explain what was done without dwelling unnecessarily on every minor problem, I will describe the various procedures in the sequence in which they occurred.

The first order of business was to create a system of marking. Each bar had to be identified not only as to which piece it was, but also as to the exact location of each member. As mentioned above, approximately 1800 pieces had to be identified, and, in addition, their splices and supporting bars had to be designated accordingly. Our draftsmen created a large plan that, in effect, opened the Statue of Liberty like a flattened tin can, with a grid system set up to identify each bar. Special portions of the Statue such as the head, the arm, and the tablet required additional layout drawings to further identify the bars in these areas. Pleated sections of the Statue were further enlarged, so that we could identify each individual part and keep records as to when a piece was taken off, handled, reproduced, and replaced. Careful records of every operation were kept.

In total, we ended up with approximately 30 or 40 sheets of drawings to identify all the pieces. Some were designated "easy pieces" and some "hard pieces." The easy pieces did not have to be removed to be duplicated, since they were more or less in one geometric plane, and we could follow a template. The "hard pieces," however, were quite a different story altogether, as will be shown later.

Before anything could be removed, the area where the bars were being removed had to be braced. We designed and fabricated braces that were made in various lengths, had telescoping sections to adjust to final size, and had universal joints and clamps on both ends. We were limited by the specifications to only four areas at any one time, each at a different level of the Statue and each at a 90° angle from the next area of work. No other bars could be removed until the old bars for the previous four areas were replaced with newly fabricated bars.

The conditions that our men had to work under were quite difficult. Because of the paint-blasting operations and because there was asbestos within the Statue (behind each bar), they had to wear completely sealed "space suits" that had motorized filters.

When a bar was removed, the first problem the workers had to deal with was the asbestos that was left on the bar from the original installation. In 1886, asbestos had not been identified as a cancer-causing agent, and it was used to insulate the iron bars from the copper skin. The asbestos strips were covered and soaked with a layer of coal tar that had been applied many years ago.

The asbestos was scraped off the bar and immediately put in a tank with an emulsifying solution to avoid its becoming powdered and blowing into the air of the Statue's interior. The bars were then brought to the shop, which was on the island itself, where the operation for making new armature bars and the operation for making a new torch and flame were housed.

The next step was to clean the bar. A simple sandblast was used to clean the old bar before any work was done, then a mold for the "difficult" bars was made. A negative mold was first formed by fitting a light iron strap into it face to face. That mold was then reinforced and the new stainless steel bars formed to fit it. The methods used to make the new bars varied from hammering, a heat process, twisting clamps, hydraulic presses—ultimately, anything necessary to identically match every twist and turn.

After forming, the excess length was cut off with an abrasive saw. The splice bars, although much shorter, still had similar bends and twists that had to be duplicated. As each bar was completed, it was marked, recorded, and either stored for future work or, in most cases, passed on to the next process immediately.

It was discovered in performing this work on the bars that we were actually inducing a process of hardening into the bars. As we continued to work on the bars, they became harder and harder. Before we started work on the bars, they had a certain musical ring to them when tapped. As the processes got under way, the ring went up the scale—considerably up the scale! By the time we finished with the bar, some parts were almost brittle because of the work-hardening process. The original iron bars were flexible to allow movement of the copper skin; for this reason, brittleness in the new stainless steel armature bars could not be tolerated. It was decided that each bar had to be annealed, so a machine to anneal each bar was needed.

We considered using ovens, but it would have taken too long to purchase the equipment and also would have required too long a period of time to bring each individual bar to the proper temperature. An electric resistance machine was designed and built, which, in operation, ran 30,000 amps through each bar for approximately 4 to 5 minutes, bringing the bar up to a temperature of 1900 to 2000°F (1038 to 1093°C). When this machine was running, practically all of the power on Liberty Island was running through that bar; the shop where the procedure was performed felt like the inside of a toaster oven. The red-hot bar was then removed from the resistance heater and quenched in water to avoid alloy segregation in the stainless steel.

After the bars were annealed and quenched, they had to be sandblasted to achieve the desired architectural texture. Unfortunately, sandblasting stainless steel affects the protective oxide and leaves it vulnerable to rust and stains; therefore, the bars had to be repassivated. The bars were wrapped after sandblasting and sent to Manhattan, New York City, for a passivation treatment. The timing of this was crucial, because the Statue could not have more than four areas open at any one time. This was mandatory, so the passivation had to be done at night by shipping the bars to Manhattan to be treated and then sent back in the morning to be installed before any new bars could be removed. It was a "round-the-clock" operation.

The procedure for the passivation process was as follows:

(a) The bars were hand scrubbed with detergent and double rinsed;
(b) They were put in a passivation bath consisting of 20% nitric acid at 90 to 100° F (32.2 to 37.8°C) for 30 minutes;
(c) They were double rinsed thoroughly, placed in boiling deionized water, and hot-air dried;
(d) They were tested with copper sulfate solution or a sodium chloride and hydrogen peroxide solution. If there was any indication that the passivation was not complete, the passivation process was repeated; and
(e) Each bar was protectively wrapped and sent back to the island the next morning.
(f) The next step was to put a substitute for the original asbestos onto the bars; a Teflon[†] strip was placed on the back of each bar and under the saddles. The bars were then ready for reinstallation. The new copper saddles were placed on the bars and riveted through the skin.

The job was a demanding and exacting one, but eventually every one of the 1800 pieces was replaced.

[†]Trade name.

■ A New Torch for the Statue

Jean Wiart
Les Metalliers Champenois, Reims, France

The story of the 100th anniversary of the Statue of Liberty is also the story of an extraordinary restoration project. For Les Metalliers Champenois (LMC), it was also the story of a challenging adventure lived by a handful of dedicated French metal workers. (Table 1 documents our work schedule.)

On November 11, 1984, armed with visas and work permits, 10 French metal workers arrived in New York with four tons of tools and equipment. We immediately went to our new home in Brooklyn, New York, while our equipment was delivered to Liberty Island. (Because of voltage differences, we purchased machine tools, welders, bench saws, and plasma-cutting machines locally.) The next day, we set out to look at the workshop, which was located at the foot of the Statue. We installed the different machines and laid out the work areas, all of which required some imagination (Figure 1). We were allotted two-thirds of the workshop, roughly 20 by 45 meters. The other third was reserved for the American metal workers, who were responsible for the Statue's new stainless steel framework. We divided our group into two teams: One organized the shop while the other started to work. Within 10 days, we were functioning smoothly.

The old torch and flame had been removed from the Statue on July 4, 1984. They were stored next to our workshop so visitors could view them. When work started in mid-November, we moved them inside to study them in detail. We set the flame on the level and had a scaffold built around it. From this vantage point, we examined the famous flame. Our first impression was a disappointing one. It was going to be a difficult task indeed to recreate the flame as it had been conceived and realized by the sculptor, Auguste Bartholdi. The flame had been transformed so many times in the past 100 years that it resembled a shapeless Chinese lantern (Figure 2). The modifications were so numerous, in fact, that reconstructing it according to its original shape and design was a major enterprise; rather than reconstruct it, we had to reinvent it.

The two sets of historical documents we had to aid us were full of errors. With the help of the National Park Service, we borrowed from the National Archives photographs dating from 1880 to 1900. Photographs, however, have inherent flaws related

■ 131 ■

TABLE 1
Work Schedule for the Statue of Liberty Restoration

Installation and flame studies	November/December 1984
Building of scale models of flame	December 1984/April 1985
Balcony	January/July 1985
Soffit	January/June 1985
Platform	February/May 1985
Drum and door	June/July 1985
Stainless steel armature	February/May 1985
Copper flame	April/September 1985
Restoration of pendant	September 1985
Restoration of spikes	September/October 1985
Final construction of new torch and flame	June/October 1985
Gold leafing of flame	October/November 1985
Patining of torch	September/October 1985
Installation of new torch and flame	November 1985
Installation of spikes	December 1985
Preparation of the original torch and flame for transportation to the museum	March 1986
Installation of original torch and flame in museum	March 1986
Restoration of the old torch (after installation)	March 1986
Restoration of the old flame (after installation)	April 1986

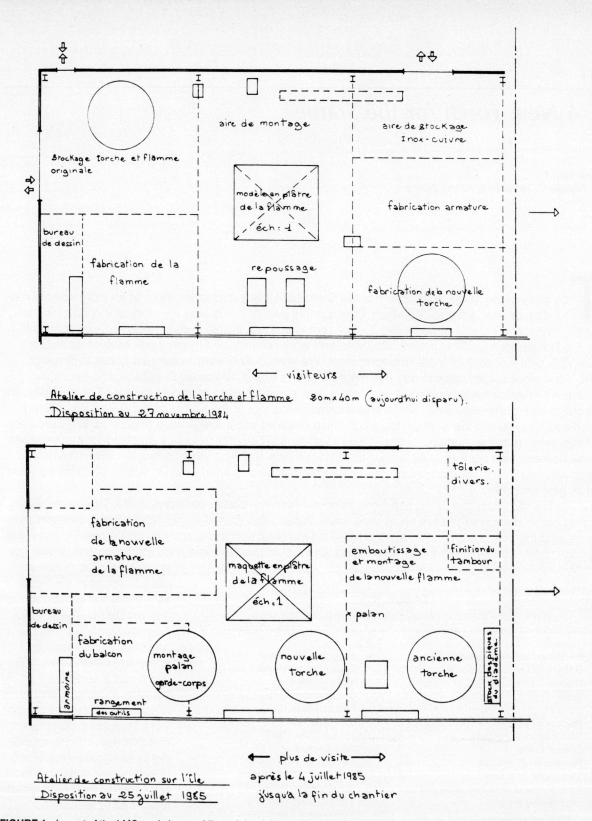

FIGURE 1. *Layout of the LMC workshop on Liberty Island: November 27, 1984 (top figure) and July 25, 1985 (botom figure).*

to perspective. Different angles led to contradictions. (Most of the pictures were taken from the pedestal.) Other photographs, taken during subsequent celebrations, were equally distorted. When we enlarged them, they were extremely imprecise.

After 100 years, the remains of the flame were not much more useful. The flame had been subjected to all kinds of abuse, including successive coats of paint, tar, and putty. It took considerable ingenuity to uncover each clue and deduct information that would reveal the "true" flame; the search turned into a real archeological "dig." The detective work was accomplished in record time, however, by

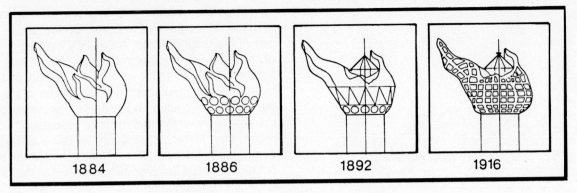

FIGURE 2. *History of the flame design alterations.*

Thierry Despont and John Robbins, the project architects, along with Serge Pascal and myself of LMC. Each joint and layer revealed the age and origin of the various elements of the flame. History also came to our rescue. Through the research of historian Carole Perrault, we learned that when the Statue left Paris in 1884, the flame had a continuous smooth surface of about 25 square meters. The 1-millimeter-thick repoussé copper sheets were riveted together with great care. It was referred to as a *ronde bosse* piece of sculpture; this was soon to change.

Bartholdi, who was obsessed with the Colossus of Alexandria, had envisioned his own colossus as a lighthouse, with light emanating from the crown. The United States Congress had, in fact, accepted this idea in its joint resolution of February 22, 1877. The idea of electrifying the flame, not the crown, came in 1885 after the Statue had arrived in America. Bartholdi would never have imagined such a misfortune for the flame. He suggested that electric lamps be placed on the edge of the platform to shed light on the Statue and the surrounding water.

The Lighthouse Board and a Lieutenant Millis were in charge of the new electrification plans. One week before the dedication on October 28, 1886, Millis came up with a new plan. He had two rows of small circular windows cut into the copper flame and placed electric lamps inside (Figure 2). In addition, lights were placed within the fort walls to light the Statue. However, the lighting of the Statue was incomplete. On the evening of the dedication, much of the Statue was still in the dark! Several attempts were made to improve the electrification. Bartholdi went so far as to suggest covering the Statue with gold or painting it to make it reflect in the dark. This lighting misadventure was not over with the failure of the electrification.

In 1892, one of the rows of small circular windows was eliminated and replaced with 24-inch-(609.6-millimeter-) high window panes to create a kind of "skydome." In 1916, the windows were removed and replaced by stained glass windows. The upper half of the flame was also fitted with matching stained glass windows. Eventually, these multiple joints began to leak. The efforts to electrify the flame had also caused considerable water damage to the torch supporting the flame.

The flame we studied in 1984 was the product of all these modifications. I believe the original flame, the one conceived and realized by Bartholdi, would have been in as good condition as the Statue itself had it been left alone. The fact that the Statue still effectively weathers the elements is eloquent testimony to the design and workmanship of our forebears. With this in mind, we began our work to make the new flame.

□ A New Flame for Miss Liberty

Once the scaffolding was installed in the workshop, we had an 18-square-meter plywood platform built around and just below the base of the old flame. On this carefully leveled platform, we drew perpendicular lines with a pitch of 120 millimeters. Each line was coded from A to Z and from 1 to 24 to create a geometric pattern of reference points to precisely locate any given part of the flame in space. Next, we built a dihedral structure on the platform. This somewhat archaic device enabled us to take dimensions on the axis of the drum beneath the flame so the exact contours could be established on the x, y, and z coordinates. In fact, we built three identical structures: one for the original flame, one to construct the half-sized model, and one to create the full-sized plaster flame. The full-sized "dihedron" was 3 meters high by 4.5 meters wide and 4.5 meters deep. Each one was constructed with four wooden square posts 100 by 100 millimeters, with upper and lower bars and diagonals to hold the entire structure perfectly level and rigid. To complete the system, a ruler was installed at the top of the dihedron. Using a plumb line, we were able to make extremely precise measurements.

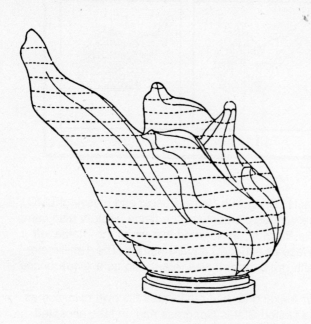

FIGURE 3. *Horizontal lines on half-sized plaster mockup.*

Once the dihedron was in place, we began the work of recreating the flame. On the upper half of the original flame, we initially marked about 8000 reference points. Later, we added another 2000 points for even better definition. To make these measurements, small pieces of paper tape were placed on the flame. Ink marks on the tape allowed the architects to precisely record key reference points on the flame without damaging the copper. These many thousands of points permitted the precise recreation of the original existing portion of the flame as well as the orientation and flow of the small flames, including their height, width, and thickness. This painstaking part of the project was completed by eight patient workers in nearly 1300 hours.

Because the early attempts at lighting the flame had altered the original shape, the lower half of the flame was recreated from early photographs and numerous plaster mockups created by the architects and our own team (Figure 3). Once the half-sized plaster mockup was completed, we drew 17 horizontal lines on it at intervals of 60 millimeters. Each line, numbered from I to XVII, traced a perfect horizontal slice of the flame at a predetermined height. Next, we took reference measurements of each slice to obtain a highly accurate contour. When all 17 contours were recorded, we were ready to start building the full-sized plaster flame.

The architects insisted that the new flame be an exact replica—in size, shape, and volume—of the original. To ensure this, a complete photogrammetric survey of the original flame and the half-sized plaster model was conducted. The results showed a perfect similarity between the two and proved the reliability of the age-old pointing method.

Each half-sized level was enlarged to a full-sized representation on 22-millimeter-thick plywood. The result was a "skeleton" composed of 17 layers of plywood with a 120-millimeter space between each layer. These were carefully installed inside the dihedron. Once completed, the "master" lines (plywood layers) of the flame were filled with plaster until the final shape of the flame was obtained. The job required approximately 500 kilograms of plaster. After weeks of effort, the Metalliers were rewarded with the official approval of the architects for both the half-sized and full-sized plaster flame. At last, we had succeeded in recreating Bartholdi's original sculpture!

The intermediate step of the half-sized plaster flame is an interesting one. The architects felt that all of the studies should be made on a smaller scale to make corrections faster and easier, while using fewer materials and less manpower than would be needed on a full-sized model.

As soon as the plaster was completely dry, we smoothed the surface and drew the location of every joint for the 23 separate copper pieces of the flame (Figure 4). We also redrew the 17

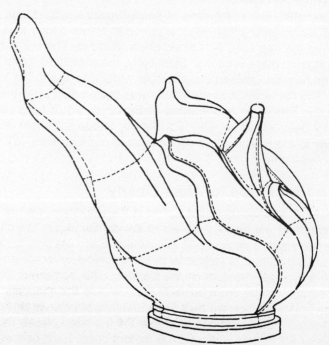

FIGURE 4. *Every copper joint was drawn on the scale model with a red pencil. The direction of the overlapping joints was indicated taking into account the direction of the water flow.*

horizontal lines using a giant shop-made marking gauge. Then we marked the location of the interior steel armature as well as the location of the copper saddles on the surface of the plaster.

Next, we started the fabrication of the 23 different repoussé molds. The volume of each one had to be precisely defined because the copper sheets covering the new flame would, in turn, be hammered and formed in them. Each mold was made from dozens of pieces of iron sheet that were hammered and shaped directly on the plaster flame. This technique was developed through thousands of hours of experience obtained restoring the monumental Stanislas Gates in Nancy, France. This cover on the flame was started in mid-April and was completed by mid-June. Once completely covered, the flame resembled a helmet from the Middle Ages (Figure 5), which prompted tourists and the American management alike to ask, "What are these French guys up to?"

The reinforcing armature for this iron shell was completed by the end of June, and the molds were removed from the plaster flame. The back of each mold was set in concrete for reinforcement and to increase its stability for hammering. The inside of each mold was smoothly ground to precisely match the contour of the flame's surface.

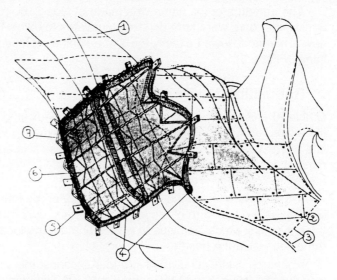

FIGURE 5. *Between every horizontal line (1), the flame was covered with small pieces of 1.5-mm-thick iron sheet. Each sheet was different from the others and forged to the precise contour and volume (2) and (3) of the flame. A total of 950 pieces was required to build the 23 molds. Each piece of iron sheet was screwed onto plywood and then welded together (6). A network of triangular space framing was built to reinforce the plates (7) and then welded onto flat steel bar bent to follow the contour of each mold (4). Some connection plates were welded onto the iron strips to connect the molds.*

The repoussé process for the 25 square meters of copper required three weeks to complete. First, the 1.1-millimeter-thick copper sheet was annealed to render it malleable. Each sheet was initially hammered on wooden blocks to prepare the volume to fit inside the steel mold. This was done with wooden mallets. The more difficult sections were formed on steel bowls with wooden or steel hammers. Next, the copper sheets were ready for repoussé work in the steel and concrete molds. The molds were placed on sandbags for proper positioning and to soften the impact of the hammering. A number of wood and copper hand tools were custom-made for use in the repoussé work on the copper sheet on the steel surface. The edge of each shaped copper piece was carefully drawn at the precise contour and cut with the extra metal needed to create an overlap of 16 millimeters.

Once the repoussé process had been applied to a copper sheet, it was finely hammered to smooth the surface and remove embossing marks. This work required four workers four weeks to complete. The copper sheets were assembled beginning with the bottom of the flame. Screws and nuts were used at first until the sheets were riveted together with 4-millimeter-diameter rivets placed 19 millimeters apart; 2600 rivets were needed. Once riveted, every joint was filled with tin solder and ground flush with the copper surface of the flame.

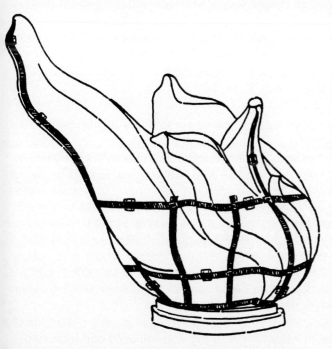

FIGURE 6. *The internal armature was made of stainless steel flat bars (35 by 8 millimeters) that followed the volume of the flame. The armature was riveted to the flame with copper saddles and insulated from the copper with Teflon tape.*

The armature of the flame was made of type 316L (UNS S31603) stainless steel. The flat 35- by 8-millimeter bars were bent on steel templates to follow the contours drawn on the plaster flame. The new armature followed exactly the same contour, direction, and method of attachment as on the original flame (Figure 6).

□ **Rebuilding the Torch**

Of the 10 artisans on the team, two were fully dedicated to the torch. It took three months to complete the entire set of 15 drawings. Again, one of the many problems we encountered was the need to translate the text and convert measurements. We also prepared a list of all materials that we needed for the restoration. All orders were approved and placed by the firm Lehrer-McGovern Inc. Construction Managers (New York, New York).

The armature inside the torch was supported by four angle bars 70 by 70 by 9 millimeters, which constitutes the armature of the torch handle. On July 4, 1984, this main armature was cut to remove the torch. Our first precaution was to precisely mark the location of each cut on every angle bar that remained inside the handle.

The torch itself was divided into four sections: the soffit, platform, balcony, and drum. Each section was put into fabrication at the same time, with two steps common to each section: (1) fabrication of wooden and/or steel molds for shaping the contour of the copper sheet, and (2) fabrication of steel molds for fine hammering and detailing of each copper sheet.

Since we were not permitted to create molds from any parts of the original torch, either directly or indirectly, and because many of these parts were badly distorted, all molds were created from new measurements and drawings. For the soffit and other sections of the torch, plywood molds were built. A sheet of 2.5-millimeter-thick copper was cut out, annealed, and shaped in this mold using large wooden mallets. Often, the fabrication of a mold required more time than its actual use. However, such molds provided extreme precision. Steel molds were needed for the intricate ornamentation around the soffit. These were built taking into account the shrinkage of the copper that occurs during hammering. The thickness of the iron sheets used for the iron molds was about 3.5 millimeters. The molds were reinforced with flat bars and sometimes with concrete.

■ 136 ■

The soffit was built in four sections; the platform and balcony in eight; the drum in three. Each section was connected with "wolf's teeth" joints and brazed. The connection of the four pieces of the soffit required a temporary steel support to make fine adjustments. The 24 curved openings in the soffit were covered with perforated bowl-shaped copper covers to ensure proper drainage and to keep out nesting birds.

The balcony was by far the most intricate part of the torch. Its design included 16 ornamental panels that were riveted to the main copper balcony. Each panel included the following:

(a) two "ears of corn" design elements: one right, one left (32 ears total);
(b) one molded cylindrical vertical baton (16 total); and
(c) one upper palm leaf (16 total).

Because of the intricacy of the repoussé ornamentation, each piece was individually hammered by hand using wooden blocks and steel tools.

Once assembled, a stainless steel armature was affixed to the back of the balcony's eight sections. The armature was isolated from the copper with Teflon[†] tape and riveted with copper saddles to the balcony. By August 1985, final adjustments were made to the soffit, platform, and drum. They were riveted together and the interior stainless steel armature was installed. The balcony was completed by the end of September and the repoussé ornamental panels were installed the first week of October.

The original access door that led from the central drum to the walkway platform was warped because there was no reinforcing armature behind the copper sheet. The new door was built with a stainless steel frame made from flat iron bars on which three bronze hinges were riveted for added rigidity. A stainless steel lock was made and installed so the door could be padlocked. We also installed a watertight stainless steel gasket to eliminate the possibility of water entering the drum.

While we were rebuilding the torch, we removed the seven "rays" from Miss Liberty's crown and the pendant from the handle of the torch. The internal armature on each ray was removed and recreated in stainless steel. Since the sides of the rays were made of cast bronze, we screwed the armature directly onto the bronze sides using flat stainless steel screws and bolts (M16).

[†]Trade name.

The original brass sheets covering the top and bottom of each ray were preserved. However, all of the brass screws that held the sheet to the bronze spikes were remade using screws (M6) with small flattened oval heads. The restored spikes were wrapped in protective plastic bubble wrap (to avoid scratching the preserved patina surface) and stored in the workshop until they were finally installed in the Statue's crown in December 1985.

To remove and transport the pendant on the handle of the torch, a special steel cradle was built in the shop. Every point of contact with the copper pendant was covered with soft rug material. Once in the workshop, the architects decided not to make an entirely new pendant but to restore the upper middle section and to replace the lower middle section. To do this, we hammered the cone-shaped volume of this section from a single piece of copper sheet. The crossing lines were hammered into the metal using the repoussé technique, first from the inside and then from the outside, to highlight the design.

The new copper section was joined to the restored portion of the pendant again using the "wolf's teeth" connection. A new stainless steel armature was also installed. Finally, a seep hole was created in the base of the pendant to evacuate water.

The restored pendant was chemically patined and placed on the cradle for the trip to the top of the Statue. According to the architects' instructions, a round stainless steel bar was secured around the main armature in the torch handle to provide additional security. The final step was to apply a light green coat of patina to the new portions of the torch to match the color of the Statue.

■ 137 ■

WEST ELEVATION

EAST ELEVATION

NORTH ELEVATION

FLAME CONNECTION DETAIL

DOOR HEAD / JAMB & SILL SIMILAR

SOUTH ELEVATION

FLAME ARMATURE AXONOMETRIC

FLAME ARMATURE DIAGRAM

RAILING DETAIL

DECORATIVE RAILING

Prepared for the
The Statue of Liberty
Ellis Island Foundation, Inc.

Restoration of the
STATUE OF LIBERTY

CONNECTION OF THE TORCH AND FLAME

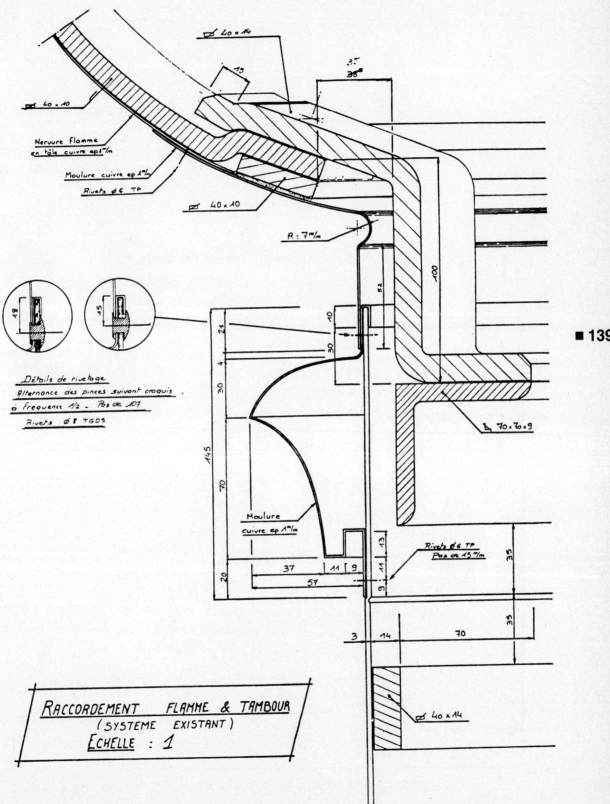

☐ 40 x 14

15

35
38

☐ 40 x 10

Nervure flamme
en tôle cuivre ep 1ᵐ/ₘ

Moulure cuivre ep 1ᵐ/ₘ

Rivets ⌀ 6 TP

☐ 40 x 10

R : 7ᵐ/ₘ

18 15

Détails de rivetage
Alternance des pinces suivant croquis .
à fréquence 1/2 - Pas de 107
Rivets ⌀ 8 TGDS

100

52

21
4
10
30
30
145
70

Moulure
cuivre ep 1ᵐ/ₘ

☐ 70 x 70 x 9

13
20
37 11 9
57
9 11
9

Rivets ⌀ 6 TP
Pas de 15 ᵐ/ₘ
35

35

3 14 70

■ 139 ■

RACCORDEMENT FLAMME & TAMBOUR
(SYSTEME EXISTANT)
ECHELLE : 1

☐ 40 x 14

ORIENTATION OF THE FLAME

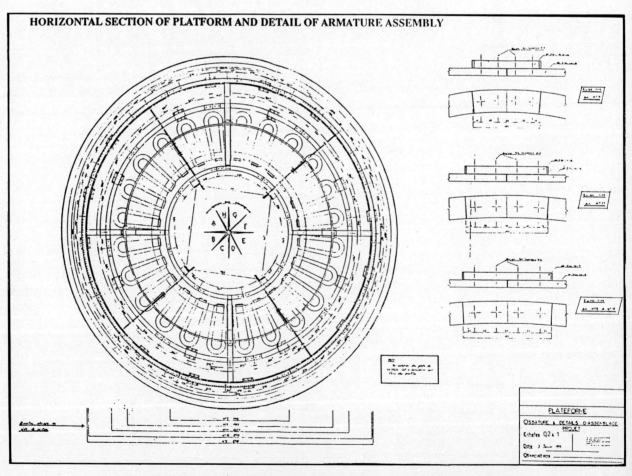

HORIZONTAL SECTION OF PLATFORM AND DETAIL OF ARMATURE ASSEMBLY

VERTICAL CROSS SECTION OF THE TORCH AND FLAME

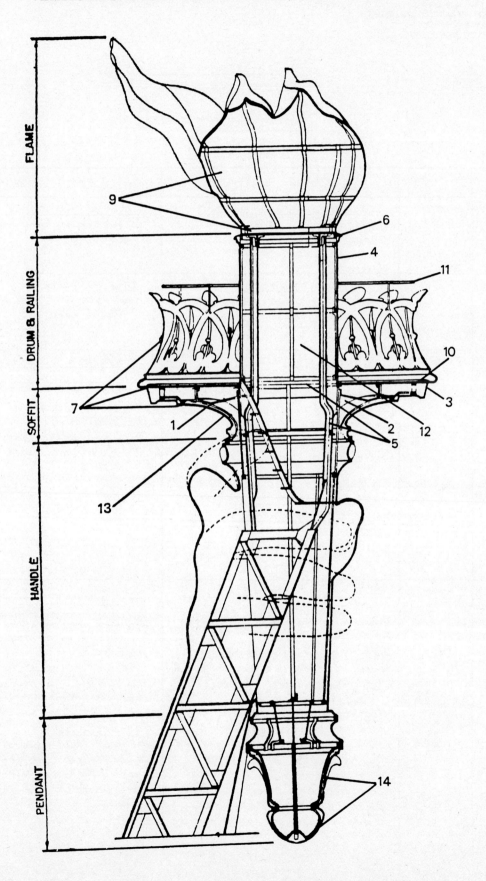

METALLIERS CHAMPENOIS
11, Rue des Létis
51500 BEZANNES - LES - REIMS
FRANCE
Tél. (26) 36 21 33 - Télex 842112

```
PLANS   - SOMMAIRE
DRAWINGS  - SUMMARY
```

■ 142 ■

Date	N° / Number	Français - French	Anglais - English
19 Dec. 1984	1	Console composée existante Elévation - Vue de dessus. Vue arrière.	Original compound bracket Elévation. Top view. Rear view
17 Dec. 1984	2	Console existante (en tôle) Elévation. Vue de dessus. Vue arrière.	Original bracket (in iron sheet) Elévation. Top view. Rear view
3 Jan. 1985	3	Plateforme. Projet n°1 Ossature & détails d'assemblage. Coupe sous plateforme Eclisses (Conforme à l'original)	Platform. Project #1 Armature and assembly détails. Horizontal section under the platform Typical splice bars (complied with the original)
16 Jan. 1985	4	Tambour. Propositions de système d'étanchéité pour la porte. 10 propositions	Drum. Door tightness proposals. ten proposals
9 Jan. 1985	5	Plateform - Consoles. Projet n°1 Console et console composée en coupe verticale. Détail de raccordement avec l'armature de la poignée (consoles - cornières éclisses). Modifications: - Pose de quatres équerres (EQ11 & EQ10) pour liaisonnement des fers plats HT10 & HT11 à la console - Consolidation de l'assemblage poignée/soffite par ajout d'une éclisse à l'intérieur de la cornière (VAB)	Platform. Brackets. Project n°1. Vertical section of the bracket (in sheet) and the compound bracket. Reconnecting détail of the handle armature (brackets. Angle bars. splice bars. Modifications: - we put four squares (EQ11 & EQ1) in order to fasten the flat bars HT10 and HT11 with the bracket (in sheet)

PLANS - SOMMAIRE
DRAWINGS SUMMARY

Date	N° / Number	Français · French	Anglais · English
	5 (continuation)	- Prolongation du bas de la console, pour la même raison - Suppression des plats soudés sur VT2', VT4', VT6' et VT8'. Remplacement par un plat unique, coudé, pour le liaisonnement de HT12 à HT7, et de la plateforme et du tambour par la même occasion. - Solidarisation de la jambe de force et du poinçon de la console composée, en une pièce unique	- We propose too, to put a new splice bar in the angle bar interior, in order to consolidate the assembly between the handle and the new soffit armature. - For the same reason, we have extend the bracket bottom. - Removing of the welded flat bars on VT2', VT4', VT6 and VT8'. Replacement by only one flat bar, bended, in order to connect the flat bar HT12 and HT7, the platform and the drum by the same occasion. - At the compound bracket we propose the stiff leg and its king post are made in only one member
24 Jan 1985	6	<u>Tambour · Coupes & détails Projet n° 1</u> - Coupe horizontale - Coupes verticale - Détail haud de tambour (moulure · Armature) - Détail d'assemblage des montants et de la traverse intermédiaire au niveau de la porte. - Equerres d'assemblage des cornières verticales et de la cornière de ceinture (F') - Détail des eclisses Aucune modification. Toutes les pièces sont conformes à l'original	<u>Drum · Sections and détails project n° 1</u> - Horizontal section - vertical section - top of drum detail (dado, circular angle bar). - Upright and intermediat cross bar of fixed door assembly square detail - Assembly square of the vertical angle bars (VAB) and the circular angle bar. - Splice bars détail. No modifications All the members of the armature are complied with the original

PLANS · SOMMAIRE

DRAWINGS · SUMMARY

Date	Nº / Number	Français · French	Anglais · English
28 Janv. 1985	7	Soffite · Plateforme · Garde-corps · Tambour · Flamme Colliers & entretoises Récapitulation de tous les colliers et entretoises. Toutes ces pièces sont conformes à l'original	Soffit · Platform · Railing · Drum · Flame Saddles and braces Recapitulatory of all the saddles and the braces. All this members are complied with the original.
26 Jan 1985	8	Annulé pour cause de refus.	Canceled to motive of refusal
4. Feu 1985	9	Flamme · Projet n.º 1 Orientation · Fixation au tambour · Armature - Assemblages type - Perspective de l'armature de la flamme - Détail de fixation sur F' - Implantation des pattes de fixation Tous les assemblages sont existants. L'armature intérieure de la flamme est modifiée en fonction de sa nouvelle forme. Pour la même raison, nous avons prolonger les plats verticaux HF9 & HF10	FLAME · Project #1 Situation · Reconnecting on the drum · Armature. - Typical splice bars. - Perspective of the flame armature (all the assembly are drawed on this view) - Reconnecting between the horizontal flat bar HF1 (in the flame) and the circular angle bar F' (in the drum) detail - Holding fixture bracket situation
11 Feu 1985	10	Garde-corps Armature · proposition - Vue arrière du garde-corps Proposition pour fixer l'armature sur le plat cuivre, sur les trous d'origine.	Railing Armature · proposal - Rear view of the railing and its armature. Proposal to clamp the armature on the cooper flat bar, in its holding fixture holes (original).

PLANS - SOMMAIRE

DRAWINGS · SUMMARY

Date	N°/ Number	Français - French	Anglais · English
13 Fev. 1985	11	Garde corps . Fixation. Main courante - Implantation de la main courante. - Détails de fixation de la main courante sur le garde · corps - Détails d'assemblage de la main courante - Implantation du garde · corps et de son armature - Détails du plat cuivre sur plateforme Modifications : Remplacement de la main courante en acier par un rond de cuivre (assemblages différents) - Différente implantation de l'armature du garde · corps sur le plat cuivre → consulter le plan N° 10	Railing · Holding Fixture. Hand rail . - Hand rail situation - Details of reconnecting between the hand rail and the railing armature. - Hand rail assembly details. - Situation of the railing and its armature. - Cooper flat bar on the platform detail. Modifications Replacement of the hand rail in iron pipe (and its uprights) by a cooper round bar (different assembly). Different holding fixture situation of the railing armature , on the cooper flat bar. → to consult the drawing #10.
Drawing in project	12	Tambour . Porte - Elevation - Coupe verticale - Coupe horizontale - Détail de paumelle - Détail de loquet	Drum . Door - Front elevation - Vertical section - Horizontal section - Hinge détail - Lock détail
Drawing in project	13	Soffite · chattière cuivre. Proposition Chattière à chaque ouverture du soffite (pour étanchéité et ventilation	Soffit - Cooper hood Proposal Cooper hood at each opening in soffit (for waterproofing and ventilation).
Drawing in project	14	Pendant. Armature . Fixation. Trou de drainage des eaux . Détail	Pendant. Armature Holding Fixture. Weep hole for draining Détail
Drawing in project	15	Couronne. Projet de remplacement des pics	Crown. Project of the spike removing.

■ *Addendum: Gilding the Flame*

Fabrice Gohard
Ateliers Gohard, Paris, France

After careful consideration by the architects, our proposal to gild the flame was accepted. Our technique, using gold leaf, offered several advantages over the competing electrolytic method, the major advantage being that we could gild the entire flame in a shorter period of time. Also, touchup of the flame is easier with gold leaf. To facilitate future touchups, we had a light aluminum scaffolding built that can be erected easily around the drum whenever needed. It is now stored at the Statue ready for immediate use. Our work, which began in October 1985 and took two workers three weeks to complete, had three distinct parts.

■ **146** ■

First, it was necessary to have a perfectly clean surface on the copper flame. All particles of dirt and grease as well as water marks were removed. Next, because of the properties of copper, it was critical to create an insulating layer for the gold leaf. This was accomplished with a special primer coat. Before the primer was applied, several suitability tests were conducted, despite the fact that we had successfully used the process for many years. One coat, carefully applied and spread over the copper surface, is sufficient. The primer dries quickly and the first coat of varnish can be applied almost immediately.

Varnishing was the second step. This special varnish is particular to the gilder's art and is prepared according to an age-old formula and tradition. In fact, this varnish has remained unchanged since it was first used in the 18th century. This is the layer upon which the gold leaf is applied. If it is too thick, the varnish will form a crust; if it is too thin, it will not properly insulate the copper from the gold leaf. Several coats of varnish are usually needed; we applied three coats to the flame.

When these steps were completed, we were ready to start gilding. We organized the work by dividing the flame into five sections: the four sides and the top. Sizing was applied to each section the evening before it was gilded. About 12 hours are needed for the sizing to dry to the tacky finish needed to properly hold the gold leaf.

The gold leaf used on the Statue of Liberty flame was specially hammered by Etablissement Dauvet in France. The process required three weeks. It was unique in that never before had such heavy gold leaf been used (33 grains per 1000 sheets). The gold leaf comes in packages of 25 sheets, 85 by 85 millimeters. Two hundred packages, or 5000 sheets, were used to gild the flame. Each sheet is placed one next to the other to follow the flow of the flame. On smooth surfaces, the gold leaf was applied directly from the package. On hard-to-reach surfaces or those smaller than the size of the sheet, we used a gilder's cushion. This cushion is really a small paddle covered with calf skin and cotton wadding. Stiff parchment paper encloses one end and two sides of the paddle. Sheets of gold leaf are stacked within the parchment holder. They are separated from one another with a knife, which can also be used to cut each sheet to the desired size and shape. Each sheet is then positioned on the flame with a small applicator charged with static electricity.

Despite the delicacy of the gold leaf, no retouching was required after the installation, with the exception of some areas that had been rubbed by the protective hood.

■ Skin Repair for Miss Liberty

Joseph Fiebiger
P.A. Fiebiger, New York, New York

The preponderance of areas that required restorative work were those that had been thinned in the hammering process. There is nothing to suggest that deterioration in the areas of the nose, eyes, lips, curls, left shoulder, neck, and fabric folds was initiated by severe corrosion. These were "deeply drawn" elements that called for a vast migration, or deformation, of material. This is evidenced via a thickness of 0.065 inch (1.65 millimeters) at the bridge of the nose, thinned progressively until fracture at the tip was at 0.012 inch (0.3048 millimeter). Curiously, yet logically, these thinned areas were usually set downward, becoming catch basins in which water would collect. Despite "weep" holes that were fashioned through the years to permit water to escape, water was entrapped by din, or dirt, and rust from armature bars. This combination caused the corrosion in these thin areas. One should note that in nominally thick areas [0.093 to 0.060 inch (2.362 to 1.524 millimeters)], which were set downward, there was no major corrosion.

Negative impressions of these areas were indexed to the Statue and allowed for a pure representation of the original male, in plaster. The plaster was then used to prepare negative "doming" blocks using a combination of epoxy and polyurethane. Copper was hammered in these negative forms. Where severe deformation was necessary, the elements were fashioned in sections. This allowed for hammering to the side of the "dome" and excluded thinning. The sections were welded together using a combination of gases and deoxidized copper, which ensure an invisible joint. This joint is invisible when polished and patined.

New elements were joined to the Statue via the implementation of an astragal that had been hammered to the same shape as the element. The astragal is common to both sides of the joint. Each side of the new element was cut 1/32 inch (0.79375 millimeter) larger, 1/16 inch (1.5875 millimeters) too large for the opening. These edges and those of the afflicted areas were then "upset." The new element was laid in place, the full meeting border being raised, after which element and skin were riveted to the astragal, and the raised area was gently hammered to create a nearly smooth and invisible joint. Because of thermal motion, a slight "hairline" crack did develop along the joint.

All restored areas were patined using various recipes. These recipes had been tested on a test "farm" set on the scaffolding. The procedures are described in Appendix A. A history of the art of the repoussé, or hammered metal, technique is presented in Appendix B.

■ 147 ■

□ Appendix A

Procedure for Patining the Replaced and Repaired
Elements on the Statue of Liberty

Application procedure for developing various antique green patinas is as follows:

The copper sheeting or form is prepared by cleaning the surface with a dilute solution of 1 part nitric acid and 25 parts distilled water, or by lightly bead- or sandblasting. The copper is washed with a dilute solution of 1 part ammonium sulfide and 10 parts distilled water, which darkens the metal to an even shade of brown-black. The metal is rinsed with distilled water, neutralizing the chemical, then the copper is allowed to dry. The surface is now prepared for the green patining.

Plaques 1 through 4—These plaques were washed successively with a solution of 1 part ammonium chloride and 17 parts distilled water. The surface was allowed to dry between coats.

Plaques 5 through 8—These plaques were washed successively with a solution of 1 part cupric nitrate, 1 part ammonium chloride, 1 part calcium chloride, and 17 parts distilled water. The surface was

allowed to dry between coats. When a light green was achieved, the patina was finished with successive coats of Solution 1 (plaques 5 through 7). Plaque 8 was washed repeatedly with Solution 2 only.

Plaques 9 and 10—These plaques were washed successively with a solution of 2 parts cupric nitrate, 1 part ammonium sulfide, 5 parts calcium chloride, and 17 parts distilled water. The surface was allowed to dry between coats. When a light blue-green color was achieved, the patina was finished with several coats of Solution 1.

Plaques 11 through 14—These plaques were washed successively with a solution of 1 part cupric chloride, 1 part ammonium chloride, and 34 parts distilled water. The surface was allowed to dry between coats.

□ Appendix B
An Evolutionary History of the Art of Repoussé

There are two acknowledged types of repoussé techniques in the history of decorative art. The first is primarily worked in a resilient material such as "pitch" or lead. The second is worked on stakes, forks, spoons, and primary doming blocks. These two types allow the execution of an element that has been created without a previously modeled or sculptured form. Throughout the history of decorative projects, the artistic blacksmith has mastered these functions as an adjunct to his craft, the synthesis of eye, hand, and hammer. These processes mandate the hand forging of the hammers, punches, chisels, drifts, stakes, forks, spoons, and doming blocks.

Various recipes for repoussé pitch are as follows:

(a) 10 pounds (4.536 kilograms) pitch, 20 pounds (9.072 kilograms) brick dust, 4 pounds (1.8144 kilograms) resin, 2 pounds (0.9072 kilogram) tallow;

(b) 6 parts pitch, 8 parts brick dust, 1 part resin, 1 part linseed oil;

(c) 14 pounds (6.3504 kilograms) pitch, 14 pounds brick dust, 7 pounds (3.1752 kilograms) plaster of Paris or brick dust, 8 ounces (226.8 grams) tallow.

When brass, bronze, copper, aluminum, or silver are to be worked in the repoussé fashion, the artisan is given a sketch of the element to be composed. Usually this element is to be nonrepetitive or is repeated only in small quantities. This process allows for the material to be hammered and drawn sufficiently so that it may be completely formed, including the undercuts, from a single piece. The material is first coaxed into its general form, via hammering from the back into a "doming block." This block is hemispherical and is made either of cast iron or wood. The latter is preferable in this stage, for there is little marring. Once given its rough shape, the element is set into the pitch block or pitch board and exposed to a soft flame that fills the voids between the material and the pitch. With this resilient background, the artisan can begin.

Details are drawn on the element and are chased, or grooved, into the piece with the chisels fashioned by the artisan. The sculptural phase is now implemented with hammers, punches, and drifts. The material work hardens throughout this procedure, and annealing must be performed to provide relief from these stresses. Though annoying to the artisan, annealing is mandatory. Patience and concentration are paramount throughout the procedure. This phase of the repoussé technique requires the craftsman to be both artisan and artist. The artisan/artist, if executing two of the same elements, cannot render the second as an exact replication of the first. The difference between these methods is that the pitch provides resiliency, not form. The form and bas-relief are the result of the talents of the artisan/artist.

Foliated forms, vessels, and chalices are fashioned via hammering without the use of punches, drifts, chisels, etc. Hammers with heads of various shapes are required. The material is hammered on iron doming blocks, forks, spoons, and raising stakes.

A variety of techniques prevail for the creation of artistic or decorative elements wherein the artist is purely the artist and the artisan is a technical craftsman. It is a misrepresentation to refer to these techniques as repoussé; they are more definitively doming, stamping, or drawing. Their origin is traced to late 17th-century France, when the repoussé workers of the era sought an alternate method of coaxing bronze, brass, and copper to a sculptured form. The method, often called "rope stamping," allowed for large and/or repeated elements to be fashioned. There is some speculation that this procedure, as an alternative means to "lost wax" casting, opened avenues for the sculpture. Pleasingly paradoxical, foundry-related skills for modeling and production of negative/positive forms were amplified. These forms offer no resiliency; they are cavities of form into or onto which the material is driven, the final work being a shell of the artist's oblique form.